A Special Edition for Friends of

PLANT CONSTRUCTION COMPANY, L.P.

This is the twenty-fifth successive annual book that Plant Construction Company has participated in producing. For the most part, our role in putting these books together has been to commit to the purchase of somewhere between 1,000 and 1,200 books upon being presented with an idea for a book that appeals to us. This commitment provides the necessary funds for the publisher to start the process of assembling the book and getting it printed. We're pleased to have supported many worthwhile books over the years.

Early in 2012, my friend Malcolm Margolin, publisher of Heyday in Berkeley, California, asked if we would be interested in partnering on a book about public art in San Francisco for our year 2013 gift. In the past, most of our book selections have been about the history of San Francisco or, in some cases, the State of California. At the time, I couldn't imagine a connection between our local history and the book that Malcolm was describing. Malcolm pointed out that there is public art just about everywhere in San Francisco, its presence shapes the way we feel about the City, and that a great deal of it commemorates or is representative of what was going on in San Francisco at the time the art was produced. I committed to going ahead with the book, but I wasn't sure that it was one of my better decisions.

It is now the middle of August 2012, and I am writing this greeting in order to have it included in the copies intended for our customers and friends at the beginning of next year. The other day, I got a virtual tour through a portion of the book on a computer at the Heyday office. It is now clear to me that almost every piece of public art in San Francisco is connected with some sort of interesting story about the artist, a crisis, a victory, a loss, a milestone, a famous person, a disaster, something that used to be located there, or any number of other stimulants. At that point, I realized that I had made a very good decision to proceed with this book and began to get excited. I think you'll be excited as well, and I hope you will enjoy the time you spend with this book.

—David G. Plant

Have a healthy, happy, and prosperous New Year!

January 2013

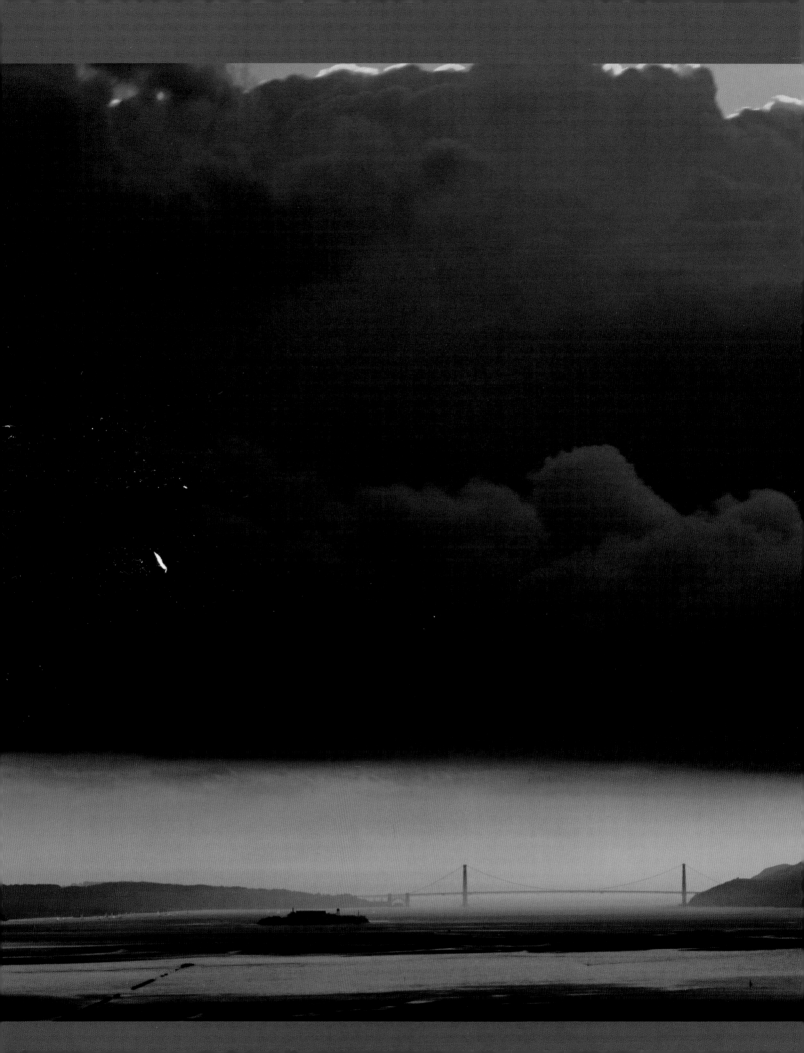

ARTS
for the
CITY

San Francisco:

1932–2012

SUSAN WELS

Civic Art and Urban Change

FOREWORD BY

JD BELTRAN, TOM DECAIGNY, AND P.J. JOHNSTON

INTRODUCTION BY

JEANNENE PRZYBLYSKI

HEYDAY, BERKELEY, CALIFORNIA

Library of Congress Cataloging-in-Publication Data

Wels, Susan.
 San Francisco : arts for the city : civic art and urban change, 1932–2012 / by Susan Wels ; foreword by JD Beltran, Tom DeCaigny, and P.J. Johnston ; introduction by Jeannene Przyblyski.
 pages cm
 ISBN 978-1-59714-206-9 (hardcover : alk. paper)—ISBN 978-1-59714-237-3 (apple e-book)
1. Arts Commission of San Francisco—History. 2. Government aid to the arts—California—San Francisco.
I. Title.
 NX742.C22S369 2013
 700.6'079461—dc23
 2012026962

Cover art by Owen Smith
Designed by Altitude Associates
www.altitudesf.com

Orders, inquiries, and correspondence should be addressed to:
Heyday
P.O. Box 9145, Berkeley, CA 94709
Telephone: (510) 549-3564, Fax: (510) 549-1889
www.heydaybooks.com

Printed in China by Everbest Printing Co. through Four Colour Imports, Ltd., Louisville, Kentucky

10 9 8 7 6 5 4 3 2 1

CONTENTS

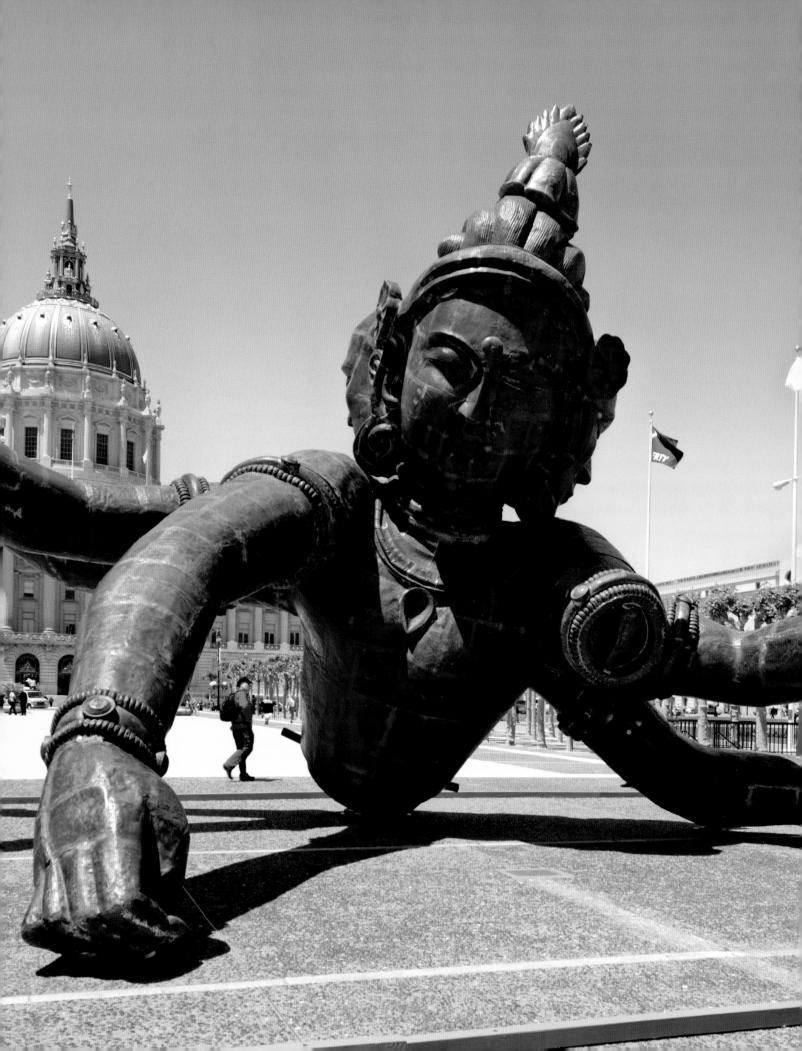

FOREWORD

Ever since its inception more than eighty years ago, the San Francisco Arts Commission has been a groundbreaking champion of the arts.

Established by charter in 1932, the commission's mission was founded on the principle that a creative cultural environment is essential to the city's well-being.

As you will witness from the fascinating story that unfolds in the following pages, the San Francisco Arts Commission, while not the first municipal arts agency in the country, has been a major leader in establishing municipal advocacy for the arts. Commission minutes from 1933 declare that "in its first year it was regarded as an innovation in Municipal Government... and its inception was undoubtedly experimental... the Art Commission is looked upon as a model to be copied and is constantly consulted by groups of citizens of other cities of the United States."

Eight decades later, the commission continues to be a national and international model, illuminating how a city agency can be responsive to legislation, politics, multiple constituencies, private interests, and the complex needs and desires of the public in ensuring that the arts are integrated into all aspects of city life. It has accomplished this despite the challenges of beginning in the midst of the Great Depression and struggling through multiple wars, economic upheavals, cultural revolutions, unforeseen tragedies, and a major earthquake. Somehow, no matter what happened, the Arts Commission made certain that art would always be present to calm, heal, educate, please, and inspire the public.

Through keen foresight, firm advocacy, innovative fiscal policy, and multiple administrations of visionary leadership, the San Francisco Arts Commission has grown to its present status as an agency overseeing numerous programs that serve a diverse ecosystem of arts organizations, individual artists, and the general public. With this firm foundation and a willingness to adapt to change, the Arts Commission looks forward to future decades with excitement and anticipation, where it can continue to be in the vanguard of establishing the arts as an essential part of everyday city life.

JD BELTRAN
Commission President

TOM DECAIGNY
Director of Cultural Affairs

P.J. JOHNSTON
Commission President, 2004–2012

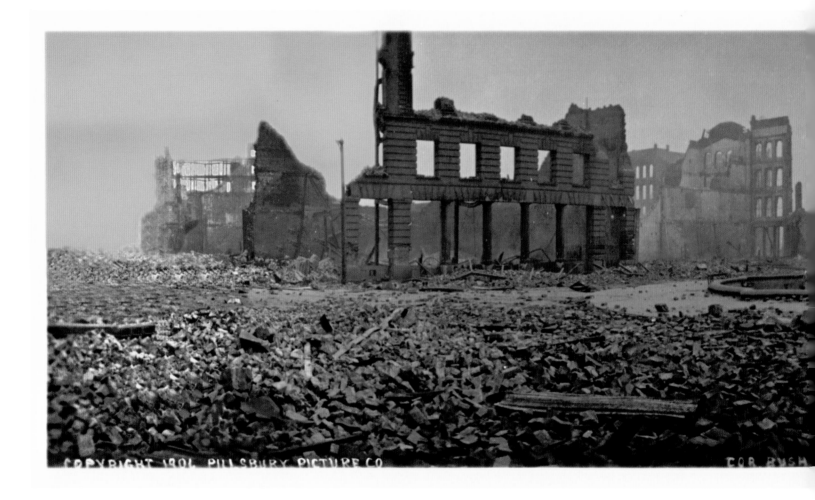

COPYRIGHT 1906 PILLSBURY PICTURE CO

The *Mechanics Monument*, by Douglas
Tilden, remained standing through the
1906 earthquake and fire.

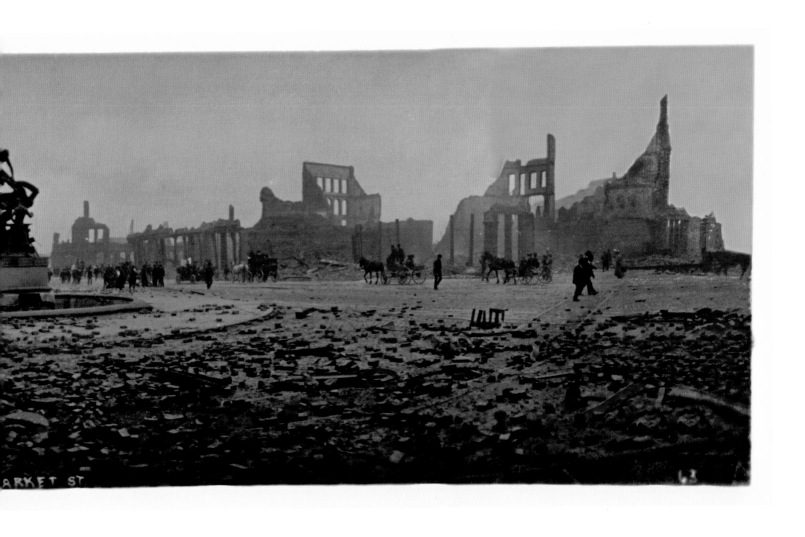

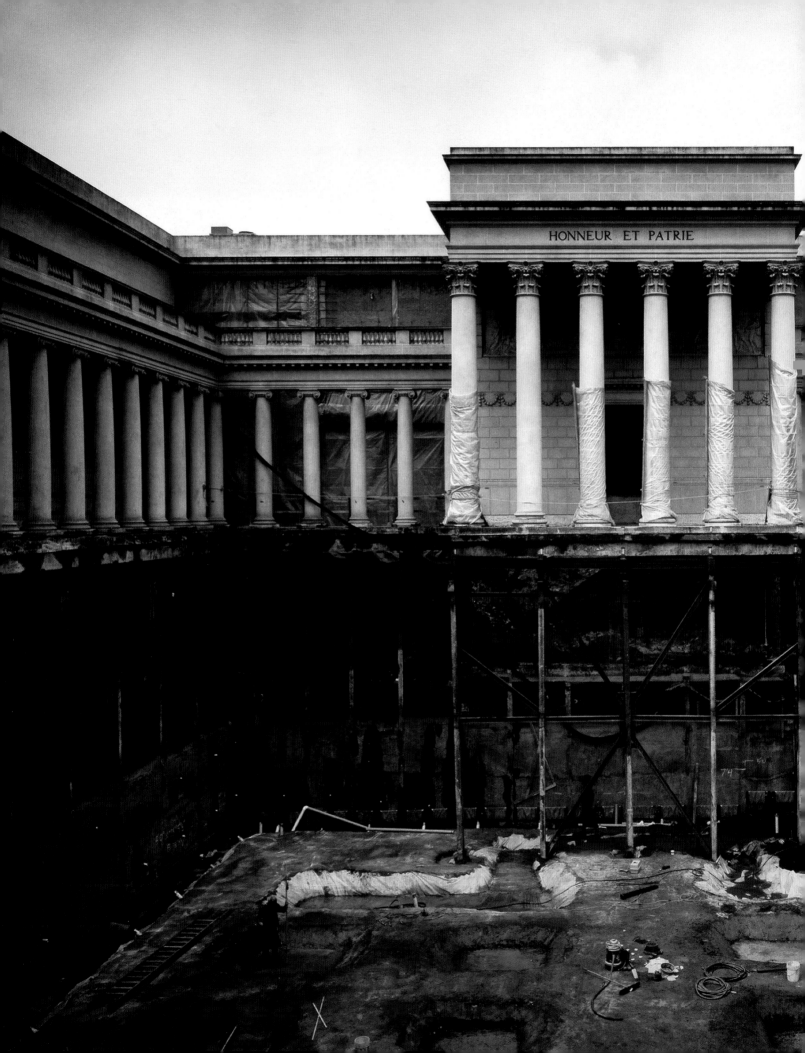

HONNEUR ET PATRIE

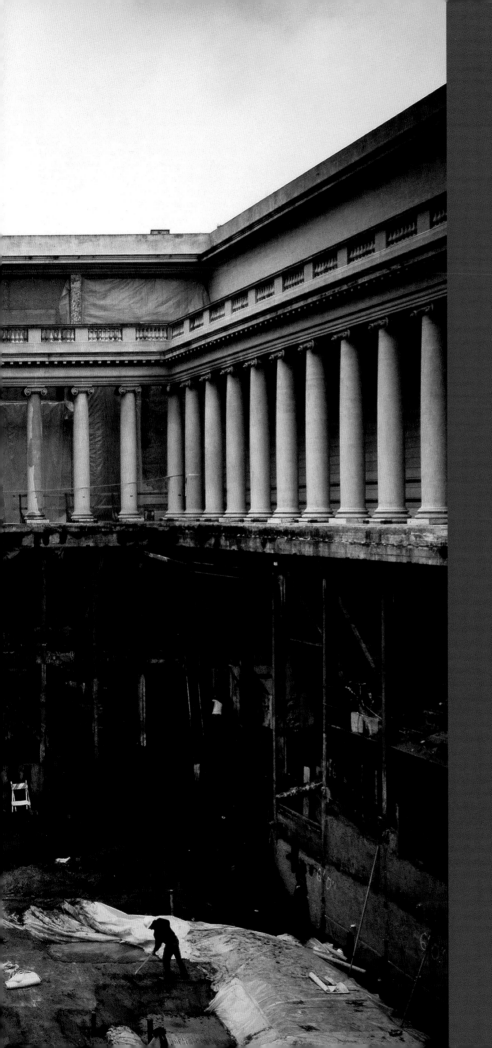

Palace of the Legion of Honor, San Francisco,
1995, by Richard Barnes

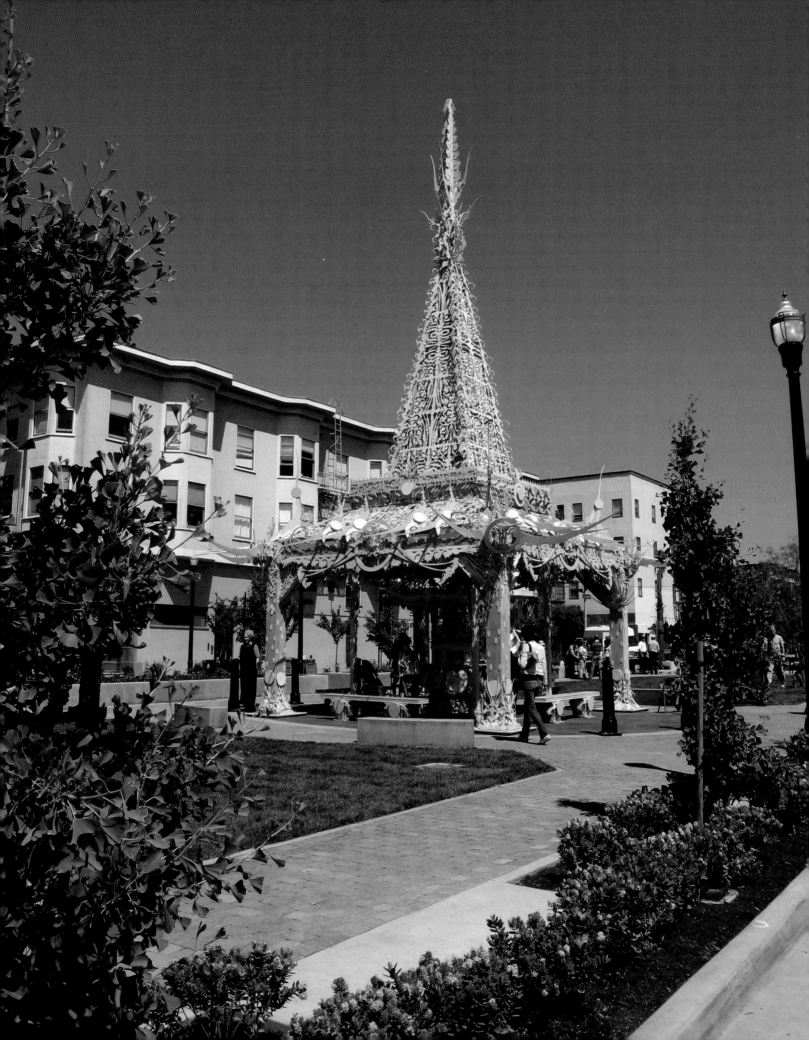

OPPOSITE: David Best's 40-foot-tall *Temple* was temporarily installed on Patricia's Green in Hayes Valley in 2005, in partnership with the Black Rock Arts Foundation.

BELOW: *Untitled (Three Dancing Figures)*, Version A, Edition 2/3, 1989, by Keith Haring. The artwork, a permanent acquisition by the City of San Francisco, stands at Howard and Third streets.

The Art of Making a Place in Time

BY JEANNENE PRZYBLYSKI

What do people ask of the art that shares their space in the city? How do they live with and around it, even "dream" through it? How is the relationship between artist and artwork, and site and public, to be powerful and consequential, rather than merely ornamental or "harmless" at best?

> *"What," I asked you, "is harmless about a dreamer, and what," I asked you, "is harmless about the love of the people?"*
>
> —TENNESSEE WILLIAMS, *CAMINO REAL*

When I was chair of the Visual Arts Committee of the San Francisco Arts Commission (2004–2009), I tried to think hard about these questions and to listen carefully anytime an answer was proposed—whether by an artist or art expert, by the citizen art lover or even art hater, or by the art itself. I did, and still do, spend a lot of time looking carefully at art in the city—whether art that we were in the process of undertaking during my tenure on the commission or art that has been entrusted to the city's stewardship as part of the Civic Art Collection or another initiative. I continue to try to imagine how all of this art might look in the future by attending carefully to the city itself as a constantly evolving ecology of hopes, desires, communities, and neighborhoods. It may seem otherwise in the heat of the moment, but neither the art nor the city, no matter how much faith we put in the permanence and durability of the built environment, stays the same forever. What makes me think this? Just look at a few of the monuments of the past that we continue to live with today.

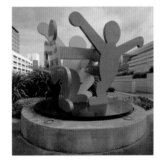

Take Frank Happersberger's Pioneer Monument (1894), which resulted from a gift by James Lick for "statuary emblematic of the significant epochs of California history." The bronze sculptures aspire to be a sort of three-dimensional picture book, but it's a book that has come to be read differently over time. It was conceived during a period when San Francisco was largely ruled by self-made men whose fortunes stemmed from mining and real estate, when San Francisco's Spanish colonial heritage was being rewritten under the romantic and rosy boosterism of the Mission Revival movement, and when notions of Manifest Destiny still governed history textbooks. Happersberger built the monument to last. It survived the 1906 earthquake and fire that razed nearby City Hall, as well as many of the ways of thinking that had inspired its imagery. Its now uncomfortable celebration

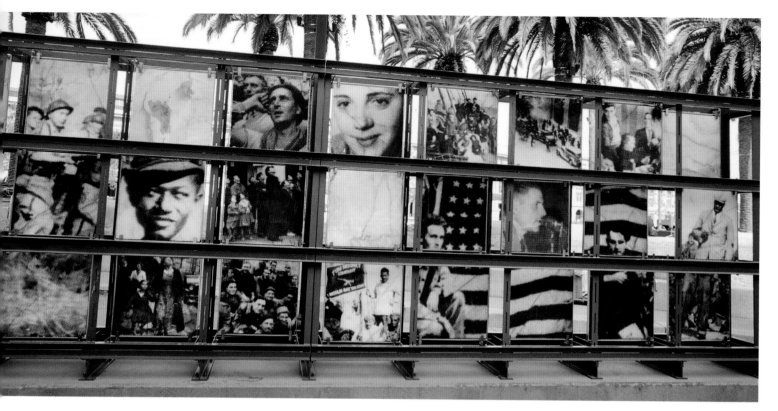

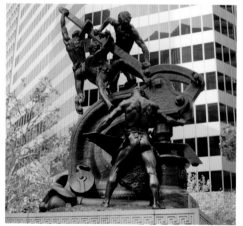

of paternalistic heroes—who stand over an allegorically compliant Nature and gratefully submissive indigenous peoples with equal authority and pretend benevolence—demands another look. When the monument was moved to its current location in 1993 (to make way for the construction of the new Main Library), the Arts Commission provided a new interpretive plaque attempting to address these other perspectives—and the plaque itself became a new source of controversy. But this is controversy worth having: nowadays the Pioneer Monument memorializes nothing so much as how profoundly social justice and equity remain unfinished business, and just how long it might take for even the famously tolerant city of St. Francis to make things right.

Or consider the fortunes of Julian Martinez's *Juan Bautista de Anza*, a magnificent equestrian bronze given to the city by Mexico in honor of the U.S. bicentennial in 1976. De Anza led the first overland expedition from Sonora, Mexico, to San Francisco in 1776, founding Mission Dolores and the Presidio. The expedition also opened up a route for settlement and commerce that would ultimately lead to a ring of military installations around the bay (many of them now being returned to open space and natural preserves), the 280 freeway (where workers in the high-tech industries now perform a reverse migration from their homes and apartments in San Francisco to the new gold country of Silicon Valley), and today's sprawling metropolitan region. *De Anza* has been moved two times. The Loma Prieta earthquake forced its removal from the original location on the Embarcadero to storage for many years, at the Ocean Beach Pump Station. It finally came to rest at Lake Merced (one of the original de Anza expedition's campsites). The layover at Ocean Beach came about when a proposal to resite the monument on the median strip in front of Mission Dolores coincided with the escalating gentrification of the Mission District during the dot-com boom of the late twentieth century. While both the Arts Commission and the historians of Mission Dolores felt the monument would provide the opportunity for a teachable moment about the complicated story of European contact in the New World (when one culture's version of "progress" entailed the near total destruction of another culture's way of life), antidevelopment activists saw de Anza as a forerunner of unchecked

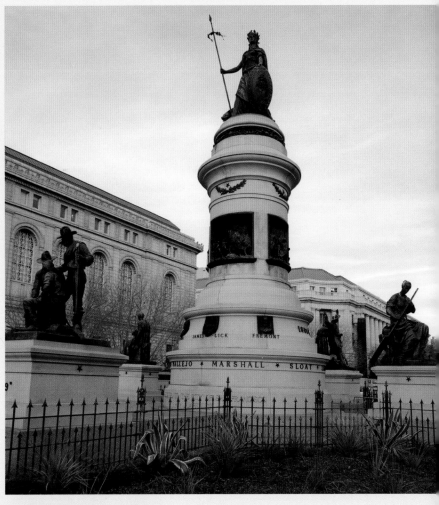

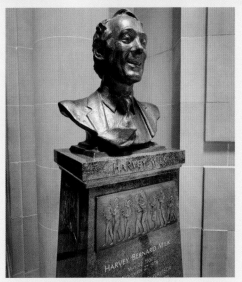

CLOCKWISE FROM TOP LEFT: Granite seals, part of a series of eight animal sculptures by Beniamino Bufano, was installed at Valencia Gardens; Pioneer Monument, by F. H. Happersberger, was dedicated to the city in 1894; *Harvey Milk City Hall Memorial Sculpture*, 2008, by Daub, Firmin, and Hendrickson; *Juan Bautista de Anza*, 1976, by Julian Martinez; *Big Peace IV*, by Tony Labat (temporarily installed on Patricia's Green in 2009); and *Ghinlon/Transcope*, 2005, by Po Shu Wang—the installation of twelve "transcopes" along Octavia Boulevard combines custom-fabricated mirrors and lenses to form a kaleidoscopic vision of the viewer's immediate surroundings.

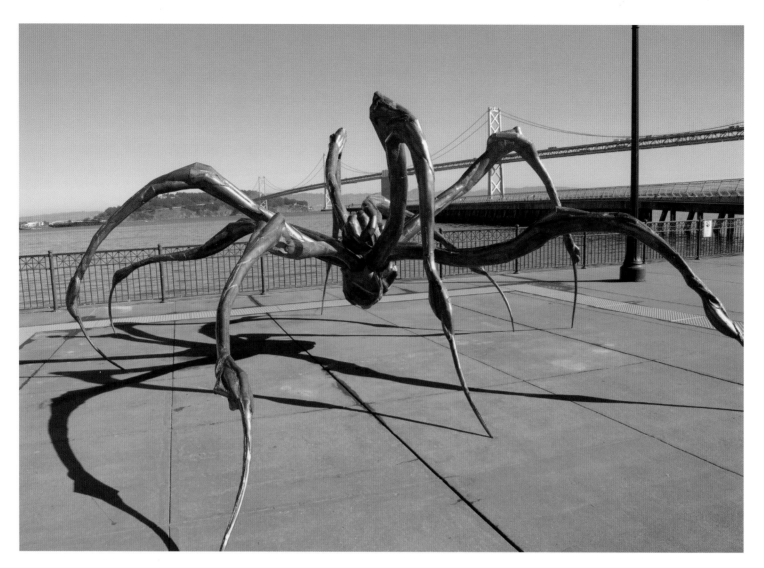

Crouching Spider, 2003, by Louise Bourgeois, was temporarily installed at Pier 14 from 2007 to 2009. The 9-foot-tall artwork spanned 27 feet.

real estate speculation and the destruction of established neighborhoods. Then Supervisor Chris Daly went so far as to suggest that the best location for the statue was at the bottom of San Francisco Bay. Fortunately, history is not so easily discarded—nor should it be. The difficulty of finding respectful ways of remembering should not be used as an excuse for simply forgetting the past.

The sense of San Francisco as a contested landscape, where the ostensibly forward momentum of city life constantly demands new forms of understanding and new ways of advocating for the mutual recognition of all its citizens, is the framework in which I continue to read art in the city. It is an ongoing story, written and overwritten in real time. Here are few of my favorite installments.

Douglas Tilden, *Mechanics Monument* **(1899)**: Located at the corner of Market and Bush streets, Tilden's grouping of heroic bronze figures honors the achievements of Peter Donahue, founder of United Iron Works in San Francisco. Drawing upon a lexicon of the classical male nude that he learned while studying in Paris, Tilden never could have dreamed, when he was creating his monument to labor and industry, that San Francisco would become a mecca for men with oiled hard bodies and a desire to hang out with one another while naked, but it did, and the rest is history.

Beniamino Bufano, *Animals* **(ca. 1930s)**: Bufano's miscellaneous menagerie of a granite cat and mouse, seals, bears, and a butterfly were originally projects of the Works Progress Administration (WPA) during the Great Depression. When the WPA began to close down

shop in local communities in the 1940s, it transferred ownership of the sculptures to the city. The San Francisco Board of Supervisors voted to install them in new housing for returning veterans of World War II at the William Wooster–designed Valencia Gardens. Valencia Gardens didn't wear well over time and was demolished and rebuilt by the San Francisco Housing Authority in 2004–2007. During the reconstruction, the animals were put out to pasture at the Randall Museum on Corona Heights, where they were a big hit with visiting families. But to me, it always seemed important to honor that original impulse to enliven public housing with art. I was glad when Bufano's animals found their way back home.

Ann Chamberlain and Walter Hood, *Abraham Lincoln Brigade Memorial* (2008): Evidence of San Francisco's labor history gets harder to find as the city's formerly working waterfront gives itself over to tourism, technology, and taste buds (with the Ferry Building reincarnated as a temple to sustainable gastronomy). This postmodern monument of photo-screened onyx and steel stands across from the Ferry Building on the Embarcadero and pays tribute to the 2,600 Americans from all walks of life who shipped out to fight against fascism during the Spanish Civil War (1936–1939). To tell the truth, some of my affection for this monument has little to do with what can be seen on the face(s) of it. Ann Chamberlain and Walter Hood were brilliantly paired to design this particular three-dimensional history book, and they firmly rooted its formal vocabulary in the utilitarian and everyday rather than the ornamental and allegorical (think of it in pointed dialectic to Happersberger's Pioneer Monument). Chamberlain and Hood are commanding examples of artists with a profound respect for human stories and lived experience—the kind of people you want as public artists. It's worth looking up the video documentation of Chamberlain as she sits around a kitchen table with Lincoln Brigade survivors, listening to their stories.

Daub, Firmin, and Hendrickson, *Harvey Milk City Hall Memorial Sculpture* (2008): On May 22, 2008, Harvey Milk took his rightful place in the gallery of portrait busts that grace City Hall. Supervisor Milk was larger than life and is still very much alive in memory to so many people. The challenge was to find a way to express that largeness of spirit without lapsing into caricature (there was already an excellent example in that vein— Robert Arneson's notorious ceramic bust of Mayor Moscone, Dan White's other victim, with Twinkie-emblazoned pedestal). Whenever I visit City Hall and see people standing to have their picture taken with "Harvey," I know that Daub, Firmin, and Hendrickson succeeded.

Po Shu Wang, *Ghinlon/Transcope* (2005): Wang's twelve kaleidoscopic lenses, mounted on graceful curving posts along Octavia Boulevard in Hayes Valley, celebrate the pedestrian's experience on a site where the Central Freeway used to rule. They are a human-scaled portal to the spectacle of urban life and an instance of permanent artwork that smartly responds to the constant flux of the urban environment.

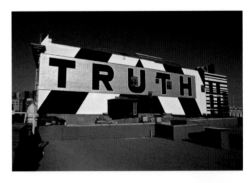

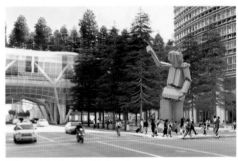

TOP: *TRUTH*, 2002, by Rigo 23. The privately commissioned mural is on Market Street, near the Civic Center.

ABOVE: A rendering of Tim Hawkinson's untitled sculpture. The artwork, estimated to be completed in 2017, was commissioned to reside outside the downtown Transbay Transit Center on Mission Street.

David Best, *Temple* (2005); Tony Labat, *Big Peace IV* (2009); Louise Bourgeois, *Crouching Spider* (2007–2009); Bill Fontana, *Spiraling Echoes* (2009): You can't see (or hear) them anymore, but these and other projects on Patricia's Green in Hayes Valley, near the Ferry Building on the northern waterfront, and at Civic Center Plaza and City Hall opened the way to a renewed commitment to temporary public art on the part of city government, neighborhood groups, and arts philanthropists. Produced by the Arts Commission with the help of gracious donors and volunteers, temporary projects, at their best, cause you to take a second look at a familiar place, to navigate it perhaps a bit differently, and to linger just a little bit longer. And part of the benefit of being a San Francisco resident is that you know they are only temporary.

Tim Hawkinson, untitled sculpture (estimated completion 2017): Tim Hawkinson was one of five artists commissioned for Phase I of the Transit Center Program as a joint project of the Transbay Joint Powers Authority and the San Francisco Arts Commission. This was among the last artist selection panels on which I served as commissioner. Hawkinson has proposed a monumental "guardian figure" made of materials recycled from the old Transbay Terminal, including reinforced concrete, Jersey barriers, and a streetlight pole. I love that it's big. I love that it will be a Transformer-like figure, rising from the rubble of old transit paradigms. I think some people will hate it. But I predict that, like the Picasso in Chicago's Daly Plaza, Hawkinson's "guardian" will one day be a beloved icon of San Francisco.

Rigo 23, *TRUTH* (2002): Rigo painted this mural in honor of Robert H. King, the only one of the Angola 3 to have been released from prison (to this day). Although not strictly speaking a part of the Civic Art Collection, it provides a wonderful closing example of how public artworks modify one another as elements in a larger urban context, irrespective of jurisdictional boundaries. The economical eloquence of Rigo's murals is as much a function of where they are as what they say. Sited on a visual axis that runs through

the Civic Center over the heads of the patriarchs of the Pioneer Monument to face off against City Hall itself, *TRUTH* will continue to speak to power as long as it's necessary.

This is the crux of site-specific work in an urban context: that the site may be specific enough but is not unchanging and that the meaning of public artwork is as much a function of time as materials and form. It is over time, through the interplay of both consent and dissent, that an always-emergent common vocabulary of community, identity, and memory is produced. In that spirit of a long view, I offer these wishes in celebration of the next eighty years of public art and place making in San Francisco.

1 That the city be brave and thoughtful about the dynamic between controversy and consensus that commonly polarizes debates about public art. Neither extreme is very productive in the end, but if I had to choose one, I'd choose controversy.

2 That the city be tenacious in making a case for ongoing civic investment in public culture. Whether in boom times or bust, art that is not confined within the wall of the museum speaks to a city's generosity of spirit, its breadth of common experience, and its commitment to stewardship for the future.

3 That the city be conscientious and resourceful in caring for the works of both aesthetic and historical value that are entrusted to its care. These artworks are as much a part of the city's infrastructure as water mains and trolley lines.

4 That the city be entrepreneurial and inventive in finding new ways to stimulate temporary projects through public-private partnerships. Temporary art is such a wonderful way to ask a question in a particular place. It can be as seasonal as springtime flowers or as ephemeral as the fog that creeps in and out the Golden Gate.

5 That the city be visionary enough to extend the benefits of ambitious public art and its many and evolving civic languages from downtown and the wealthy neighborhoods of the northeast to the entire city. The paths and picnic lands around Lake Merced could be the next Millennium Park. McLaren Park is just waiting to be the next jewel in the city's crown. And those are just places to start...

And my dream will be a pageant, a masque in which old meanings will be remembered and possibly new ones discovered...

—TENNESSEE WILLIAMS, *CAMINO REAL*

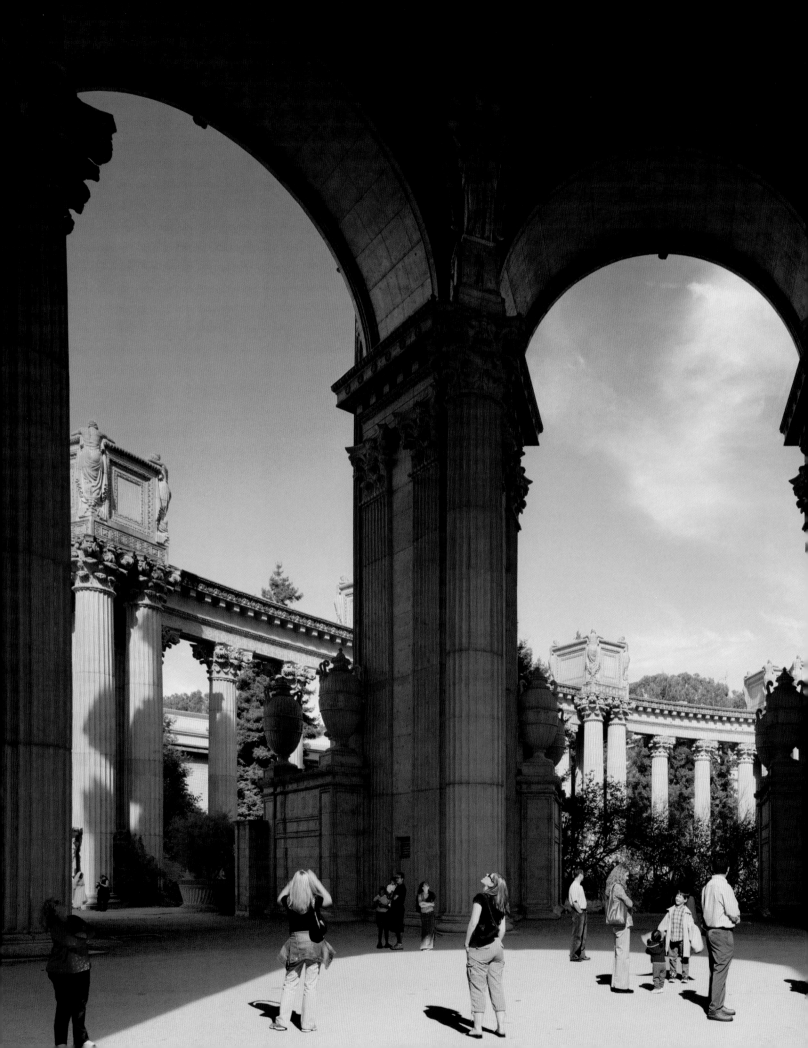

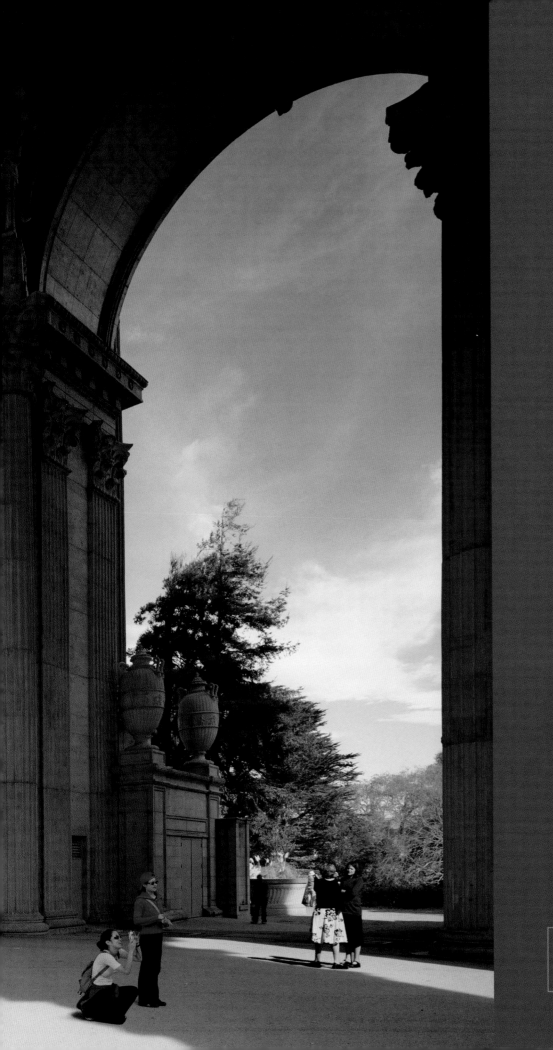

Palace of Fine Arts, 2004, by Doug Hall

CHAPTER ONE

1932
1949

THE POLITICAL ARTS: CONSENSUS AND CONTROVERSY. *In 1932, San Francisco was a city on the edge. Perched on the Pacific Ocean, proud of its natural beauty and spirited past, it was striving to secure its place in the world as a city of importance. Los Angeles, however, with its booming population and abundant land, was competing for West Coast dominance as a commercial center.*

FRANCISCO ART COMMISSIO

EDWARD D. KEIL, *President*

PRESENTS

First

ual Municipa

Exhibition

BY

Bay Region Artist

CIVIC CENTER PLAZA

SAN FRANCISCO

OCTOBER 17 TO 20 INC. NOON
TILL NI

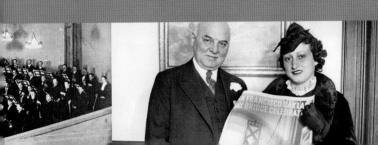

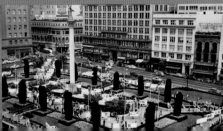

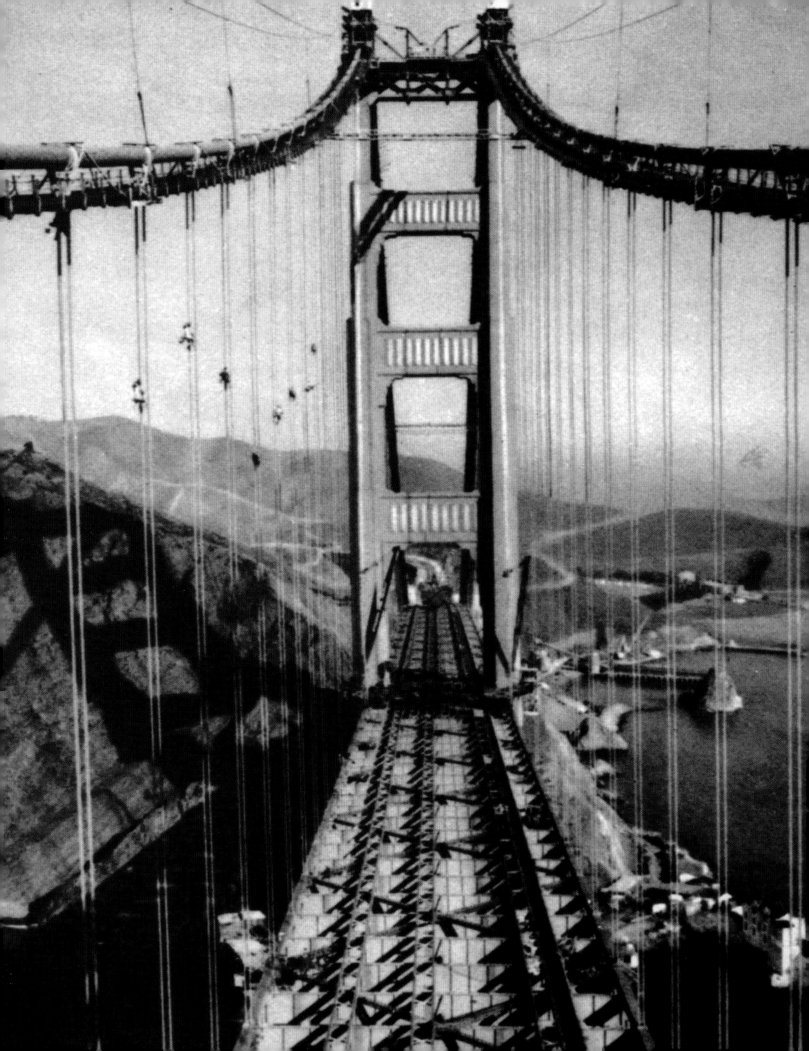

01

San Francisco was smaller, hemmed in by the ocean and San Francisco Bay and hobbled by the hardships of the Great Depression. Its chances of being a world-class city were slipping away, but it didn't stand still.

That year, despite fears of bank failures and discouraging bread lines, San Francisco won financing to build the Golden Gate Bridge, a dramatic lifeline—the longest suspension span in the world—linking the city to the state's northern reaches. Plans were also in place to build the San Francisco–Oakland Bay Bridge—the biggest, most expensive bridge ever constructed and an economic boon during the Depression. Boosters trumpeted San Francisco as the Wall Street of the West, and public and private groups worked together to polish its reputation as a cultural center.

Since the end of the nineteenth century, civic leaders had promoted a vision of San Francisco as a cultivated "imperial city" adorned, like the great capitals of the world, with grand public buildings, parks, and monuments. In 1904, its new Association for Improvement and Adornment advocated the beautification of San Francisco. These aesthetic ambitions—seen as vital for securing its place as a great metropolis—took physical form in the Panama-Pacific International Exposition, a world's fair that San Francisco hosted in 1915. Local artists and architects, according to a brochure for the event, "erected a city straight out of a beautiful dream" to draw international attention to San Francisco. Intended to celebrate the completion of the Panama Canal and the city's recovery from the 1906 earthquake and fire, the fair pulled together business leaders, city officials, and ordinary San Franciscans in a project that engendered broad public support for civic art and culture.

Still, as one newspaper, the *Argus*, noted in 1928, San Francisco was "not yet an important art center in appreciation, in collecting or in producing." The exposition had begun educating the public by showcasing modern sculpture, paintings by Claude Monet and Edgar Degas, and artworks from California and around the world. As late as the mid-1920s, the city had no permanent municipal art collections except for the M. H. de Young Memorial Museum, named for the owner of the *San Francisco Chronicle*. Filled with

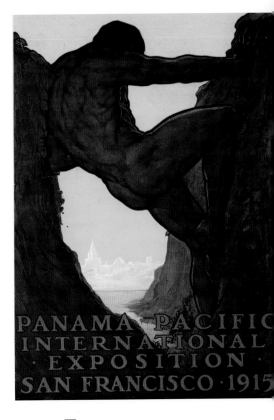

ABOVE: **The Panama-Pacific International Exposition celebrated the completion of the Panama Canal and San Francisco's recovery from the 1906 earthquake and fire.**

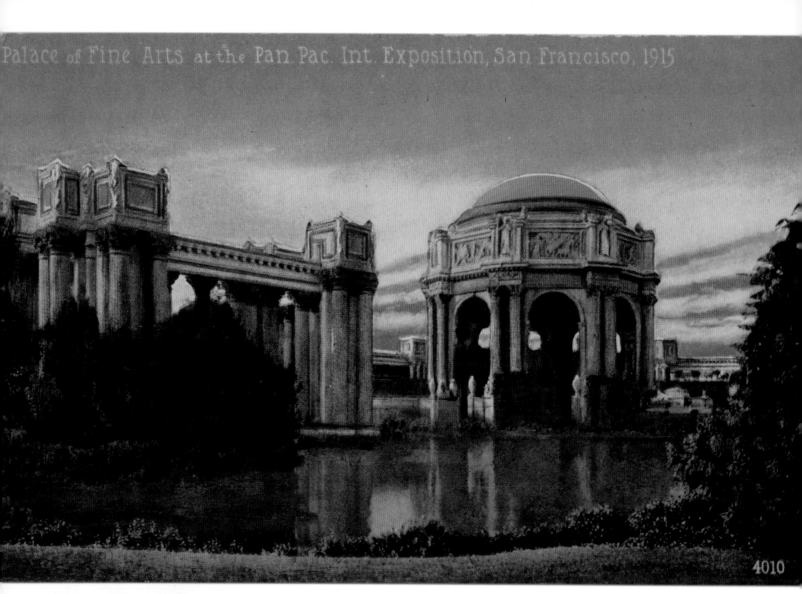

4010

TOP: **The Palace of Fine Arts was built for the 1915 Panama-Pacific International Exposition.**

ABOVE: **A 1936 news photo of some of the musicians in the 70-piece WPA Federal Music Project symphony orchestra.**

antiquities and collections of objects that de Young had donated to the city—including furniture, fans, pistols, and powder horns—the museum was voted a municipal agency in 1924. That year, voters also approved city funding for a new permanent art museum, the California Palace of the Legion of Honor, a gift to San Francisco from Adolph B. and Alma de Bretteville Spreckels.

The city was beginning to raise its cultural profile through the joint efforts of philanthropists, voters, and municipal government. Its tradition of civic cooperation had been a fruitful model. Still, it was an ad hoc approach and occasionally inefficient. After voters approved bonds in 1927 to build a War Memorial opera house complex, for example, disputes among parties involved delayed construction for several years, and ground was not broken on the project until 1931.

That same year, a citizens' committee proposed, and San Francisco voters approved, a new city charter that would reorganize city government according to a streamlined business model. Calling for nonpartisan expertise at all levels of city government, the new charter, the first since 1898, aimed to separate administrative and legislative functions, clearly assign duties and responsibilities, and replace troublesome delays with the prompt and efficient conduct of municipal business. In the area of civic culture, the charter created a new Art Commission that would make judgments about public art and aesthetics. An Architectural Committee (later called Civic Design) would oversee the quality of the built environment.

The Art Commission's members, appointed by the mayor, included seven professionals recommended by architectural, art, musical, library, and other cultural groups. They also included the mayor and five ex officio seats—for the chairmen of the parks, library, city planning, de Young Memorial Museum, and Legion of Honor panels and boards. Art commissioners, serving without pay, were charged with approving any work of art and the design of all buildings, signs, and other structures on municipal property. They were also responsible for maintaining the city's art collection and supervising the expenditure of any appropriations that the San Francisco Board of Supervisors made for art and music.

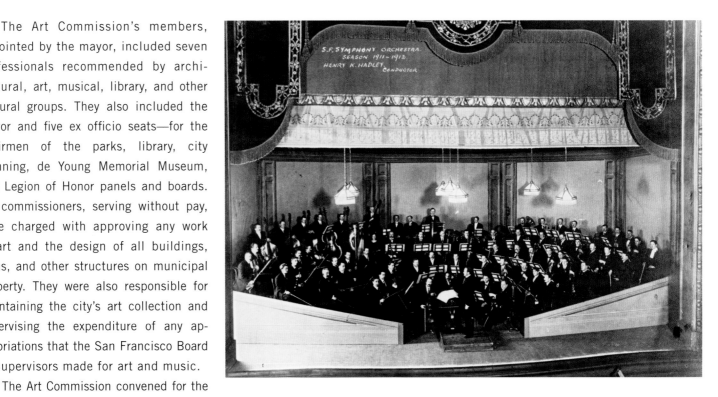

In 1911, Henry K. Hadley conducted the first season of the San Francisco Symphony.

The Art Commission convened for the first time on January 21, 1932, in the mayor's office at City Hall. It was a civic and cultural innovation, although it was not the first art commission in the country. Boston had established an art panel in 1890, Baltimore in 1895, New York in 1898, and Los Angeles in 1903. Several other cities, including Philadelphia, Milwaukee, and New Haven, had created similar agencies by 1912. These civic commissions, however, dealt only with public visual culture, including monuments and the built environment. The San Francisco Art Commission, by contrast, was also uniquely responsible for the advancement and cultivation of municipal music.

Since the city's boisterous Gold Rush days, music had been essential to culture in San Francisco. Over the decades, cosmopolitan residents had shifted their tastes from melodeons and music halls to promenade concerts, choral societies, chamber music, and opera. The city's first symphony concert series debuted in 1874, and the permanent San Francisco Symphony Orchestra performed its first concert in 1911. From its earliest days, the symphony had held concerts for working-class people and children, and twenty years later, in the middle of the Great Depression, the Art Commission was responsible for making music accessible and affordable to all members of the public. The commission supervised the Municipal Band—a fixture at civic celebrations and Sunday afternoon concerts in parks, playgrounds, and squares—as well as the Municipal Chorus, one of the only civic choral groups in the United States. The Art Commission also sponsored popularly priced municipal recitals and winter, spring, and summer public concert series of the city's symphony.

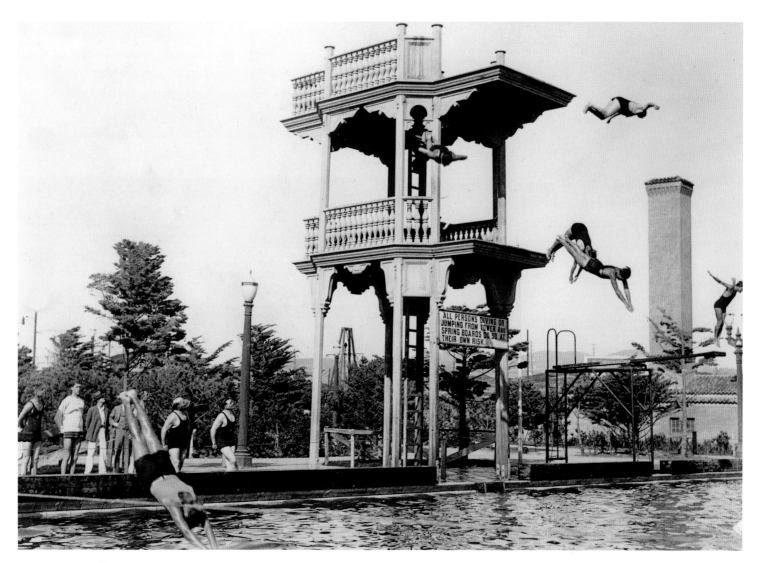

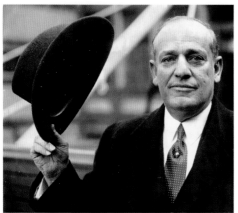

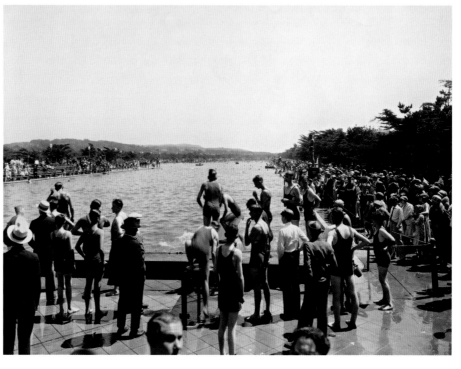

TOP AND RIGHT: Built in 1925, the huge Fleishhacker Memorial Swimming Pool was part of a recreational complex at the end of Sloat Boulevard.

ABOVE: Financier Herbert Fleishhacker steered many of the Art Commission's plans in its early years.

ART AND POLITICS

Although it was conceived as an efficient government reform, the Art Commission, from the start, was subject to political pressure. Its first president was Lewis P. Hobart, the architect of Nob Hill's Grace Cathedral. Its dominant member, however, was banker and philanthropist Herbert Fleishhacker, one of the most influential power brokers in San Francisco. A member of the Board of Supervisors, president of the San Francisco Parks Commission, and president of the board of trustees of the California Legion of Honor, Fleishhacker took a seat on the Art Commission's executive committee and forcefully steered many of the agency's plans and decisions.

A gregarious, backslapping businessman with a "cold, keen brain," according to *Time* magazine, Fleishhacker was involved in wide-ranging business ventures from the Philippines to the Rocky Mountains. He also had a hand in major civic projects in San Francisco and wielded extraordinary influence in local politics. The city's longtime mayor James "Sunny Jim" Rolph, who had served from 1911 to 1932, had suffered a business collapse in 1923 and personally owed Fleishhacker $1 million—a staggering sum in the 1920s, equal to more than $13 million today. The mayor had rewarded his generous patron by appointing him to the Parks Commission and the Legion of Honor board. By 1925, Fleishhacker, then president of the parks panel, had spearheaded the city's construction of the world's largest heated saltwater pool, a six-million-gallon tank that was big enough to hold ten thousand swimmers. Rolph named the gargantuan project the Fleishhacker Memorial Swimming Pool, and Fleishhacker soon began planning construction of the Herbert Fleishhacker Zoo, adjacent to the pool and the new Fleishhacker Playground. In 1932, when Fleishhacker was appointed to the Art Commission, he was already planning construction of a towering new city project on Telegraph Hill.

The edifice would be a memorial to Lillie Hitchcock Coit, a colorful San Franciscan who had left a third of her fortune—$118,000, worth nearly $2 million today—to "be expended," she instructed, to add beauty to "the city which I have always loved." Coit, the handsome, dashing daughter of a wealthy doctor, had been a legend in San Francisco since the 1850s. As a teenager, she would race out her front door whenever she heard fire bells to help the volunteer firemen of the city's Knickerbocker Engine Company No. 5. She was such a regular at the Knickerbocker station house and its parades and banquets that the firemen made her an honorary member of their brigade. In 1863, they gave her a gold and diamond "No. 5" fireman's badge, which she always wore pinned to her dress, even in her coffin.

> *By 1925, Fleishhacker, then president of the parks panel, had spearheaded the city's construction of the world's largest heated saltwater pool, a six-million-gallon tank big enough to hold ten thousand swimmers.*

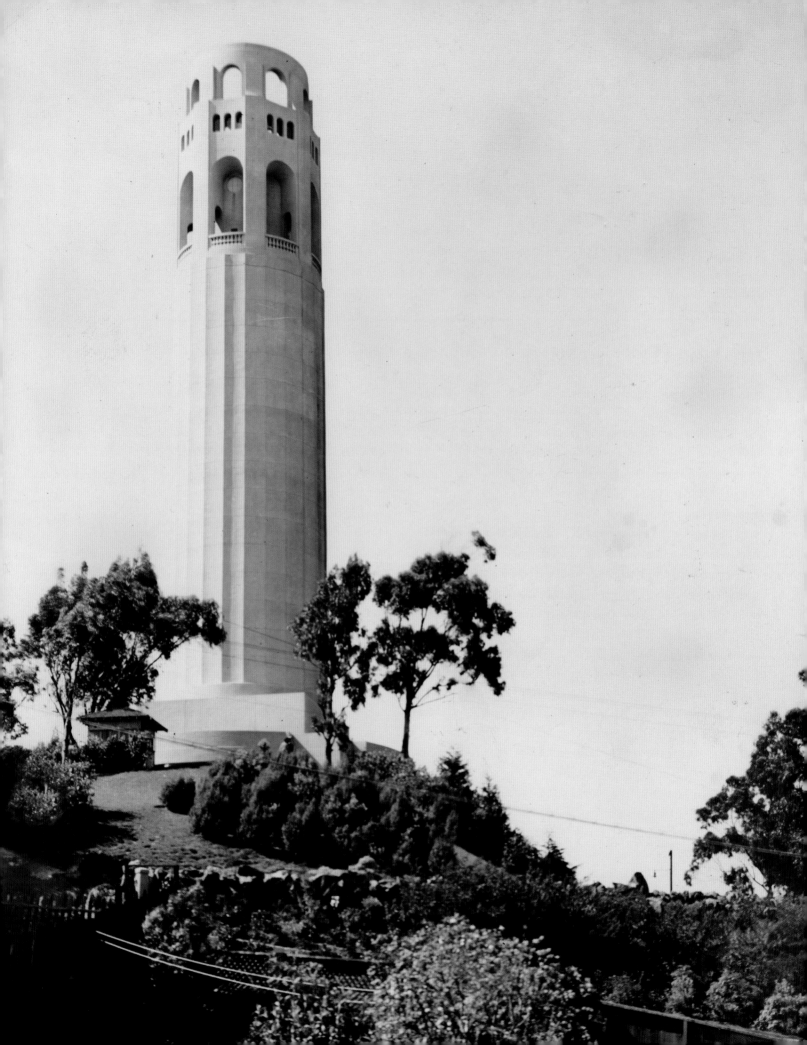

In 1931, two years after Coit died, Fleishhacker was named to an advisory committee that would recommend how to use the money she had left the city. The group proposed erecting a memorial tower on top of Telegraph Hill—an edifice that would be constructed with 3,200 cubic yards of concrete and 5,000 barrels of cement from one of Fleishhacker's concerns, the Portland Cement Association. Fleishhacker pushed to finish the deal before the new Art Commission began its work in January 1932, since the panel would have to approve designs for the municipal project. The contracts were not completed in time, but Fleishhacker was determined to win approval for the memorial tower.

It was not so easy. By mid-August, nearly five hundred San Franciscans had signed petitions protesting construction of the tower. Letters and telegrams to the Art Commission called it "a grave aesthetic error," "a glorified smoke stack," and "a smelter chimney... monumentally treated" that would destroy the natural beauty of Telegraph Hill. The commission's Architectural Committee unanimously approved the tower's design, but at least one commission member, novelist Gertrude Atherton, strongly opposed the project, declaring that it "looked like the remnants of an old ruin."

Atherton, as strong and powerful a personality as Lillie Coit, was an extraordinarily prolific author who published sixty novels during her career. She was "a brilliant, very unusual woman," according to the *New York Times*, with "a clear and capable brain, swift perceptions, social charm and a will of steel." Atherton and the only other woman on the Art Commission, Mrs. Alfred McLaughlin, were dead set against the construction of the memorial tower. As Atherton recalled in her memoir, *My San Francisco*, "Both women protested in vain; men always stand by other men against women, and after days of wrangling, the males of the Commission went into a huddle and emerged with the dictum that they were for the Coit Tower, and that was that. They were very polite about it, and there was nothing for two lone females to do but sulk. So there it stands, insulting the landscape."

Coit Tower was dedicated to the City of San Francisco on October 8, 1933, in a ceremony featuring a concert by the Municipal Band. The *San Francisco Chronicle* called the tower—170 feet tall and 30 feet wide—stately and beautiful, but critics complained that it looked like a silo. Within weeks, however, an opportunity emerged to make the controversial tower a patriotic symbol of the New Deal, economic recovery, and public art.

The Depression had taken a serious toll on artists throughout the United States. Prices for art had collapsed by at least two-thirds, and many professional artists were barely surviving. At the end of 1933, the U.S. Treasury Department, recognizing their

OPPOSITE: **Coit Tower was built in 1933 at the top of Telegraph Hill.**

ABOVE: **Novelist and Art Commissioner Gertrude Atherton judged a contest in 1939.**

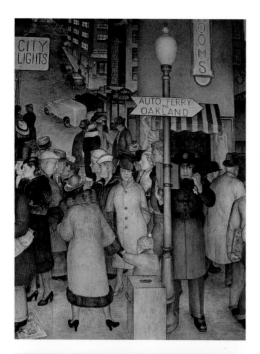

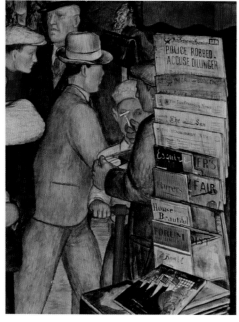

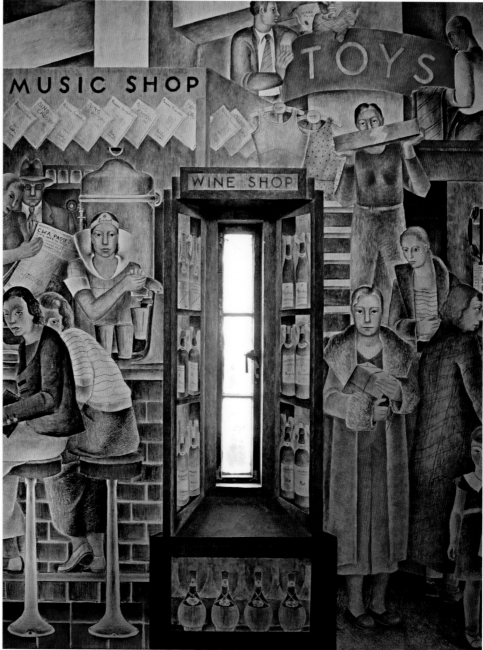

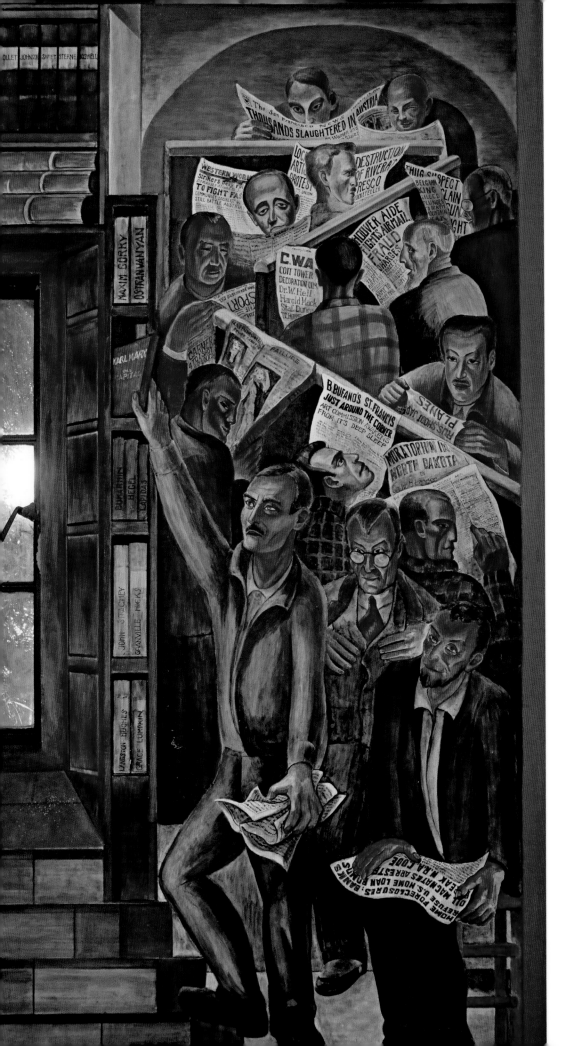

OPPOSITE, FAR LEFT, ABOVE AND BELOW: Details from Victor Arnautoff's Coit Tower fresco, *City Life*

OPPOSITE, RIGHT: Detail from Frede Vidar's Coit Tower fresco, *Department Store*

LEFT: This detail from Bernard Zakheim's Coit Tower fresco, *Library*, features fellow artists Ralph Stackpole, Beniamino Bufano, and John Langley Howard.

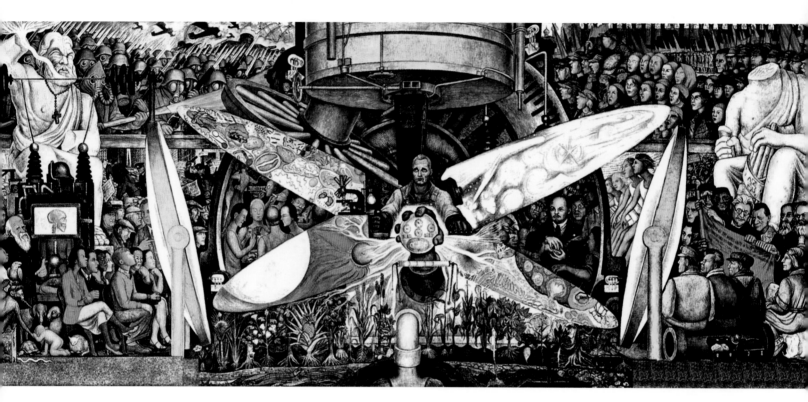

Man, Controller of the Universe, displayed in Mexico City, was painted by muralist Diego Rivera in 1934. It was a re-creation of his mural *Man at the Crossroads* at Rockefeller Center in New York City, which had been destroyed that year.

desperation, created a new agency, the Public Works of Art Project (PWAP). Paying wages of $25 to $45 a week, the PWAP hired more than two thousand artists across the country to beautify public buildings with figurative murals and other artworks depicting everyday life.

In December 1933, the PWAP's local executive committee in San Francisco decided to put the city's artists to work adorning the interior walls of the new Coit Tower. Dr. William Heil, director of the de Young Memorial Museum, envisioned the city's mural project as the PWAP's most important work. Many of San Francisco's best painters would contribute to this major project on a popular site overlooking the bay, transforming it into an attraction for locals and tourists.

The PWAP's focus on mural painting had been inspired by the work of Mexican artists such as Diego Rivera, who had been hired by his government to adorn buildings in Mexico City in the 1920s. Rivera had become a revered figure in American art circles, particularly in San Francisco. On November 10, 1930, the burly, charismatic muralist arrived in the city with his wife, painter Frida Kahlo, to create his first American fresco, *Allegory*

of California, for the Stock Exchange Luncheon Club. Rivera remained in San Francisco to paint a second mural, *The Making of a Fresco Showing the Building of a City*, for the California School of Fine Arts (now the San Francisco Art Institute). Despite his reputation as a master painter, however, some potential patrons, including Fleishhacker, were wary of Rivera because of his support for Marxism and his past membership in Mexico's Communist Party.

Several of the artists selected to create murals in Coit Tower—including Bernard Zakheim, Ralph Stackpole, Ray Boynton, and Clifford Wight—had previously visited Rivera and worked closely with him in Mexico. In early January 1934, they joined twenty other PWAP artists to create twenty-two frescoes, four oil-on-canvas paintings, and one egg-tempera mural on the tower's lobby and second-floor walls. The artists started work in a surprising spirit of cooperation. "Like the lion and the lamb," the *Chronicle* observed on January 11, "violent modernists and intense conservatives have met amiably upon common ground. They have worked out plans for the interior decoration of Coit Memorial on Telegraph Hill, the starting point for the campaign of interior beautification without even so much dissension as the memorial itself has aroused … the expected Battle of Telegraph Hill is at least postponed if not averted."

The tranquility, however, did not last long. In New York, Diego Rivera had been commissioned to create a mural in Rockefeller Center and included in the work a life-size portrait of Vladimir Lenin. Without warning, in mid-February, the center's management destroyed the mural, a move that the San Francisco Artists' and Writers' Union decried as "an act of outrageous vandalism and political bigotry." Union members held a protest meeting at Coit Tower, but the artists there soon resumed their work, and the frescoes were expected to be revealed on July 7.

The "Battle of Telegraph Hill," however, was just beginning. In early May, the Longshoremen's Association called the Pacific Maritime Strike, which hit ports from Seattle to San Diego. When the teamsters and freighter crews joined the strike, commerce in San Francisco ground to a halt. The artists working on Coit Tower had clear views of the picket lines below them on the city's waterfront, and some of their artwork, increasingly, had political overtones. John Langley Howard's mural depicted a May Day workers' march. Victor Arnautoff's mural of a newsstand included a self-portrait of the artist gazing at the left-wing newspapers the *Daily Worker* and the *New Masses*. Zakheim's fresco of a library showed Howard reaching for a copy of *Das Kapital*, and Wight's mural included a hammer and sickle and the phrase "United Workers of the World." The Art Commission had approved the artists' original sketches, but when Dr. Heil saw the finished work in early June, he anxiously notified Washington, DC, that some artists had, at the last minute, incorporated details and symbols that might be interpreted as communist propaganda.

A month later, tensions inside and outside the tower were becoming explosive. Fleishhacker advocated destruction of the murals, and on July 3, the *Chronicle* reported that "perspiration has begun to bead the brows of members of the Park Commission and

TOP: Coit Tower muralist Bernard Zakheim works on a mural at the University of California Hospital.

ABOVE: Detail of *California*, a Coit Tower fresco, by Maxine Albro

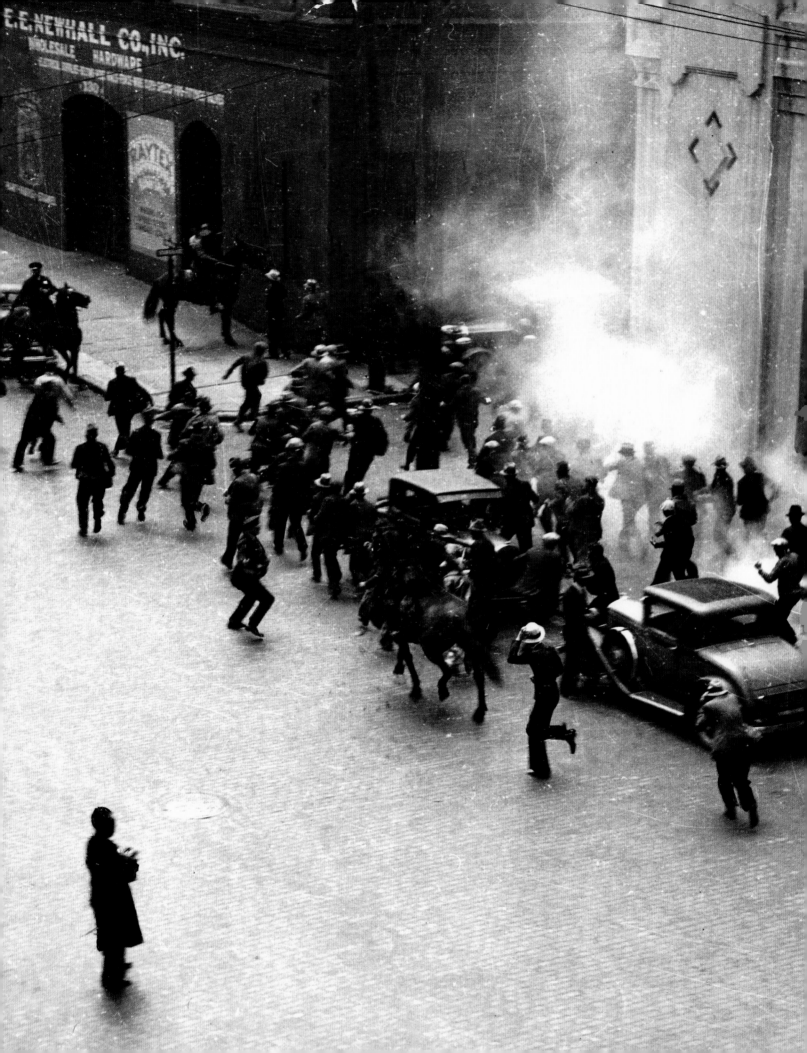

the Art Commission, who are sore put to decide whether the daubings on the interior of Coit Memorial Tower are art or whether they are merely grotesque rebellion of starved souls against the existing order...The commissions, as yet, have neither accepted nor rejected the murals."

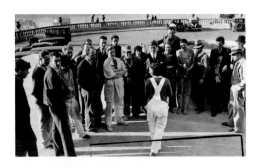

Two days later, on Thursday, July 5, the *San Francisco Examiner* published a composite photo of Wight's hammer and sickle positioned over Zakheim's painting of a library, including *Das Kapital*. The sensational image became a flashpoint. That same day, the picket lines beneath Coit Tower turned into bloody scenes of death, rioting, and hand-to-hand combat as strikers battled waves of mounted San Francisco police. By the end of that night, two people were dead, thirty-one had been wounded by gunfire, and seventy-eight had been seriously injured by bricks, tear gas, and clubs.

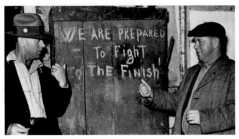

After the brutal conflict of "Bloody Thursday," other unions in the city joined the strike. Downtown streets were deserted, and the police blocked access to Coit Tower, which had already been padlocked for three weeks so that strikers wouldn't be able to hurl rocks from Telegraph Hill.

By the first of August, however, the strike was over, and tensions in the city began to cool. That day, art commissioners visited Coit Tower. They decided that, "for artistic reasons," Wight's controversial panels had to be removed, and they locked the building.

Coit Tower finally opened to the public on October 24, 1934. The mural project—

> *The police blocked access to Coit Tower, which had already been padlocked for three weeks so that strikers wouldn't be able to hurl rocks from Telegraph Hill.*

which had employed the skills of forty-two artists and assistant artists—had been the largest, and probably most contentious, PWAP program in the country. Art critic Junius Cravens, reviewing the murals, declared that "San Francisco should be not only proud of the artists but grateful to them as well...not only for what they have given the city but also because of the courageous way in which they tackled such a gargantuan problem, fraught as it was with difficulties and discouragements, and licked it—knocked it out cold."

BUILDING BRIDGES

In the 1930s, the Art Commission was involved in another iconic project, the San Francisco–Oakland Bay Bridge. Construction of the span—the longest cantilever and suspended-deck bridge in the world—began in July 1933, and the structure, commissioners noted, would transform the appearance of the harbor and establish the first impression of San Francisco. The commission's main concern was the approach to the new bridge, which planners originally located in an unsightly alley. Instead, the Art Commission proposed beautifying the approach streets to the bridge and even detailed a color preference for the span, recommending gray or aluminum paint for all the steelwork.

OPPOSITE: **Street fighting on "Bloody Thursday," July 5, 1934**

TOP: **Coit Tower muralist Maxine Albro, surrounded by fellow artists, presented a manifesto condemning the destruction of Diego Rivera's mural in New York's Rockefeller Center in 1934.**

ABOVE: **Striking longshoremen point to a declaration of their sentiments.**

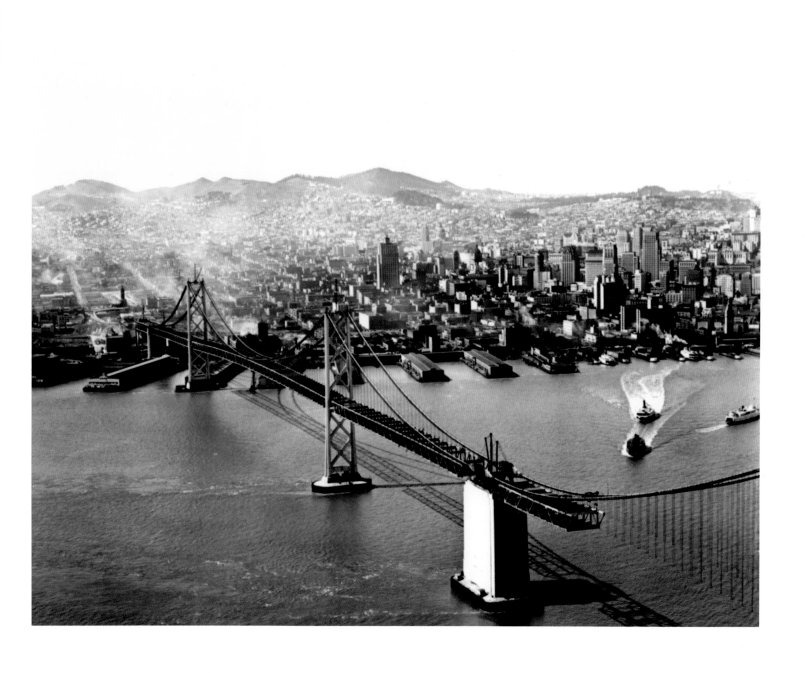

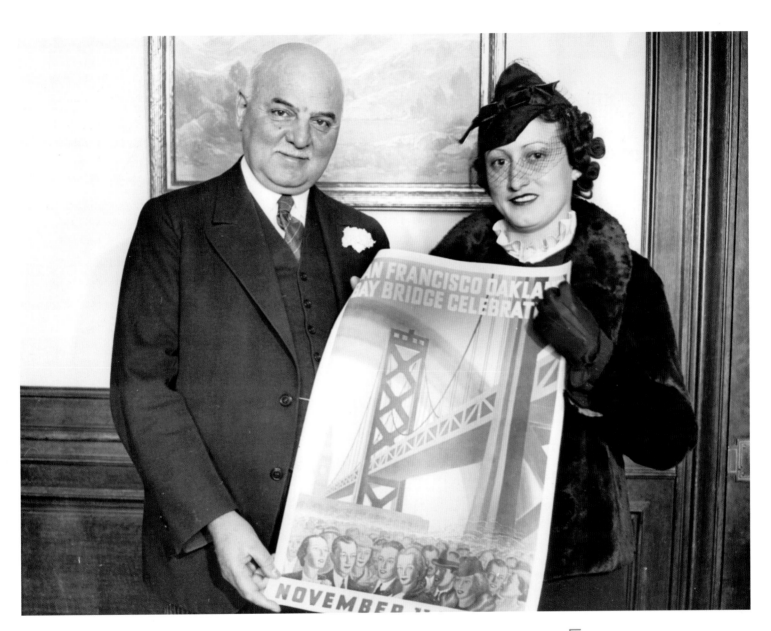

OPPOSITE: The San Francisco–Oakland Bay
Bridge was completed in 1936.

ABOVE: Mayor Angelo Rossi and a visitor to
San Francisco hold the official poster for the
Bay Bridge opening celebration.

When it came to the color of the Golden Gate Bridge, however, the commission opted to remain silent. Construction of the span between San Francisco and Marin had begun in January 1933, and by early 1936, critics were expressing concern about its unusual hue. Some warned that painting the bridge orange-red would be "a grave mistake," but commission members decided that, this time, it was not their responsibility to comment.

It was in the field of music that the San Francisco Art Commission forged public consensus. Since the first years of the Depression, the San Francisco Symphony had been at serious financial risk. Orchestras were costly, patronage had declined, and radio was competing for concert audiences. In December 1930, the symphony announced that it would have to decrease the size of its orchestra, given financial realities. More drastically, it canceled the 1934–35 season due to lack of funds, and it was on the brink of bankruptcy. In response, the Art Commission sponsored a charter amendment in 1935 asking for a slight property tax increase that would enable the agency to maintain the symphony. On May 3, voters overwhelmingly adopted the amendment, and San Francisco became the first city in the country to subsidize a symphony orchestra.

Construction of the span—the longest cantilever and suspended-deck bridge in the world—began in July 1933, and the structure, commissioners noted, would transform the appearance of the harbor and establish the first impression of San Francisco.

A second mural controversy, however, bedeviled the commission. In February 1939, San Francisco played host to another world's fair, the Golden Gate International Exposition. Celebrating the opening of the spectacular new Bay and Golden Gate bridges, the fair, centered on Treasure Island, was conceived as a "Pageant of the Pacific." The exhibits, from around the country and the world, included displays of art masterpieces from Europe, the Americas, and Pacific cultures. The city reprised the exposition for four months in 1940, with a new addition—a dynamic exhibition called *Art in Action*, in which the public could watch some sixty artists creating artwork inside the Palace of Fine Arts. The star attraction of the event was Diego Rivera, who returned to the city to execute a huge mural for San Francisco Junior College (now City College of San Francisco).

The Art Commission had approved Rivera's full-scale charcoal drawing of the mural, as well as its artistic design and technique. It strongly urged the Board of Education to approve its content. When Rivera completed the mural at the end of November, thousands of art lovers flocked to see it, and a few were shocked. The executive board of the City and County Federation of Women's Clubs called the artwork "subversive" because it included images of Hitler, Stalin, and Mussolini. Once more, a mural ignited a civic controversy, but the Board of Education and Art Commission ultimately approved the painting, which remained intact.

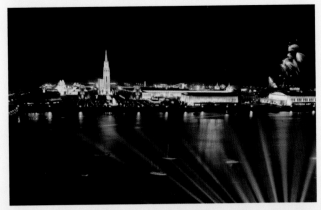

CLOCKWISE FROM TOP: Night view of Treasure Island in 1938, before the opening of the Golden Gate International Exposition (GGIE); *Peacemakers*, a frieze by Margaret, Esther, and Helen Bruton and Eleanor Pickersgill, was created for the exposition; Martin Snipper, later director of the city's Art Commission, inspects a 9-by-15-foot panel for the San Francisco building at the GGIE; and Diego Rivera paints his mural *Pan American Unity* at the GGIE's *Art in Action* exhibition.

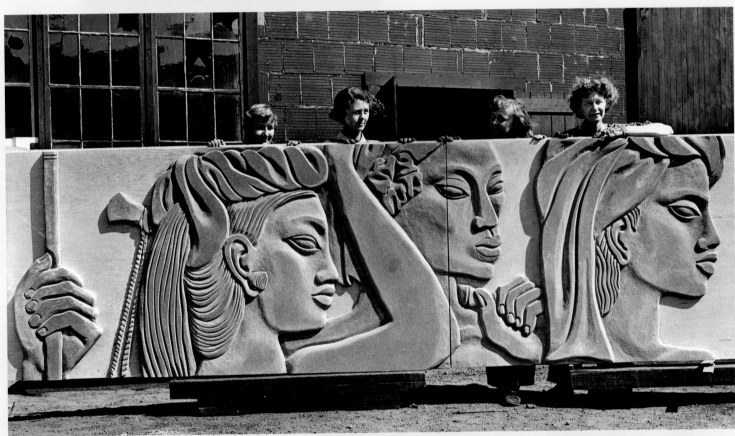

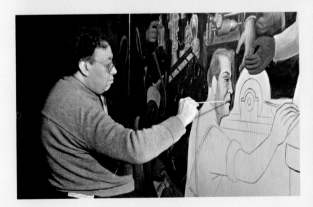

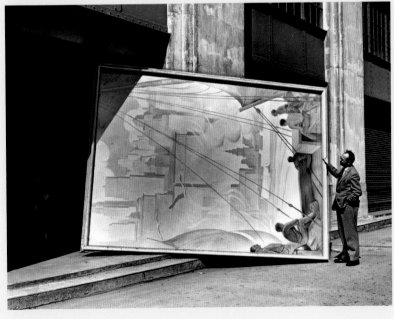

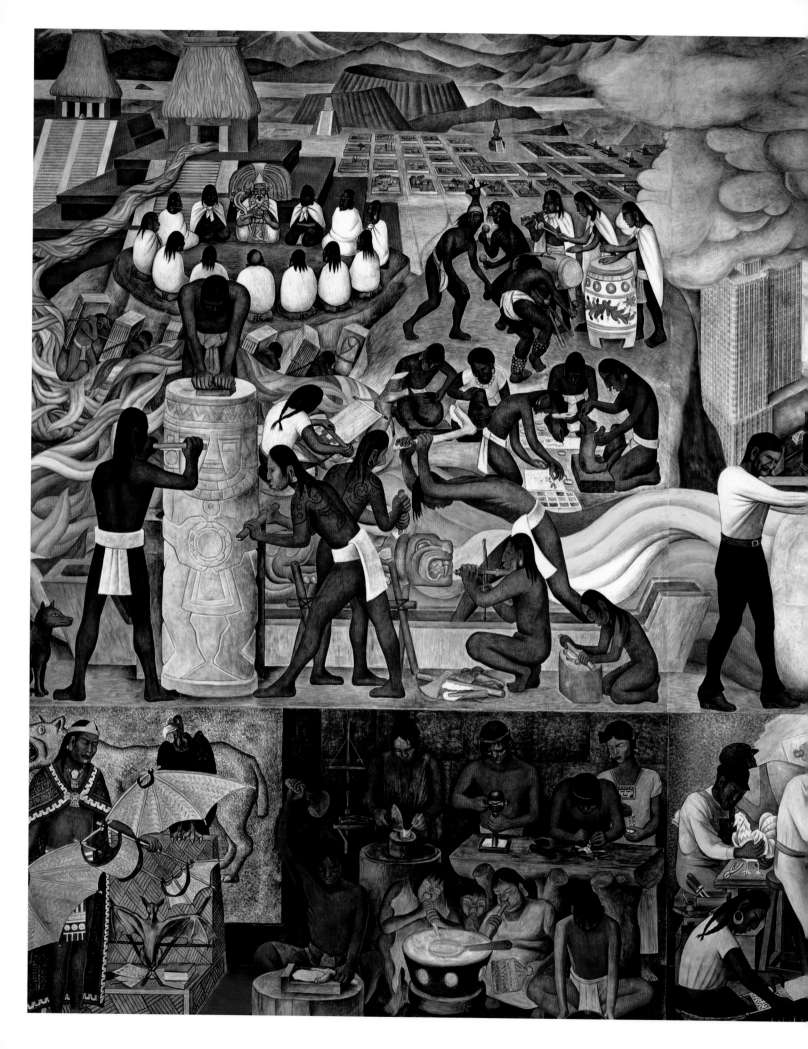

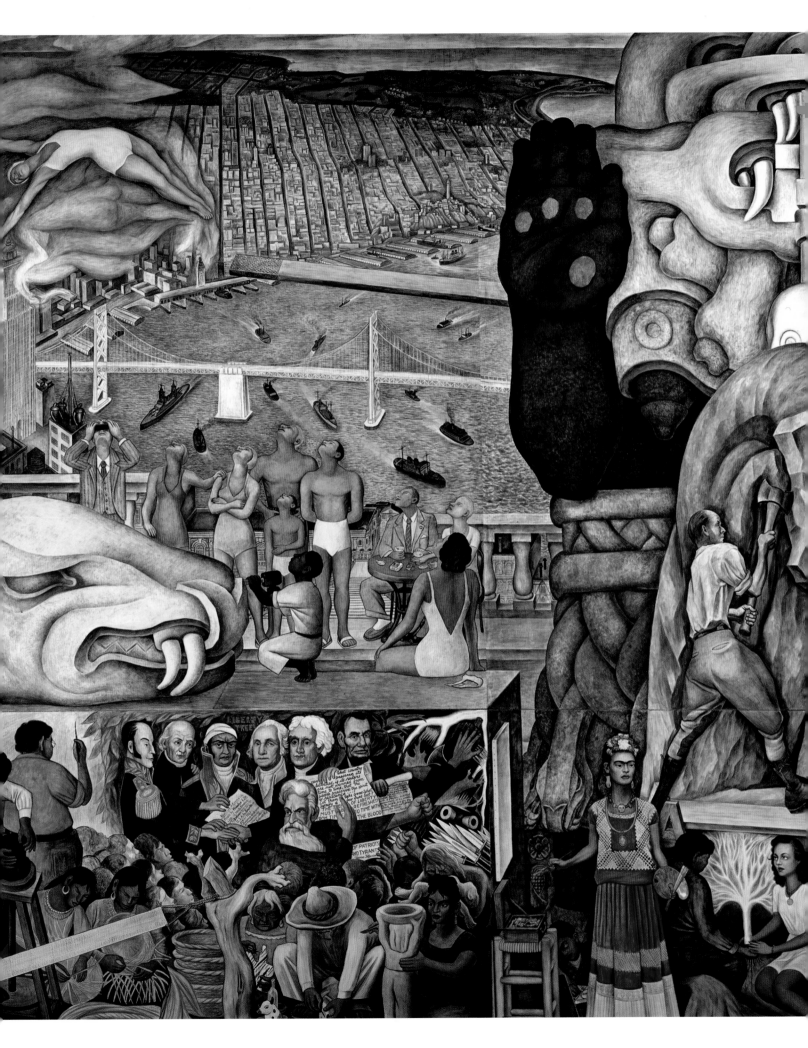

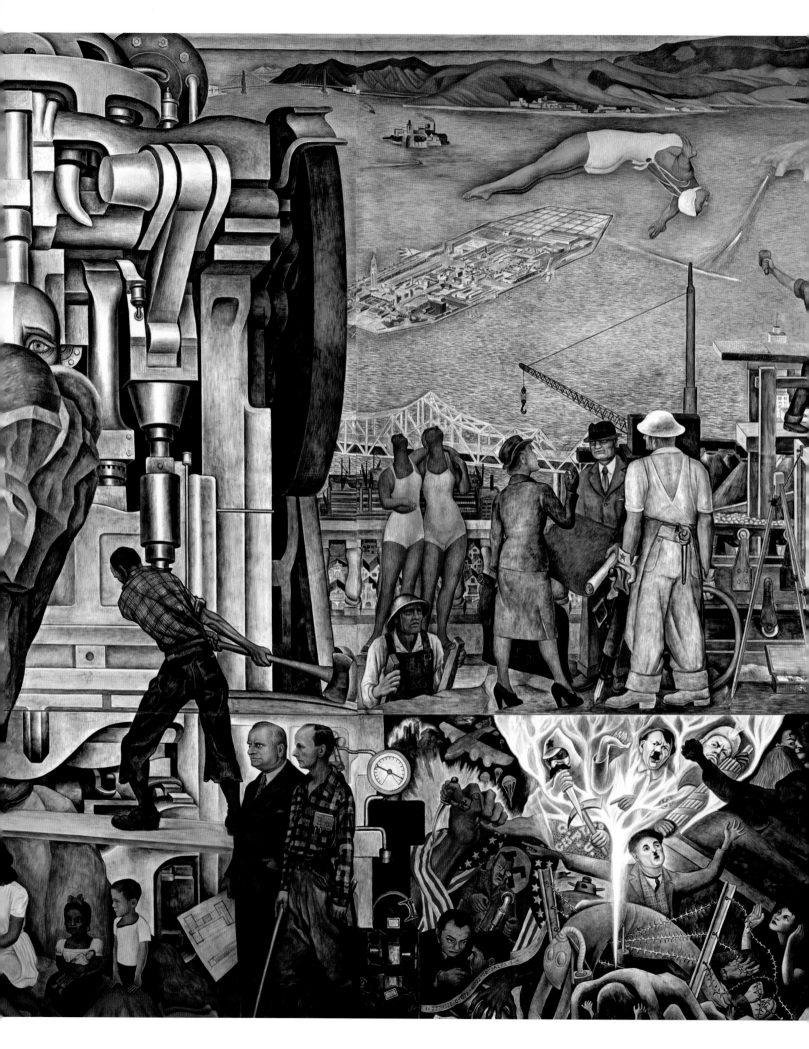

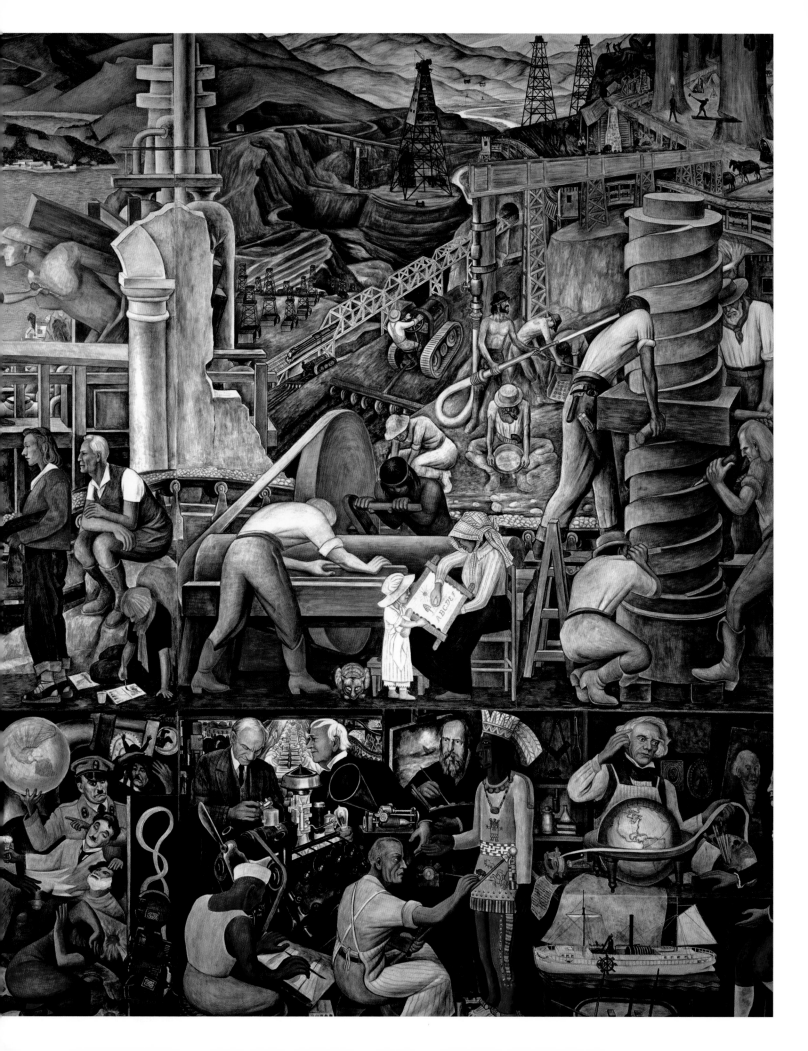

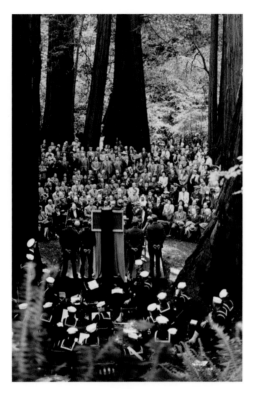

MUSIC AND MOBILIZATION

Music remained a safer haven, and in 1941, after the Japanese attacked Pearl Harbor, the Art Commission used the occasion to foster civic unity. On December 16, 1941—nine days after the attack—the commission decided to open its San Francisco Symphony series on schedule. Despite blackouts and the shock of war, six thousand people came to the concert at Civic Auditorium and cheered. By the end of 1942, municipal music, in fact, was a national priority. That December, James C. Petrillo, president of the American Federation of Musicians, met with President Franklin D. Roosevelt at the White House. "The President," the San Francisco Art Commission reported, "was very much concerned that the people in the smaller towns and cities in the United States are not getting enough first-class concert music, especially during war time. He pointed out that in many foreign countries, concert orchestras are sent from city to city so that the people who are not in a financial position to travel to the big cities to hear the larger orchestras could hear the finest music free of charge."

The commission responded by adopting the slogan "Music Maintains Morale—Music Must Go On." It gave free concert admission, like the symphony, to all members of the armed forces, even at sold-out events, and dispatched the Municipal Band to entertain at army and navy centers and hospitals in San Francisco.

World War II transformed the city. San Francisco was a staging center for military mobilization, and a million and a half servicemen and -women passed through the region during the war. A hundred thousand permanent new residents, including tens of thousands of African Americans, swelled the city's population, drawn by Bay Area factories producing war supplies and shipyards launching four hundred ships a year, more than any other part of the country. The surge of newcomers forever changed the culture, character, and politics of San Francisco.

Then, in February 1945, as war was ending, the city was chosen as the site for the historic signing of the international charter that established the United Nations. At the UN Security Conference preceding the signing, held from April 25 to June 26, the Art Commission and San Francisco Symphony helped entertain thousands of visiting UN delegates and representatives.

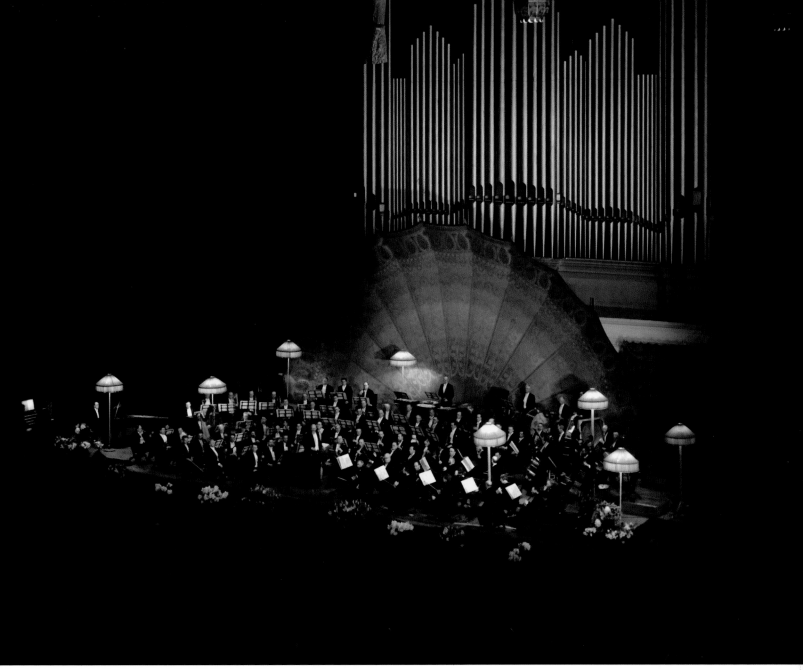

BRINGING ART TO THE PUBLIC

San Francisco was changing rapidly, but the Art Commission, many believed, had grown stale and stagnant. According to Mayor Roger Lapham, it "hadn't had the semblance of a new idea for years." A number of commissioners recognized that it was overly concerned with music and had done little in the areas of architecture, sculpture, painting, literature, and landscaping. In 1944, determined to shake things up, the mayor appointed a new commission member, sculptor Beniamino Bufano, an irascible artist who would become the "stormy petrel" of the municipal Art Commission.

Born in Italy and raised in New York City, Bufano first moved to San Francisco in 1915 and rapidly became known for his skillful artwork. Many of his sculptures were simple, masterful depictions of animals. Bufano, who stood a mere five feet tall, was as famous for his outsize personality as for his talent. The sculptor claimed that during World War I he had chopped off his trigger finger and mailed it to President Wilson as a pacifist act of protest. On the Art Commission, he was a constant goad, pushing his fellow commissioners to adopt his ideas and challenging accepted notions of official decorum.

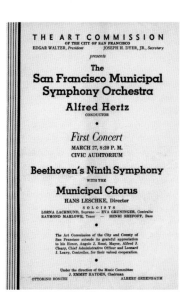

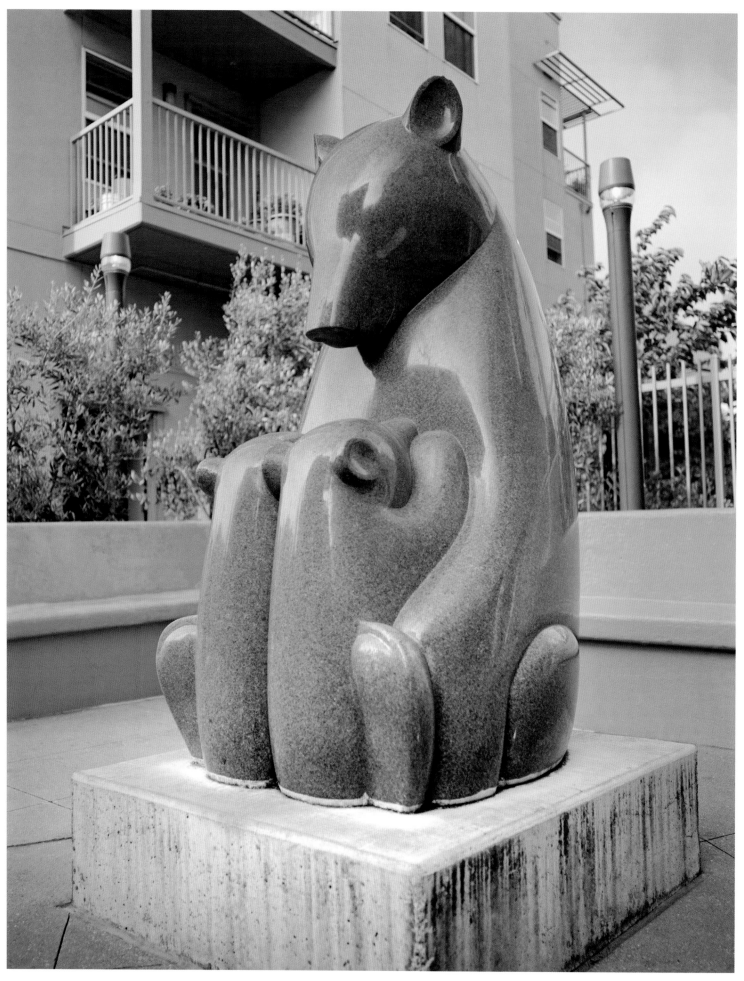

SAN FRANCISCO: ARTS FOR THE CITY

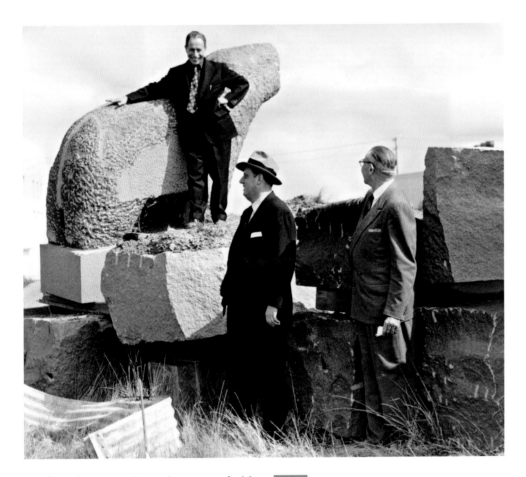

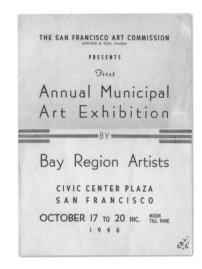

Despite, or perhaps because of, his obstreperousness, Bufano managed to win commission support for several initiatives that he fought hard for. In 1944, the commission approved his recommendation to beautify San Francisco by planting trees on city streets, and in 1946, the agency agreed with his proposal to hold an outdoor exhibition of artwork for the public. Two months later, the commission's first municipal outdoor art show—the first in the country—displayed work by almost six hundred local artists and craftspeople. Forty percent had never exhibited before. Attendance was huge—a quarter of a million people came to the show in Civic Center Plaza, and many bought original artwork. Before the exhibitors packed up, they signed a yard-long letter of thanks to the Art Commission, expressing hope that the show would be repeated annually. By 1948, the art festival was a major yearly cultural event. Public art, Bufano stated, should be "big enough to belong to everybody," and the annual show brought art outside the city's museums, into the public square.

Bufano, who stood a mere five feet tall, was as famous for his outsize personality as for his talent. The sculptor claimed that during World War I he had chopped off his trigger finger and mailed it to President Wilson as a pacifist act of protest.

OPPOSITE: A statue of bears, by Beniamino Bufano, at the Valencia Gardens housing development

ABOVE LEFT: Beniamino Bufano posed atop one of his bear sculptures in 1956.

ABOVE RIGHT: A brochure for the city's first municipal art exhibition

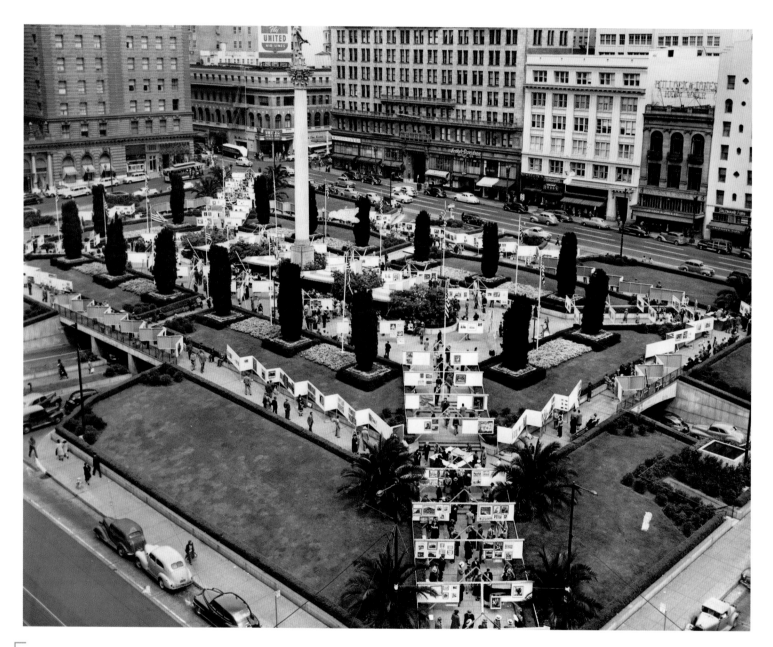

ABOVE: In May 1948, some 600 artists exhibited their work at the Art Commission's Open Air Art Show in Union Square.

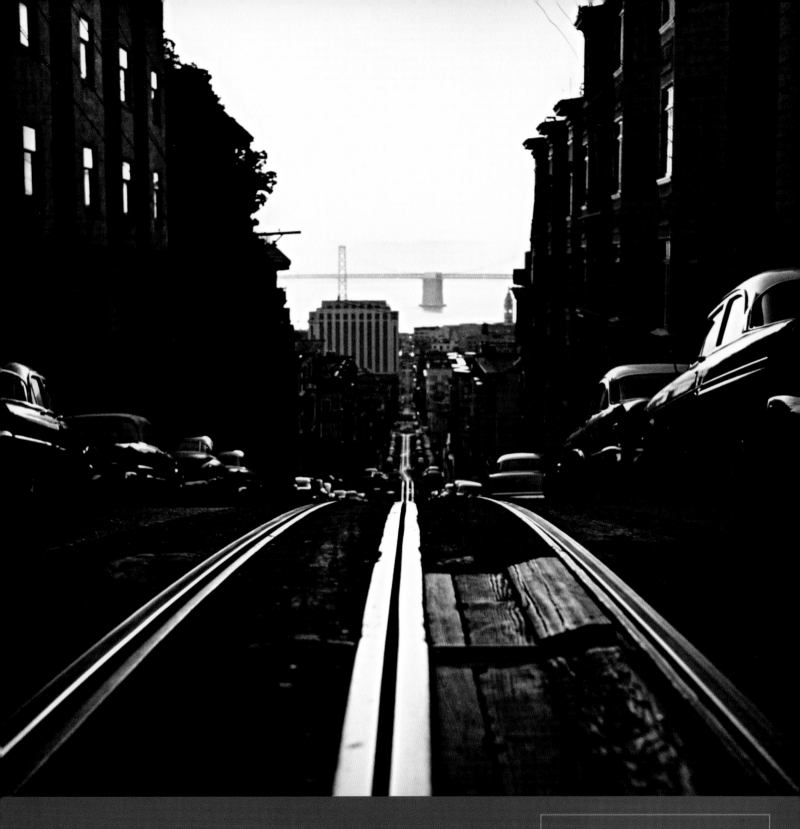

Cable Car Tracks at California Street, San Francisco, 1956, by Ruth Bernhard

CHAPTER TWO

1949

1966

CULTURAL CLASHES. *New eclectic, avant-garde impulses swept over San Francisco after World War II. The city, once a western outpost of mainstream culture, was now suddenly seen as a vibrant multicultural hub for musicians, painters, and free spirits in all the arts. The transformation was sparked by an influx of newcomers and the expanding diversity of San Francisco.*

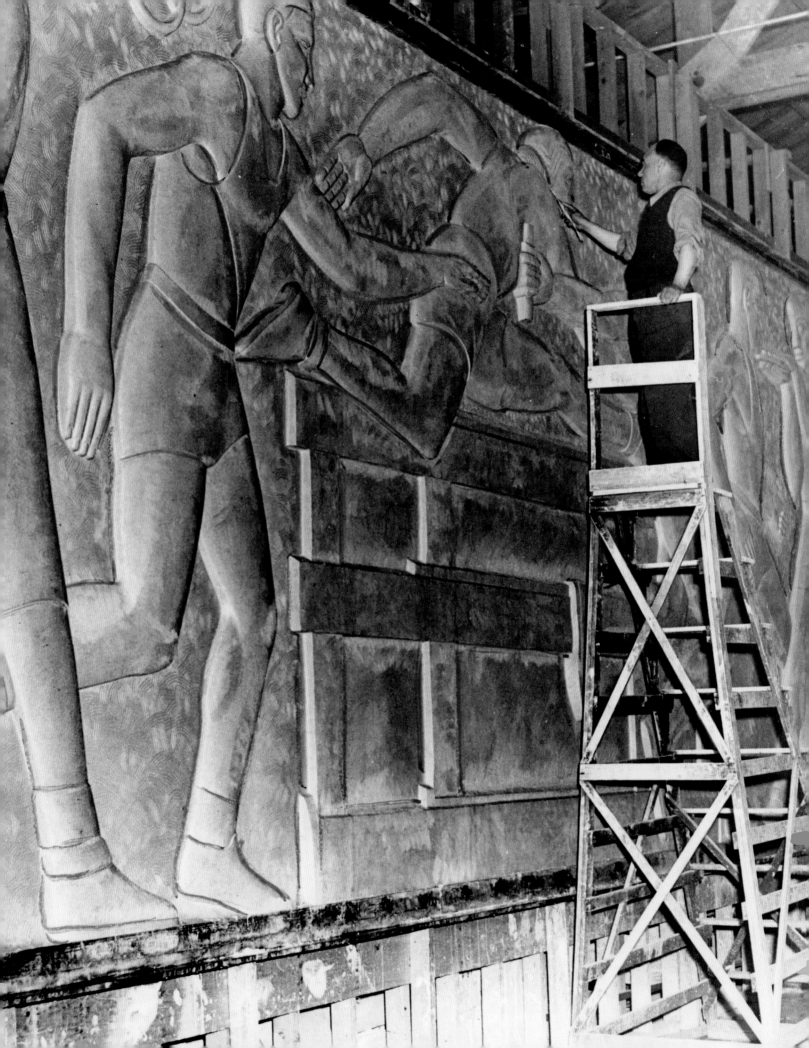

OPPOSITE: In 1940, renowned African American painter and sculptor Sargent Johnson worked on a monumental frieze for Washington High School, a project for the San Francisco Art Commission. Johnson had been employed as an artist and supervisor for the Federal Arts Project in the Bay Area. The frieze still stands at Washington High.

BELOW: In 1950, jazz musicians (from left) Cal Tjader, Ron Crotty, and Dave Brubeck performed at San Francisco's Black Hawk nightclub.

BOTTOM: An actress in a touring Chinese opera troupe from Hong Kong

02

The city's African American population had grown nearly 700 percent during the war, surpassing the Asian populace as its largest nonwhite community. In the Fillmore District, known as the Harlem of the West,

nightclubs throbbed with the sounds of swing, bebop, and rhythm and blues and hosted legendary jazz greats from Billie Holiday to Louis Armstrong. Asian nightclubs—like the Forbidden City in Chinatown, which inspired the novel and Rodgers and Hammerstein musical *Flower Drum Song*—drew GIs and movie stars with their glamorous floor shows during World War II and the Korean War.

Other cultural currents were reshaping the city into a dynamic creative center. In the mid-1940s, artistic pacifists, anarchists, and other nonconformists had moved south to San Francisco from Waldport, Oregon, where they were interned as conscientious objectors (COs) during the war. After laboring sixty hours a week reforesting rugged slopes, the inmates of Waldport's Fine Arts CO Camp painted, presented concerts, put on plays, wrote and read poetry, and published two magazines. Settling in the city after the war, they helped trigger an expansive renaissance of performing, visual, and literary arts.

An explosion of abstract painting, exemplified by the work of Mark Rothko and Clyfford Still, shook San Francisco's art world. Their unfettered, emotionally intensive canvases were at the vanguard of the abstract expressionist movement in modern art in the late 1940s. They were also emblems of the city's new vibrant, adventurous cultural climate. By the 1950s, painters including Elmer Bischoff, David Park, Richard Diebenkorn, Wayne Thiebaud, James Weeks, and Nathan Oliveira—as well as sculptors including Manuel Neri—launched the Bay Area Figurative movement by applying abstract expressionist styles to realistic figures. At the San Francisco Art Institute, photographers Ansel Adams and Minor White established the first department in the country dedicated to photography as a fine art. In music, Dave Brubeck's avant-garde, improvisational jazz drew capacity crowds at the Black Hawk nightclub, the "Taj Mahal" of West Coast cool, and established San Francisco as an epicenter of the modern jazz age.

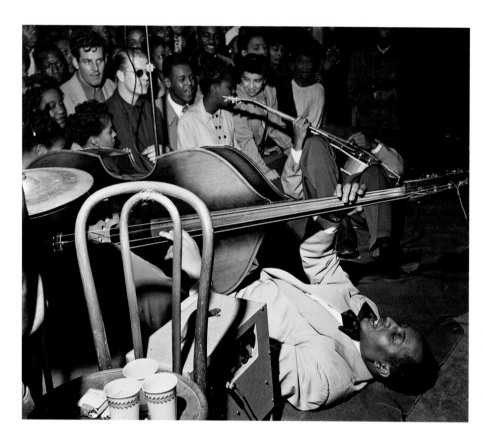

By the mid-1950s, the San Francisco renaissance evolved into the Beat movement. Poets, hipsters, and bohemians—"the beard-and-sandal set"—streamed into San Francisco to gig with jazz players at the Cellar and the Place and play chess at the Co-Existence Bagel Shop, the capital of North Beach, at Grant and Green. *San Francisco Chronicle* columnist Herb Caen dubbed the new bohemians "beatniks." They attracted fame and fury for their rejection of conventional culture and mores in the conformist '50s. These underground upwellings of expression, philosophy, and dissent clashed with America's—and San Francisco's—mainstream culture. Neoconservative Norman Podhoretz fumed that the country was "witnessing a revolt of all the forces hostile to civilization itself," and FBI Director J. Edgar Hoover warned that America's greatest threats came from eggheads, communists, and beatniks.

In San Francisco, the cultures collided head-on over "Howl," an epic poem written by Beat poet Allen Ginsberg and published by Lawrence Ferlinghetti's City Lights Books. Officials considered the poem, with its frank references to sex and sexuality, unfit for children. The local police confiscated copies and arrested Ferlinghetti on obscenity charges. The case went to trial in June 1957 in San Francisco, under a presiding judge who appeared completely hostile to Beat culture and lifestyle. Judge Clayton W. Horn taught weekly Bible classes and had recently sentenced shoplifters to watch the movie *The Ten Commandments*. "Howl," Horn declared, contained vulgar language and presented unorthodox, controversial ideas. Yet he also concluded that it had "redeeming social importance" and was therefore protected by the First and Fourteenth Amendments and the state constitution. According to the *Chronicle*, Horn's decision was greeted by cheers from a packed audience filled with "the most fantastic collection of beards, turtlenecked shirts and Italian hairdos ever to grace the grimy precincts of the Hall of Justice."

Provocative art was also finding its way into municipal art shows. At an exhibition sponsored by the San Francisco Art Commission in the late 1940s, an angry viewer pulled down an abstract expressionist painting by Ernest Briggs and stomped on it, infuriated by what a *Chronicle* critic called the "optical indigestion" of modern art. Others saw more sinister implications in abstract painting. In an era of hard-line McCarthyism, one congressman, Michigan's George Dondero, claimed that modern art was a Soviet conspiracy

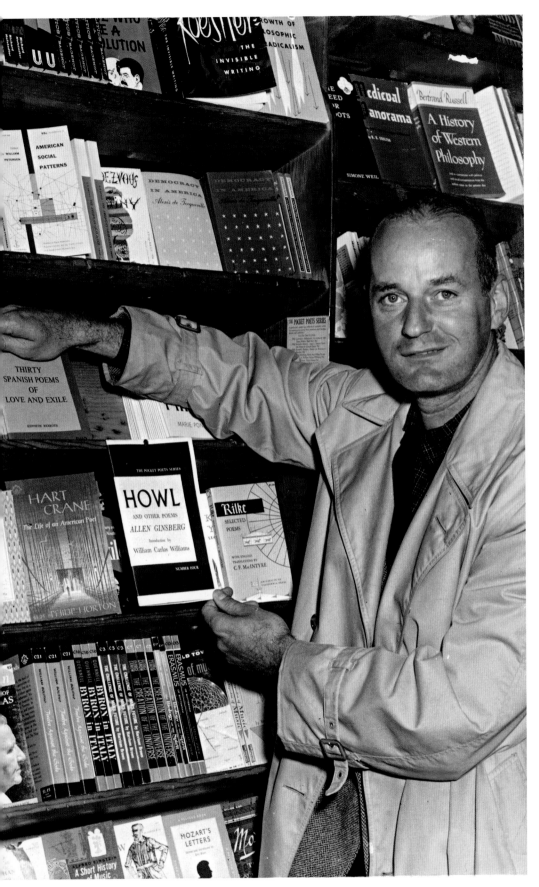

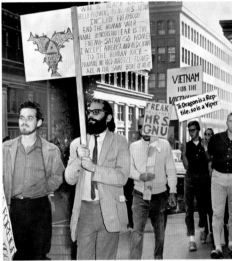

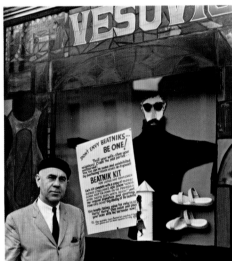

LEFT: In 1957, poet Lawrence Ferlinghetti, proprietor of City Lights Books, posed with a copy of "Howl," an epic poem written by Allen Ginsberg. Ferlinghetti faced obscenity charges for publishing the book, which San Francisco police had confiscated for its sexual references. The case was decided in Ferlinghetti's favor.

TOP: In 1963, poet Allen Ginsberg marched in a San Francisco protest against U.S. policies in Vietnam.

ABOVE: Henri Lenoir, owner of Vesuvio Cafe, a bohemian saloon across from City Lights books in North Beach

PREVIOUS PAGES: A Chinese opera at the
Great China Theatre in San Francisco

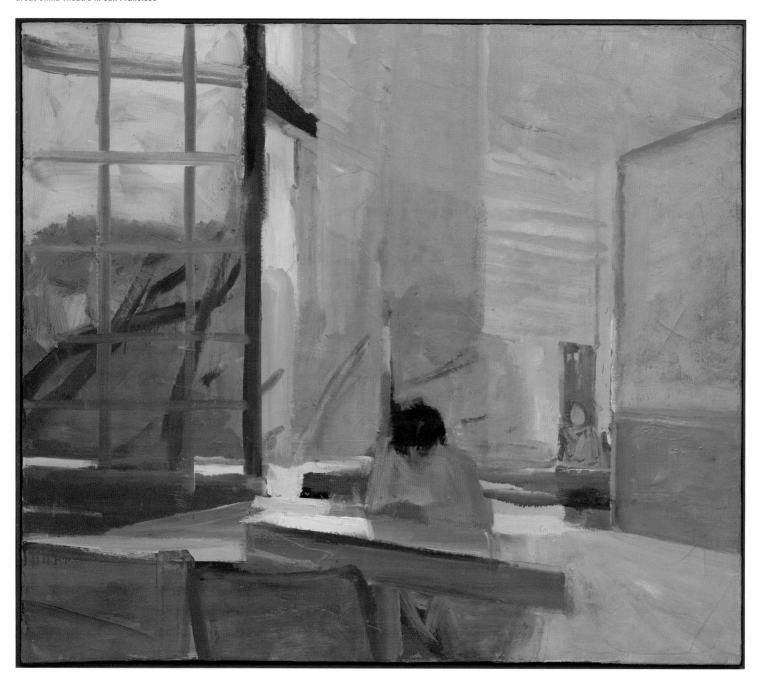

The Bay Area Figurative movement
emerged in the 1950s. ABOVE: *Orange
Sweater*, 1955, by Elmer Bischoff;
OPPOSITE: *Woman in Profile*, 1958, by
Richard Diebenkorn

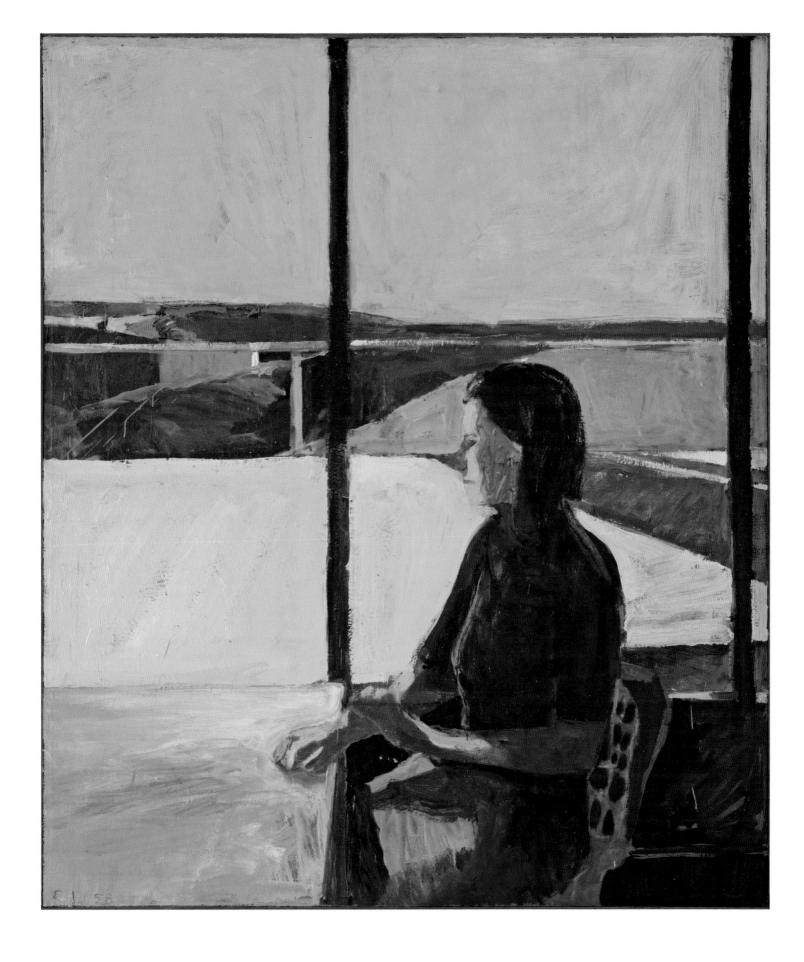

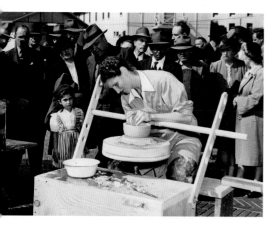

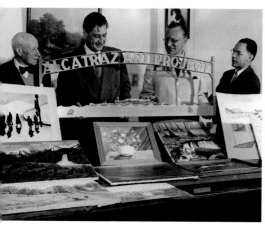

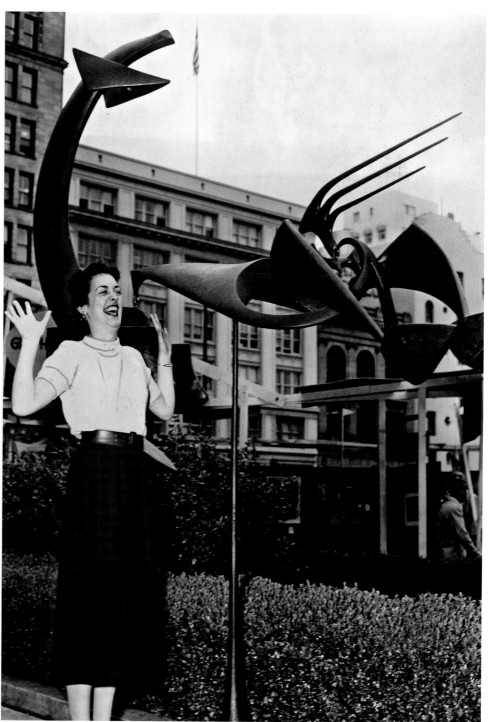

TOP: A quarter of a million people attended the Art Commission's first outdoor art show in 1946.

ABOVE: A jury of four art commissioners viewed works by Alcatraz inmates at the 1949 Open Air Art Show.

RIGHT: Robert B. Howard's mobile, *Excelsior*, on exhibit at the commission's seventh annual Art Festival

to spread communism in the United States. In San Francisco, too, there was little official tolerance for art with a political message. At another San Francisco Art Commission exhibition in 1955, Victor Arnautoff, the former Coit Tower muralist, submitted a color lithograph satirizing Vice President Richard Nixon as "Dick McSmear." The commission promptly removed the artwork, explaining that elected officeholders "of whatever party should not be the subject of a caricature displayed at an art exhibit financed by all the people." Local artists protested that the commission was stifling freedom of expression. Even Vice President Nixon suggested to Commission President Harold Zellerbach that the public should have a full opportunity to see the print.

Despite these occasional controversies, the commission's art shows reflected the energy, range, and vitality of the city's art scene. They also helped raise the national cultural profile of San Francisco. In 1950, the commission expanded and transformed its

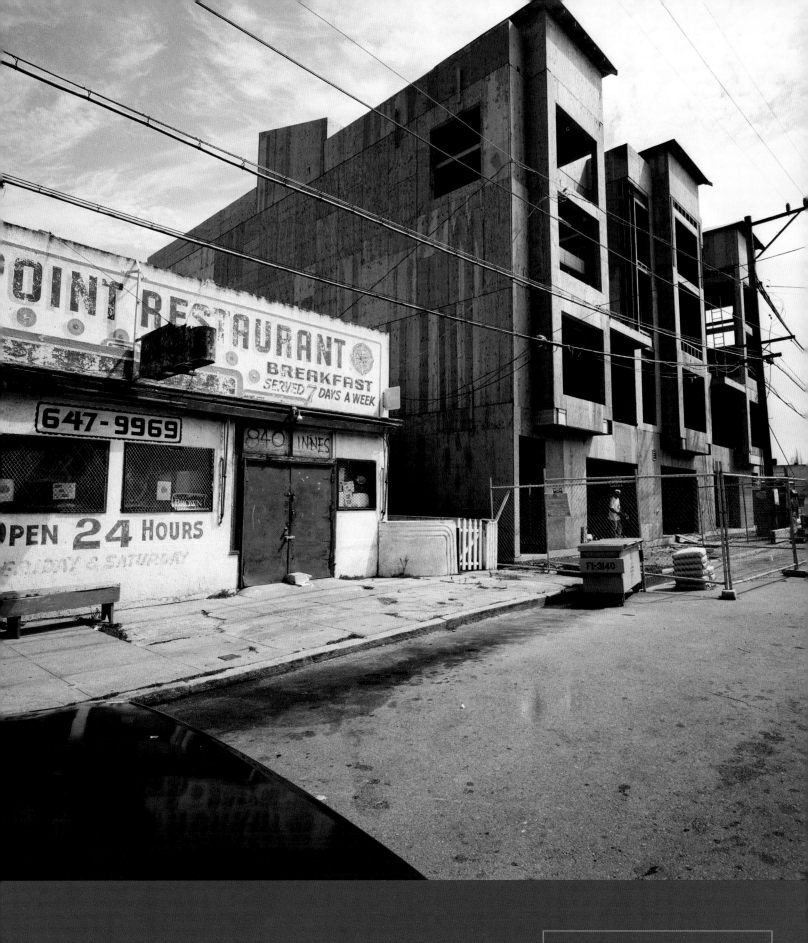

POINT RESTAURANT

BREAKFAST
SERVED 7 DAYS A WEEK

647-9969

840 INNES

BROWN

OPEN 24 HOURS
FRIDAY & SATURDAY

FI-3140

Hunter's Point Restaurant, 2000, by
Susan Schwartzenberg

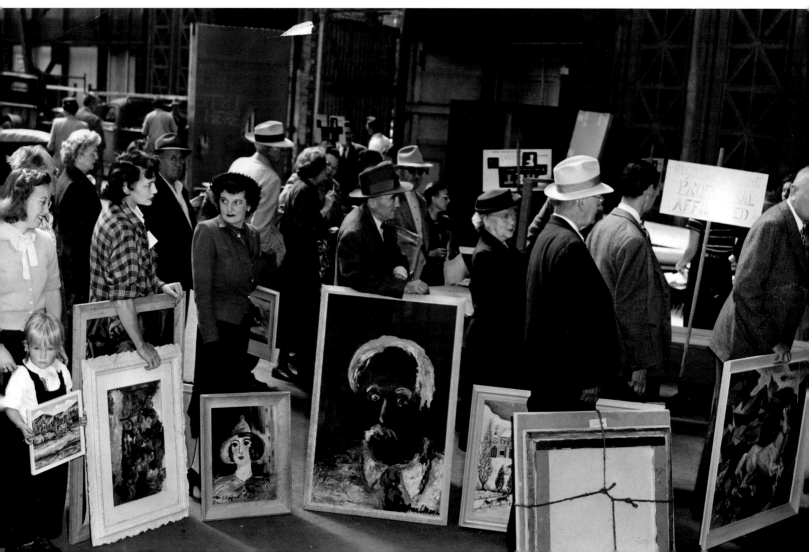

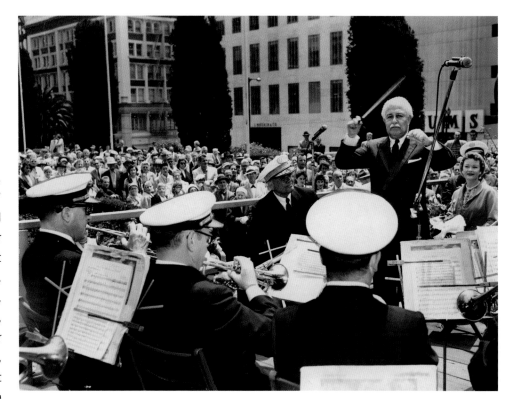

original outdoor art show into a "vast, complicated, contrapuntal, fantastic" event. The new San Francisco Art Festival was the largest-scale art exposition ever sponsored by an American city. Staged at the huge, semicircular Palace of Fine Arts, the festival featured music, theater, dance, poetry, architecture, crafts, sculpture, and thousands of paintings by amateur and professional artists. Folk dancers, madrigal singers, plays, experimental art movies, and puppet shows entertained a hundred thousand visitors—from bearded art students and prim dowagers to kids on roller skates—in a free, high-spirited spectacle that combined, according to the *New York Times*, the energy of an avant-garde art show and the showmanship of P. T. Barnum and Cecil B. DeMille. Second only to New York, the *Times* observed, San Francisco seemed to be the liveliest center of art activity in the country.

Attendance doubled at the second Art Festival, in 1951, and by the mid-1950s, the sprawling event had become a municipal institution, with all of the prestige and problems that one entails. To maintain public interest and the quality of submissions, the Art Commission established screening committees to jury painting, sculpture, and crafts. Over the course of a decade, the commission moved the festival from the Palace of Fine Arts to Washington Square, then to Fisherman's Wharf, and finally to the Civic Center. Given its "migratory history, rainouts, and the handicap of insufficient funds," Zellerbach conceded, the wandering Art Festival began attracting its share of critics by the early '60s. Still, despite the challenge of refreshing a complex creative event year after year, the festival continued to draw thousands of attendees to its varied exhibits. Using monies budgeted from the city's general fund, the Art Commission also purchased submissions selected by the festival jury. With these acquisitions, the commission not only supported local artists but also began building an expansive Civic Art Collection, including a growing number of significant works placed in municipal buildings.

MUSIC AND FILM FESTIVALS

In the early 1950s, the Art Commission launched another annual event aimed at popularizing the fine arts in San Francisco. Since 1932, the commission had sponsored spring, summer, and winter concerts of the San Francisco Symphony, at low prices to the public, to make live music widely accessible and provide year-round work for symphony musicians. In 1951, the commission broadened its standard symphony offerings by inaugurating a Mid-Summer Pops music festival conducted by Arthur Fiedler, maestro of the nationally acclaimed Boston Pops Orchestra.

OPPOSITE, TOP: In 1957, a downpour drenched the Art Festival and its director, Martin Snipper, in Washington Square. OPPOSITE, BOTTOM: In 1951, artists lined up at the Palace of Fine Arts to register their exhibits for the five-day Art Festival.

TOP: In 1958, Arthur Fiedler conducted the Municipal Band in Union Square before the opening of the Mid-Summer Pops festival. ABOVE: A 1979 Pops program

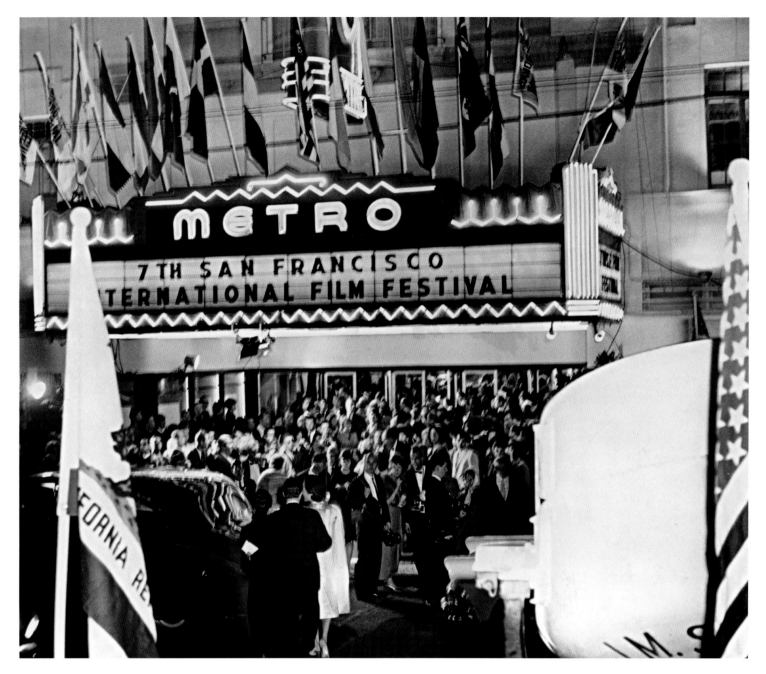

In 1963, crowds gathered outside the Metro Theater on Union Street for the seventh San Francisco International Film Festival.

Fiedler, an energetic, peripatetic showman, blended classical, semiclassical, and popular music in concerts designed to appeal to a wide public and featuring the debuts of talented young local soloists. Held in Civic Auditorium, the Mid-Summer Pops concerts were staged, as in Boston, in traditional Viennese style. Patrons, seated casually at candlelit tables, could enhance their enjoyment of musical programs with pretzels, beer, and—bowing to public pressure in San Francisco—free-flowing hard liquor. Though the first Pops concert filled just a third of the auditorium, the popularity of the series grew enormously year after year. By 1956, when television was increasingly competing for concert audiences, almost every San Francisco Pops performance was sold out. Arthur Fiedler, who never turned down an invitation to conduct, traveled with his own air-conditioned podium and became a beloved musical figure in San Francisco. The maestro was made an honorary citizen of San Francisco in 1957, and two years later, the city saluted him by officially proclaiming and celebrating Arthur Fiedler Day.

By the late 1950s, the San Francisco Art Commission ventured beyond its traditional focus on civic art and music. Foreign and experimental art films were increasingly attract-

ing audiences in San Francisco. As a result, the commission realized it had an opportunity to make the city a center for cinematic arts by inaugurating the first international film festival in North America. At the time, only four cities in the world—Venice, Berlin, Edinburgh, and Cannes—hosted international film competitions, and no international cinema events existed in the United States. On the evening of December 4, 1957, with the leadership and funding of San Francisco theater operator Irving Levin, the commission launched the first San Francisco International Film Festival at Union Street's Metro Theater. An audience of celebrities, media correspondents, and members of the consular corps turned out for the gala opening, which featured fourteen movies from twelve countries. At the end of the festival, the Art Commission presented four Golden Gate Awards for the best picture, director, actor, and actress selected by a panel of Bay Area drama critics. By 1960, celebrities including Mary Pickford and John Steinbeck were traveling to San Francisco to attend the festival, and the pioneering event won national praise. San Francisco "is no Cannes," the *New York Times* commented, but for people "who look upon movies as an art form, this city is far more exciting these days than Hollywood."

Hollywood, in truth, barely acknowledged the San Francisco festival and rarely took part in it. In 1958, Twentieth Century Fox entered its movie *Rally 'Round the Flag, Boys!*, starring Paul Newman and Joanne Woodward, then abruptly withdrew it from the competition. The next year the studio submitted *Beloved Infidel*, an F. Scott Fitzgerald biopic starring Gregory Peck and Deborah Kerr, but the movie fared badly at the event. A film critic for the *New Yorker* walked out of the screening after five minutes. Herb Caen scathingly dubbed it "*Beloved Infi-Dull.*" For the next four years, Hollywood boycotted the festival, fearing that a movie's poor showing in the event would harm ticket sales. As a matter of sportsmanship, the *New York Times* reported, "a spokesman for the festival declined... to consider the possibility that the film boycott might be connected with the rivalry between San Francisco and Los Angeles."

That rivalry erupted openly in 1962, when Hollywood threatened to create its own international film festival to outshine, outdraw, and sabotage the San Francisco event. Although the *Times* predicted that a Hollywood festival would easily outclass San Francisco's by drawing a galaxy of stars, writers, directors, and producers, it could not match the impartiality that the San Francisco festival had clearly demonstrated. "Audiences at the Metro Theater," the *Times* added, "... are not cheering sections. If they don't like a movie they walk out, or even hiss. This may be rude. But their reactions, both favorable and unfavorable, are just." They were rewarded. In 1963, Columbia Pictures director Carl Foreman broke the Hollywood boycott by entering his film *The Victors*, and its glittering opening-night audience included George Plimpton, George Hamilton, Peter Fonda, and Sammy Davis Jr. The next year, the San Francisco festival won a prestigious class A rating from the International Federation of Motion Pictures, placing the event in the same category as esteemed and established foreign film competitions in Cannes, Venice, and Berlin.

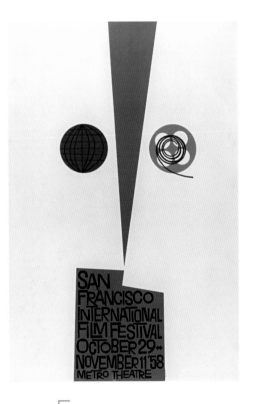

A poster for the 1958 San Francisco International Film Festival

ANNUAL

UNION at COLUMBUS (in north beach)

ARTS*FESTIVAL

sept. 26th thru 29th

A PROJECT OF THE SAN FRANCISCO ART COMMISSION

ABOVE: A program for the 1957 annual Arts Festival

OPPOSITE: In 1960, poet ruth weiss read at the Grant Avenue Fair in North Beach.

CULTURE WARS

In 1964, city cultural policies were making headlines in San Francisco. Former Congressman John F. Shelley was sworn in as mayor after what the *Chronicle* noted was the first political campaign in city history in which the arts and what to do with them had been an issue. Shelley and his opponent, Harold Dobbs, had both courted the culture vote, and when Shelley took office, he hoped to encourage "fresh young ideas" about cultural plans and policies. The first wave of the baby boom was coming of age in an era of political and social turmoil, and society was fracturing along racial, ethnic, and generational lines. A year after President John F. Kennedy's assassination and Martin Luther King Jr.'s March on Washington, landmark civil rights legislation was working through Congress, and the U.S. was strengthening its presence in Vietnam. In San Francisco, the Beatles and the Republican National Convention were playing the Cow Palace, and young artists joined students in Free Speech protests, sit-ins, and lie-ins. "This new generation of California culture-bearers," observed San Francisco poet Kenneth Rexroth, is "through with The Bomb, racial discrimination, war, poverty and... the rotting affluence of the world about them. They do not propose to reform this situation but to stop it right now by personal intervention." That attitude, he added, was "reflected in all the arts."

The cultural divide was also evident in the comments of a new art commissioner appointed by Mayor Shelley. Thirty-eight-year-old Jeremy Ets-Hokin was cofounder of the hungry i nightclub, which helped launch the careers of performers including Lenny Bruce; Mort Sahl; Bill Cosby; Peter, Paul and Mary; and the Kingston Trio. The club had opened in the basement of the International Hotel in Manilatown—considered part of North Beach today—which was the center of the city's Filipino community. Ets-Hokin ignited a furor in 1964 when he charged that San Francisco hadn't advanced culturally since the 1930s. "The arts in San Francisco," he declared, "are now ruled by a small coterie," a docile moneyed elite "imbued with an almost incestuous lethargy.... We have a lot of organizations that are trying to overcome this but their views are being repressed." Los Angeles, he added, had long surpassed San Francisco as a cultural capital.

SAN FRANCISCO POETS
READING
(HOST: JORY SHERMAN)

CID CORMAN
RICHARD McBRIDE
ROBERT STOCK
MICHAEL GRIEG
WILLIAM MORRIS
STANLEY McNAIL
DANIEL LANGTON
HELEN ADAM
JOHN RICHARDSON
C.V.J. ANDERSON
BILL BUTLER
TRACY THOMPSON
DAVID R. WANG
ROBERT BRIGGS
VICTOR GIPSON
JORY SHERMAN . . .
AND OTHERS
Thank You

Mayor Shelley protested that Ets-Hokin was speaking with "the voice of impatient youth," and the *Examiner*'s art editor, Alexander Fried, dismissed him as "an erratic observer." Still, it was obvious that, more than ever, there were two faces of city culture—the traditional "high-art" activities—including the symphony, opera, and ballet—and the exuberant, diverse, dissident activities of urban artists.

The schism crystallized in 1965 in the debate over Proposition B, a bond issue to modernize and renovate the War Memorial buildings and construct a new Musical Arts Building. Other American cities were outshining San Francisco with spectacular new cultural facilities, and the city risked losing its reputation as the Paris of the Pacific. New York City was building its Lincoln Center complex for symphony, ballet, theater, and the Metropolitan Opera, and Los Angeles had just opened a dazzling art museum and the Music Center for the Performing Arts. The project was transforming L.A., *Time* magazine noted, from "a city…dismissed as an uncouth poor relation of San Francisco" to a powerful new center of culture rivaling Manhattan.

The arts, the panel concluded, were not "for a privileged few but for the many…their place is not on the periphery of society but at its center…they are not just a form of recreation but are of central importance."

San Francisco was under pressure to respond. In 1961, the city had established Grants for the Arts, a program to subsidize nonprofit cultural groups from a portion of its Hotel Tax Fund. The program quickly became an internationally admired model of municipal funding and support for arts and culture. Despite this dedicated city support, however, Mayor Shelley saw Prop B as vital to maintaining the city's status in the performing arts. The measure opened a gaping rift between "the classes and the masses" over civic culture. There was fierce debate in San Francisco, the *Chronicle* reported, about whether public funds should subsidize cultural activities that were largely enjoyed by elite audiences or those that were designed specifically for a wide public and reflected changing attitudes and demographics.

Despite the efforts of the mayor, city business leaders, and "the Burlingame set," as wealthy families were known, Proposition B lost on election day by a wide margin. It was a turning point in San Francisco's cultural life. The Art Commission, headed by longtime president Harold L. Zellerbach, subsequently took the lead in developing new policies and proposals for the public arts. Zellerbach—a bespectacled, impeccably dressed patron of the arts and executive of his family's paper firm, the Crown Zellerbach Corporation—had served as head of the commission since 1948. From the beginning, he had been interested in expanding the scope of its activities in art and music. The commission, on his watch, had created three major cultural events—the Art Festival, the Mid-Summer Pops, and the International Film Festival—but innovation was frustratingly slow. By 1966, the commission's old guard was gone, and Zellerbach seized the opportunity to broaden and disseminate civic cultural life.

CULTURAL DEMOCRACY

San Francisco was experiencing a cultural explosion, as were many cities and towns across the country. With more leisure time and education than ever, people were demanding access to high-art performances and more public support for community-based cultural activities. Zellerbach had unique exposure to this cultural shift. In 1965, he had been named to a panel, sponsored by the Rockefeller Brothers' Fund, that issued a report advocating "cultural democracy." The arts, the panel concluded, were not "for a privileged few but for the many... their place is not on the periphery of society but at its center...they are not just a form of recreation but are of central importance."

A year later, Zellerbach joined the board of the Arts Councils of America, which encouraged diversity and community participation in the arts. It was a significant moment for the organization, according to a reporter who attended the group's twelfth national conference. At past meetings, he recalled, participants had largely been members of the establishment who sat on the boards of art institutions. Now, by contrast, there were young, middle-class attendees from virtually every state. As the *New York Times* noted, "the old notion that the arts are somehow highbrow and effete is dying as men and women from all walks of American life join to discuss and diffuse them" and democratize cultural participation.

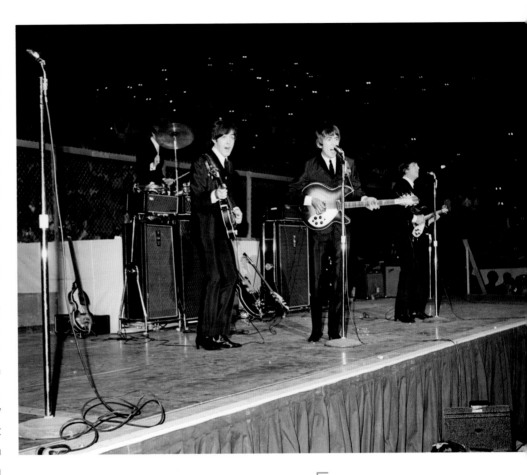

In 1964, the Beatles kicked off their second American tour at the Cow Palace in Daly City, south of San Francisco.

In San Francisco that year, Mayor Shelley created and Zellerbach chaired a diverse new Arts Resources Development Committee. The panel, sponsored by the Zellerbach Family Fund, issued a study advocating a new, community-based civic cultural program. The study proposed neighborhood arts facilities for rehearsal, production, performance, and exhibition. It also advocated arts instruction in elementary and secondary schools, as well as adult, college, and professional arts education. For the first time, according to cultural critic Amalia Mesa-Bains, an artist and former art commissioner, "underrepresented communities would be encouraged to take their place in the larger artmaking picture, to take charge of their own narrative." At the leading edge of civic arts policy, San Francisco was charting a new course to bring diverse cultural currents into the mainstream.

Boy Selling Newspapers, San Francisco, about 1950, by Imogen Cunningham

CHAPTER THREE

1966

1980

A DANCER

CREATIVE UPHEAVAL. *The cultural dam was breaking, and the arts were moving from concert halls, theaters, and museums into local communities. In May 1966, poet Kenneth Rexroth urged students at San Francisco State College to reject elite "skyscraper cathedrals of culture" and diffuse the cultural life of the city into the neighborhoods. It was a challenge that rapidly gained popular momentum.*

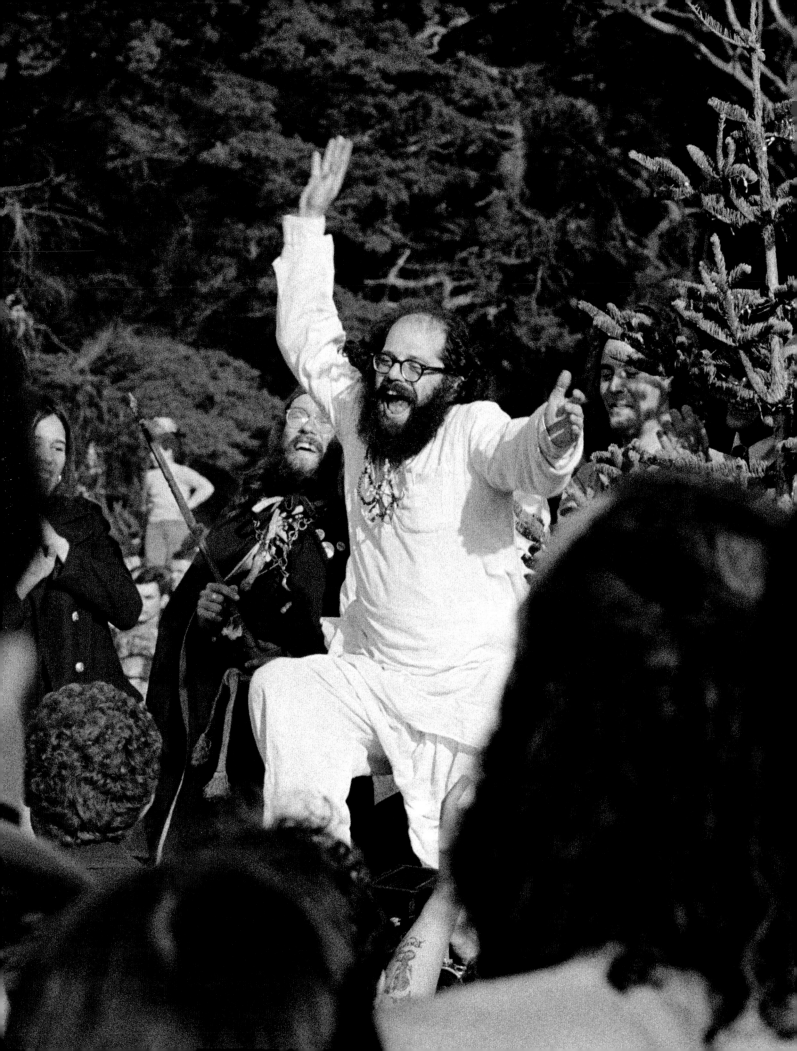

03

That summer, a provocative new group, the Artists Liberation Front (ALF), organized to fight continuing pressure for a new symphony hall and civic cultural center. The ALF wanted to bring recognition,

member Peter Coyote explained, "to the work of community-based artists and people of color who were being ignored." In just a few months, the group was organizing free weekend art festivals—hauling rolls of paper, brushes, and buckets of paint to the Tenderloin and other low-income, ethnic communities in San Francisco. Called Free Fairs, the outdoor events urged neighborhood residents to pick up a brush, dance to live music, and participate in the "spontaneous creation of a living culture."

That autumn and winter, the streets of the city were erupting with impromptu "happenings," rock concerts, rallies, and political theater. The Haight-Ashbury, a new haven for artists, was the epicenter of the next generation of countercultural youth, dubbed "hippies" by the *San Francisco Examiner*'s Michael Fallon. In the fall, the Diggers, a street theater group, placed a twelve-foot-high, bright yellow square, called a "Frame of Reference," at the intersection of Haight and Ashbury and directed passing pedestrians in a traffic-stopping performance that drew crowds and cops. Artistic expression—unfettered, flamboyant, and experimental—was fueling a rebellious, psychedelic youth culture of "beads, blossoms, and bells," rock music, and hallucinogens. In October, a free performance by Janis Joplin energized three thousand colorfully dressed activists who took to the streets in a Love Pageant Rally protesting a new law criminalizing LSD. Three months later, in January 1967, more than twenty thousand "hippies, beardies . . . lovecultists and leftists," according to United Press International, gathered at a vast Human Be-In in Golden Gate Park. The crowd listened to rock music by the Jefferson Airplane and the Grateful Dead, poetry and chanting by Allen Ginsberg, and exhortations by LSD advocate Timothy Leary to embrace psychedelics, abandon conventions, and "turn on, tune in, and drop out."

That spring and summer, the hippie phenomenon was in full flower. By July, a hundred thousand young people from all over the world—lured by news reports about the

TOP: In 1967, Paul Krassner (center), editor of the underground publication *The Realist*, spoke at a happening in the Panhandle with members of the Diggers street theater group.

ABOVE: A 1968 screen print featuring a phrase popularized by the Diggers

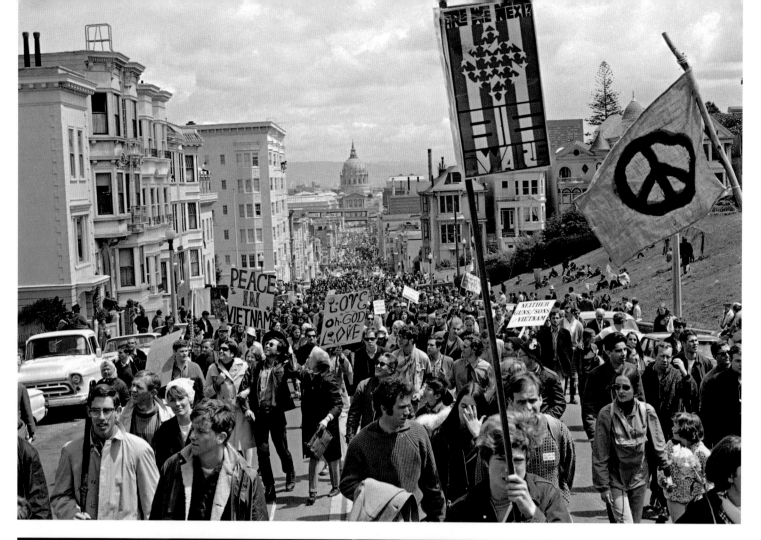

city's counterculture and the Human Be-In—streamed into the Haight-Ashbury for San Francisco's legendary Summer of Love, a "living fever dream" of music, liberation, art, activism, and drugs. Meanwhile, San Francisco State College students were demanding a new focus on ethnic studies, the history of communities of color, and indigenous art forms. According to Beat poet Michael McClure, young people throughout the city were declaring "the possibility of a new culture." There was no doubt, Rexroth explained, that a wholesale change was taking place, a dramatic democratization of the cultural environment.

The Haight-Ashbury, a new haven for artists, was the epicenter of the next generation of countercultural youth, dubbed "hippies" by the San Francisco Examiner's Michael Fallon.

NEIGHBORHOOD ART

Art subcultures were thriving in the city's neighborhoods. Inspired by their creative energy, Rod Lundquist, a member of the Artists Liberation Front, and Art Bierman, a philosophy professor at San Francisco State, joined forces to seek civic support for community art services. In January 1967, they approached the San Francisco Art Commission's newly hired director, Martin Snipper, with the idea of developing a groundbreaking arts program in the city's neighborhoods. Snipper, a longtime teacher and painter, had directed the commission's Art Festival for nearly two decades and was fully aware of the vital cultural life in the city's communities. Together, Bierman and Snipper conceived of a three-way partnership: San Francisco State would establish courses and provide personnel to work in the communities, neighborhood groups would take on responsibility for programming, and the Art Commission would provide technical support and equipment for programs and events, on request, as a service agency.

Snipper liked the concept and brought it to commission president Harold Zellerbach, who immediately saw its potential for broadening public engagement with the arts and reducing neighborhood opposition to a performing arts center. "Harold was very responsive...very adventurous," Snipper recalled, and he wanted to involve the commission, which had been relatively static for years, in a project that would recognize and nurture the city's vibrant community cultures.

With commission funding, the new Neighborhood Arts Program (NAP) rolled out in July 1967, with Lundquist as its first director. Its first performing arts festival, called "An Afro-American Thing," toured San Francisco neighborhoods to demonstrate the kind of community artistic endeavors that might be possible. A multimedia production featuring poetry, dance, and other presentations, it opened in February 1968 in five San Francisco neighborhoods. Performances were "absolutely jammed," Snipper said. "Harold came out, and he couldn't believe the response." From that time on, neighborhood groups were coming "out of the woodwork," Snipper recalled, "pounding on the door" and requesting the NAP's help with community art programs.

OPPOSITE, TOP: **In 1967, peace demonstrators filled Fulton Street.** BOTTOM: **A March 1967 headline reflected urban unrest in San Francisco.**

San Francisco, 1977, by Henry Wessel

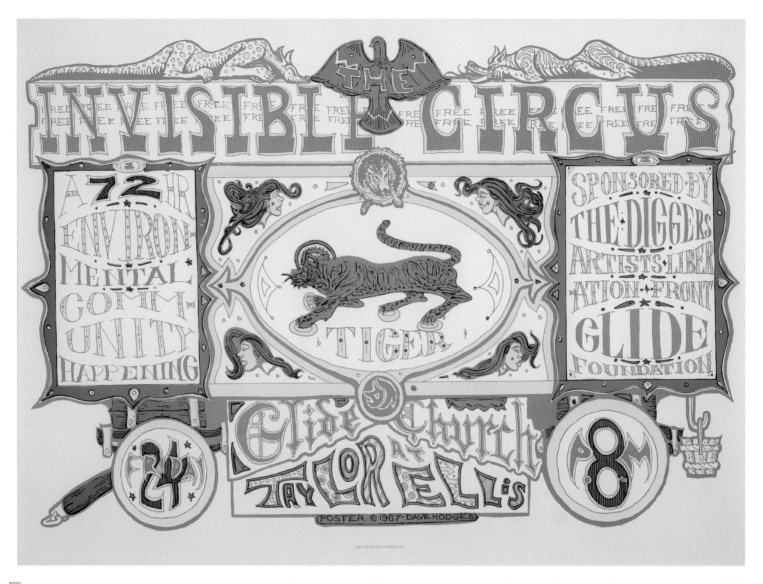

A poster for "The Invisible Circus," sponsored by the Diggers in 1967

Under Lundquist's successor, community organizer June Dunn, demand for NAP services was so intense that the Zellerbach Family Fund stepped in with additional funding. In fiscal year 1968–1969, the program sponsored or organized nearly 450 neighborhood arts events, including street fairs, music and theater performances, arts and crafts programs, and free public art workshops. The NAP, according to Snipper, "was going like a house afire," and its budget for the next year doubled to more than $150,000, thanks to funding from the city, private foundations, and the National Endowment for the Arts. The NAP was also building strong ties and trust with local communities, and its programs began reflecting the cultural identities of the city's African American, Latino, Chinese, Mexican, Filipino, Samoan, and Native American populations.

ART AND IDENTITY

San Francisco was a crucible of minority and ethnic identity movements. In 1968, students at San Francisco State staged a five-month campus strike, the longest in U.S. history. Led by the college's Black Student Union and Third World Liberation Front—comprising African American, Asian American, Chicano, and Native American students—the protesters called for a more diverse campus and curriculum. After months of confrontations, arrests, and sporadic violence, the administration and strikers negotiated an agreement that created a School of Ethnic Studies and expanded the new Black Studies Department. The conflict was emblematic of identity power movements throughout the city.

Asian Americans organized in 1968 to protest the eviction of tenants at the International Hotel on Kearny Street, the home of many elderly male Filipinos. Supported by the faith community, the labor movement, and many multicultural students and activists, the protesters halted the evictions for almost a decade. The battle over the I-Hotel became a powerful symbol of Asian American cultural identity in San Francisco and inspired an upwelling of creative expression, including murals, music, and dance, in the community. The Kearny Street Workshop—now the oldest Asian Pacific American multidisciplinary arts workshop in the country—emerged in 1972 from the struggles over low-income housing, labor, and the I-Hotel in the Chinatown/Manilatown community.

San Francisco's Chicano identity movement arose from the farm labor organizing struggles of the 1960s. It, too, inspired a flowering of artistic expression addressing social and cultural conditions of the Chicano community. "There were nearly a hundred fifty artists living in the Mission District who were very active and gave voice to a lot of people," said René Yañez, an artist and former staff member of the Neighborhood Arts Program. Galería de la Raza, in the Mission District, became a center for exhibitions, community art programs, and cultural activism that explored and affirmed Chicano and Latino identity. Another Chicano arts organization, Precita Eyes Muralists—one of only three community mural centers in the United States—taught art classes and worked with artists and volunteers to create murals that reflected Chicano history and culture.

The city's Native American community was galvanized, in 1969, by the occupation of Alcatraz by American Indian activists representing "Indians of All Tribes." The nineteen-month takeover of the island sharply focused public attention on the condition of Native populations in the United States and fostered literary and other creative expressions of identity.

Those cultural identity movements found civic support through the Neighborhood Arts Program. The NAP, Yañez said, had strong neighborhood backing, touched many lives, and "was an integral part of what was going on in the city." In the summer of 1970, however, the Art Commission abruptly decided to reorganize the project and its personnel, a fiercely contested move that resulted in the mass resignation of Dunn's staff. In a decision opposed by many community members, the commission brought the quasi-independent program under its full control and transferred the NAP's leadership from Dunn to Stephen Goldstine, previously an assistant professor of philosophy and chair of the art department at St. Mary's College in the East Bay.

Under Goldstine, the revived and restructured NAP continued to support neighborhood arts groups. The program lent equipment, created flyers, promoted events, and helped groups contact funders, write proposals, and secure office, rehearsal, workshop, and performance space. The NAP expanded rapidly, attracting local and national funding and drawing praise as the first community program of its kind in the country. The Neighborhood Arts Program, stated the Ford Foundation, was "virtually unique to San Francisco" and a model for emerging community arts programs in other cities.

TOP: The Pickle Family Circus performed in Berkeley in 1978.

ABOVE: A poster for the San Francisco Mime Troupe, an influential political satire theater group formed in 1959

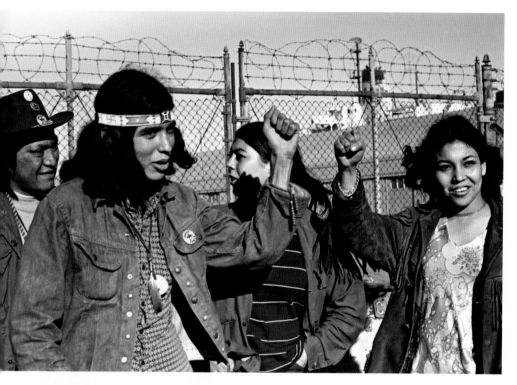

CETA ARTISTS

In 1974, the NAP and San Francisco Art Commission launched another pioneering effort when they began employing artists under a new federal manpower initiative, the Comprehensive Education and Training Act (CETA). Congress had passed the block-grant legislation in December 1973, in the middle of a deep recession and painfully high levels of unemployment. As in the Great Depression, artists were especially hard-hit by the financial downturn. They were "desperately poor," recalled John Kreidler, who was doing a six-month internship with the NAP through UCLA's School of Management. Kreidler had previously worked in the federal Labor Department and Office of Management and Budget, and it occurred to him that there might be a way to use the new CETA legislation to design a program employing artists in community service projects through the NAP. In late 1974, Kreidler wrote and submitted a proposal requesting CETA funding, through the mayor's Office of Manpower, for twenty-four NAP artist positions in San Francisco. The office immediately approved the proposal and soon after assigned funding for 123 CETA artist positions.

By early 1975, the NAP had dispatched CETA dancers, musicians, poets, storytellers, sculptors, muralists, actors, theatrical designers, theater technicians, textile designers, filmmakers, video specialists, editors, art historians, photographers, and gardeners to work on community arts projects across the city. CETA artists taught in classrooms, brightened the physical environments of public schools, and brought art to community centers, hospitals, prisons, and homes for the elderly. Muralists adorned hundreds of walls in low-income areas and collaborated with sculptors and landscape artists. Other artists taught schoolchildren filmmaking, puppetry, and Chinese classical music. Performers such as the Talespinners entertained seniors, and the Pickle Family Circus and Make-a-Circus introduced audiences of all ages to circus arts on an intimate scale. Their combined creativity fueled an explosion of art and culture that became a national model. The program inspired CETA arts initiatives in other cities and sparked what the *New York Times* noted was "the biggest unexpected infusion of Federal funds into the arts since the Works Progress Administration of the 1930s."

In San Francisco public schools, the contributions of CETA artists complemented the symphony's longtime education program and the efforts of the Alvarado Art Workshop,

TOP: On June 11, 1971, moments after their removal, occupiers of Alcatraz raised their fists to show that the struggle for Native American rights would continue.

ABOVE: The Black Festival of Dance in 1968

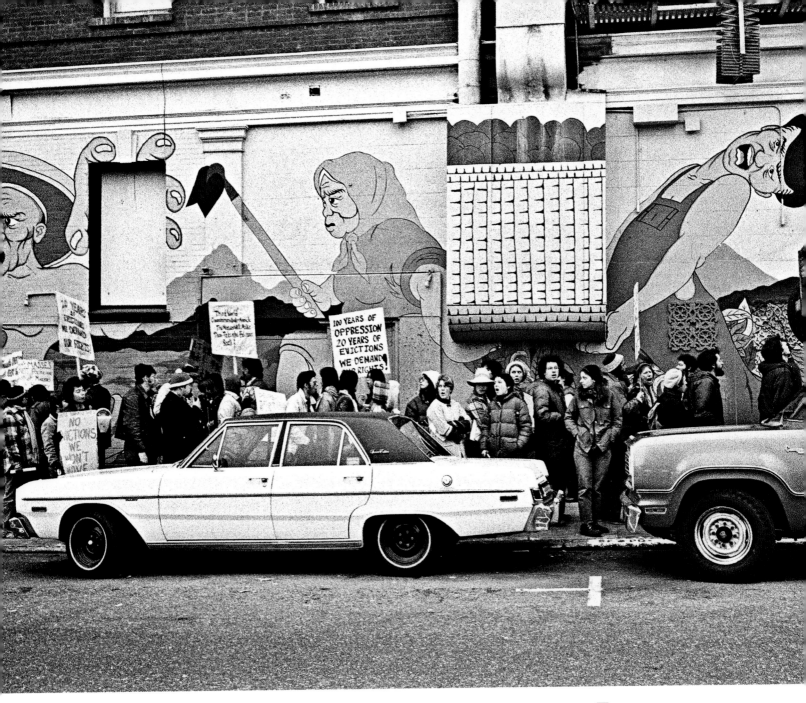

which coadministered sixty of the NAP's CETA positions. Founded in 1968 by art commissioner and sculptor Ruth Asawa—nationally known for her intricate abstract works made of woven wire—Alvarado engaged professional artists to guide schoolchildren in creating murals, gardens, sculptures, and multimedia performances. Asawa, a thoughtful and powerful member of the commission, was passionate about bringing children, families, and neighbors together around art activities. In 1973, she began taking her collaborative vision a step further by bringing schools together to exchange ideas and encourage the growth of programs in arts and sciences. Called the Music, Art, Dance, Drama, Science Festival, the annual event, sponsored by the NAP, aimed to break through the isolation that limited the range of typical school art programs. The festival was a forum for creative cross-pollination and inspiration and offered "four days of excitement," Asawa said, "in which parents and teachers can *see* new ideas," from chamber music ensembles, Afro-Haitian jazz dance performances, art exhibitions, and scientific displays to hands-on activities such as kite making, soap carving, spinning, and weaving.

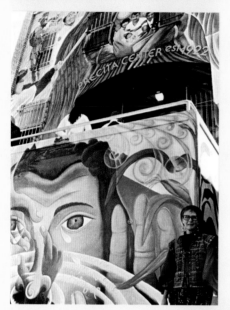

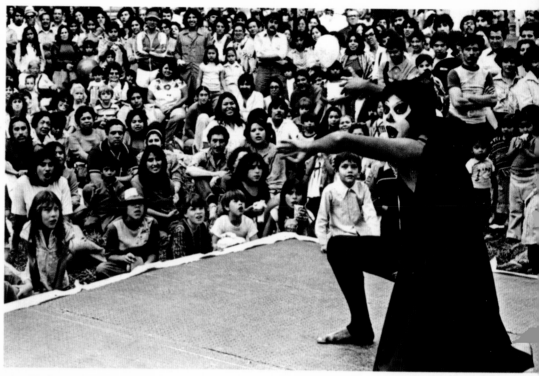

MISSION CULTURAL CENTER

GALERIA MUSEO

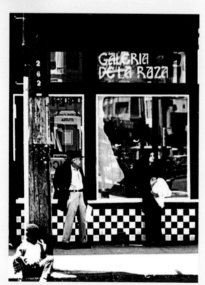

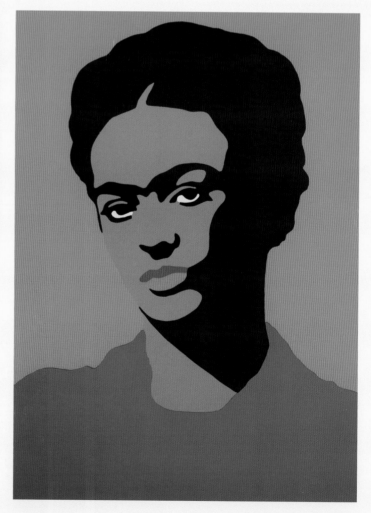

CLOCKWISE FROM TOP LEFT: The Mujeres
Muralistas completed their first experimental
mural in 1972 on Balmy Alley in the Mission
District; a 1972 postcard from the Mission
District Cultural Center for the Latino Arts;
Frida Kahlo, 1975/2002, by Rupert Garcia;
the Galería de la Raza was founded in 1970 to
foster appreciation of Latino art and culture;
in 1977, Mission District artists, including
Susan and Luis Cervantes, founded the Precita
Eyes Muralists Association and Center

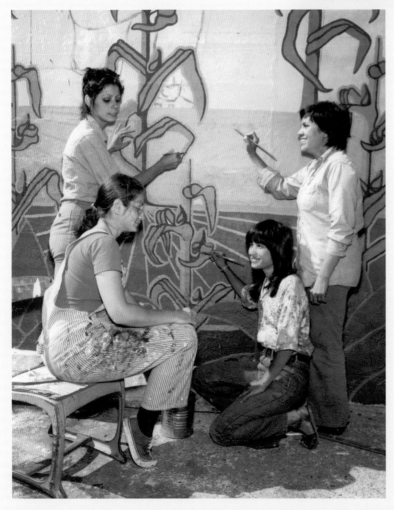

CLOCKWISE FROM TOP LEFT: A poster advertising art workshops at the Mission District Cultural Center for Latino Arts; *Latinoamerica*, 1974, on Mission Street between 25th and 26th streets, was the first formal public artwork created by the Mujeres Muralistas; in 1972, Cesar Chavez, cofounder of the National Farm Workers Association, marched with State Senator George Moscone and others in a McGovern-for-President rally in San Francisco; muralists on Mission Street in the 1970s

ABOVE AND OPPOSITE, LEFT: Performers in the 1978 San Francisco Ethnic Dance Festival. OPPOSITE, TOP RIGHT: A 1967 *Look* magazine article profiled Gloria Unti, who had founded San Francisco's Performing Arts Workshop two years earlier as a creative outlet for inner-city teens. CENTER: Nancy Wang, who began her dancing career with the Performing Arts Workshop, later cofounded Eth-Noh-Tec—an interdisciplinary theater group focused on Asian traditions—with Robert Kikuchi-Yngojo (below right). Fellow dancer Gary Draper (below left) went on to become artistic director of the Performing Arts Workshop. BOTTOM: The 1974 Cherry Blossom Festival parade in Japantown

SPACES FOR ART

Practicing artists in San Francisco also found new channels for creative expression through the city's first municipal art gallery, Capricorn Asunder. Located at 155 Grove Street, adjacent to the Art Commission offices, the gallery had been founded in 1970 by modernist sculptor and painter Elio Benvenuto, who was visual arts director of the commission and longtime director of its Arts Festival. Working with San Francisco artists known as the Visionaries for their symbolic, dreamlike style of painting, Benvenuto transformed a municipal building across from City Hall into a white-walled, skylit visual art space. At a time when the Bay Area had only a few nonprofit art galleries, Capricorn Asunder showcased the city's emerging talent and established artists. Its first exhibition, *Saturnalia*, featured paintings and sculptures by Saturn & Company, a Visionary Art collective, and drew attention to the possibilities of a city-supported gallery for local artists.

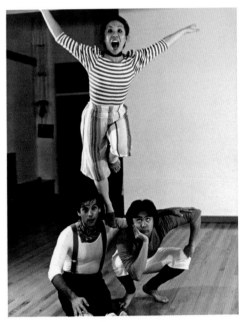

This exhibition includes work from my days as a student up to the present. What you see here is work in progress, first attempts, in some instances studies for projects, and finished works. Ideas first encountered thirty years ago still require more study.

From age ten, while working on my parents' farm, I dreamed of becoming an artist. Uninformed adults, including teachers and counselors, tried to persuade me to be practical, advising, "There is no way to make a living with art; art is not basic; at least get a teaching credential." But my Zen Buddhist parents, who were working eighteen-hour days, as farmers during the Depression, thought that art couldn't possibly be more precarious than their occupation. In those early years I was encouraged by two teachers, Gwendolyn Cowan in the seventh grade and Edith Lowe in high school.

With our entrance into World War II and the internment of all West Coast citizens of Japanese ancestry, I received my first concentrated experience with art. Japanese artists who worked for Disney Studios were interned with us and they taught drawing, cartooning, and animation. We drew for hours each day and sometimes into the night. No other sixteen-year-old Americans were receiving (and still aren't) such training — many hours of instruction and practice with professional artists.

Upon graduation from high school, I was permitted to leave the internment camp in Arkansas to attend college. I pursued a teaching credential in art at Milwaukee State Teachers College, studying drawing, painting, print-making, pottery and weaving. After three years I was told that no one would hire me because we were still at war with Japan.

Fellow students who had gone to Black Mountain College, North Carolina, the year before persuaded me to go with them to their new school. Teachers there were practicing artists, and there was no separation between studying, per-forming the daily chores, and relating to many art forms. I spent three years there and encountered great teachers who gave me enough stimulation to last me for the rest of my life — Josef Albers, painter, Buckminster Fuller, inventor, Max Dehn, the mathematician, and many others. Through them I came to understand the total commitment required if one must be an artist.

Since Black Mountain, San Francisco has been my home. I have reared my own family here and have tried to integrate that undertaking with "being an artist". Most of this show is a diary of these years. Fortunately there have been commissions which permitted me to realize bigger projects than would have been possible in my kitchen or basement workshop.

Through this show I hope to share with you the joy and wonder I find in working. Perhaps some of you will make art an integral part of your daily lives. It is a very satisfy-ing preoccupation.

Ruth Asawa Lanier

Program for the 1976 Ruth Asawa Honor Award Show at the Capricorn Asunder gallery.

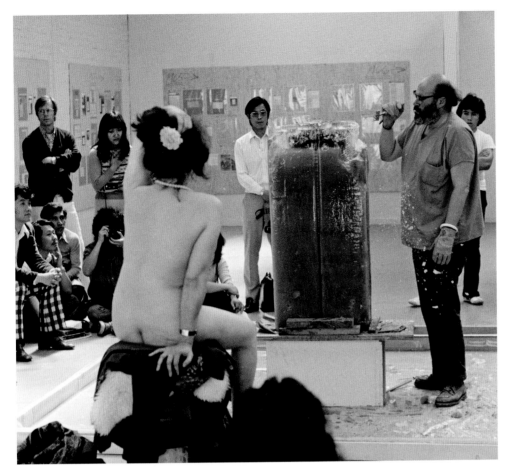

Capricorn Asunder became a jury site for Art Festival submissions, a springboard for artists' careers, and a public laboratory for contemporary art in San Francisco.

Capricorn Asunder's early curators, including John Almond and his successor, Ansel Wettersten, assembled exhibitions that drew large crowds and critical attention. A series of Honor Award Shows celebrated career achievements by artists including Ansel Adams, Sargent Johnson, and Imogen Cunningham. Ruth Asawa's solo exhibition was mounted at the gallery just after she completed two terms of service as an art commissioner. Other shows reflected the era's irreverent, impromptu, and participatory aesthetic tone. As part of a retrospective, for example, on St. Patrick's Day in 1978, conceptual artist and sculptor Art Grant carved a 350-pound block of green ice into a nude leprechaun, a spectacle that drew lunchtime crowds from City Hall and packed the gallery.

Physical space, meanwhile, was a pressing issue for the Neighborhood Arts Program, whose community artists lacked adequate facilities to teach, create, exhibit, and perform. The program had converted an old UC Extension gym in the Western Addition into the NAP Community Theatre, but the location was almost always booked. Artists were forced to share temporary work spaces with schools, libraries, and the Recreation and Park Department. In 1973, frustrations flared when the city announced that it would spend $5 million in federal revenue-sharing dollars to develop the controversial $18 to $30 million Performing Arts Center. Angry neighborhood artists organized the Community Coalition for the Arts to oppose the plan. Using their leverage, they won a commitment from San Francisco to spend $2.5 million in revenue-sharing funds over five years to purchase and develop community cultural centers around the city.

By 1977, the San Francisco Art Commission had used those monies to acquire four buildings and convert them into neighborhood art centers: the historic 1888 South San Francisco Opera House (now the Bayview Opera House, Ruth Williams Memorial Theater)

on Third Street; the Mission Cultural Center (now the Mission Cultural Center for Latino Arts)—formerly Shaff's Furniture store—on Mission Street near Twenty-fourth Street; the Western Addition Cultural Center (now the African American Art and Culture Complex) on Fulton Street; and the South of Market Cultural Center (now SOMArts) on Brannan Street. The commission also leased art facilities in Chinatown, North Beach, and Bernal Heights. The new cultural centers offered fixed, dedicated space for free classes and workshops, performances, and exhibitions and symbolized the city's commitment to community arts. "The cultural centers were an exciting civic investment," said Roberto Vargas, former NAP associate director. "They made people feel like their art, their identity, and their culture meant something and was part of something. People finally had the space to share their art, dance, and music with other communities, and the centers quickly developed rich creative lives of their own."

> *"People finally had the space to share their art, dance, and music with other communities, and the centers quickly developed rich creative lives of their own."*

Community-based art in San Francisco extended well beyond galleries and neighborhood art centers. Since the late 1960s, street artists had been an active presence in the city, selling paintings, sculptures, wall hangings, candles, leatherwork, jewelry, macramé, and other arts and crafts at Aquatic Park, Union Square, and other areas that drew high foot traffic. By late 1971, however, street artists were being regularly rounded up by police for selling goods without peddlers' permits. Local merchants were furious about the congestion and competition that street artists created, and unregulated use of the streets was jeopardizing public safety. Frustrated by daily police sweeps, representatives of the city's Street Artists Guild met with Mayor Joseph Alioto, who sought to end the friction between artists, merchants, and police. Street artists, he said, added color and charm to European cities, and they could do so for San Francisco.

Soon after, in early 1972, musician and broadcaster Ray Taliaferro—the first African American art commissioner, appointed by Alioto—spearheaded a plan to license street artists and designate official locations and times for them to sell their wares. By spring, the Board of Supervisors had approved an ordinance. The board would have the authority to designate public locations, such as sidewalks and plazas, where artists could sell their work, and the Art Commission would have the authority to license and regulate street artists, after verifying that they created their own artwork. The move, supported by both street artists and business interests, resolved a contentious legal and commercial impasse by creating a new municipal art program that was the first of its kind in the country. Three years later, in 1975, San Francisco voters mandated the new program, which was eventually funded entirely by its own license fees and inspired similar programs in other cities and countries.

CLOCKWISE FROM TOP: **Street artists at Justin Herman Plaza in 1979; a preprinted postcard (shown back and front) encouraged support for the Street Artists Program by local officials**

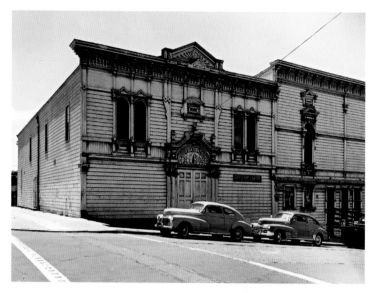

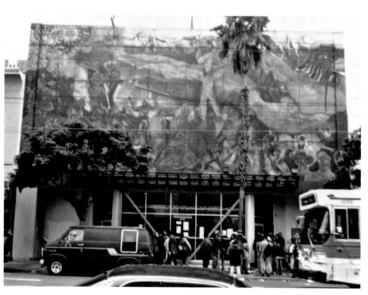

By 1977, the Art Commission had acquired four buildings and converted them into neighborhood art centers. CLOCKWISE FROM TOP LEFT: The South San Francisco Opera House (now the Bayview Opera House, Ruth Williams Memorial Theater); the South of Market Cultural Center (now SOMArts); the Mission Cultural Center (now the Mission Cultural Center for Latino Arts); and the Western Addition Cultural Center (now the African American Art & Culture Complex)

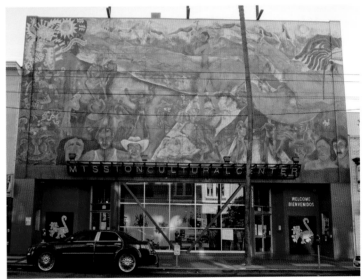

The city's cultural centers remain vibrant creative spaces in 2012. CLOCKWISE FROM TOP LEFT: The Bayview Opera House, Ruth Williams Memorial Theater on Third Street; SOMArts on Brannan Street; the Mission Cultural Center for Latino Arts on Mission Street near 24th Street; and the African American Art & Culture Complex on Fulton Street

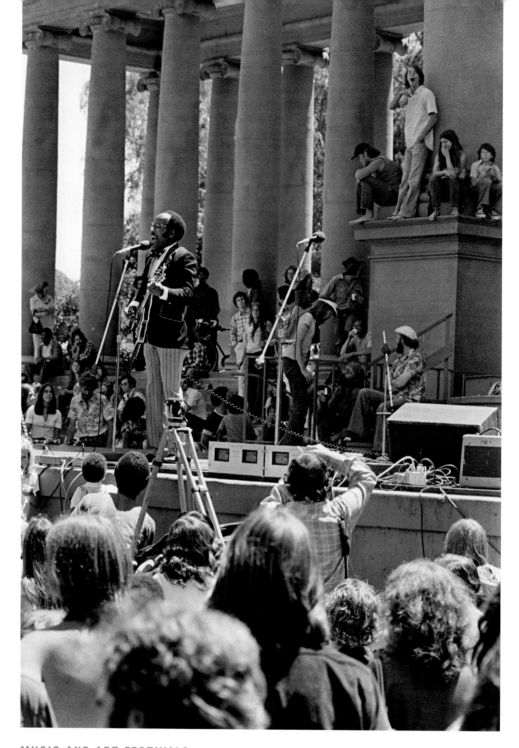

MUSIC AND ART FESTIVALS

While community-based art activities flourished in the 1970s, attendance was dwindling at the traditional Mid-Summer Pops concerts. Tastes were changing, and a new concert series, sponsored by the NAP, was energizing another group and generation of music lovers. In February 1973, thousands of San Franciscans crowded into the small basement space of the NAP Community Theater in the Western Addition for the first San Francisco Blues Festival, conceived and organized by blues evangelist Tom Mazzolini. In 1972, he had proposed a festival celebrating the powerful African American blues tradition in the Bay Area that emerged during World War II. Europeans knew about Bay Area blues, Mazzolini argued, but San Franciscans didn't, and he was on a mission to promote the music and educate the public. The NAP agreed to sponsor a free two-day festival featuring forty Bay Area blues performers and more than a dozen acts. "It was a smash,"

ABOVE: The second annual San Francisco Blues Festival, in 1974, was held in Golden Gate Park.

OPPOSITE, CLOCKWISE FROM TOP: San Francisco Blues Festival founder Tom Mazzolini (left) with rock concert impresario Bill Graham; a poster for the first Blues Festival in 1973; and a participant in the 1977 Arts Festival in Civic Center

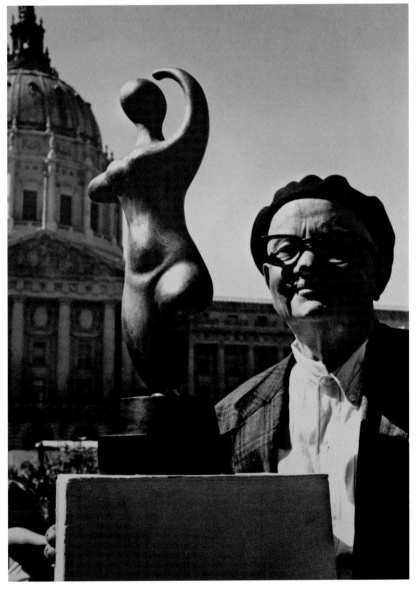

SAN FRANCISCO
BLUES FESTIVAL
Special Appearance: JOHNNY
FULLER!! SCHOOLBOY CLEVE,
LUTHER TUCKER, Mr. BOOGIE
DAVE ALEXANDER, HIGHTIDE
HARRIS BLUES BAND, JAMES
REED, GARY SMITH BLUES BAND,
LITTLE WILLIE LITTLEFIELD,
L.C. "GOOD ROCKIN" ROBINSON,
CHARLEY MUSSELWHITE, K.C,
DOUGLAS ＊＊＊＊ FREE at the
U.C. Extension (Haight-Buchanan)
2 PM Saturday·Sunday Feb.10·11

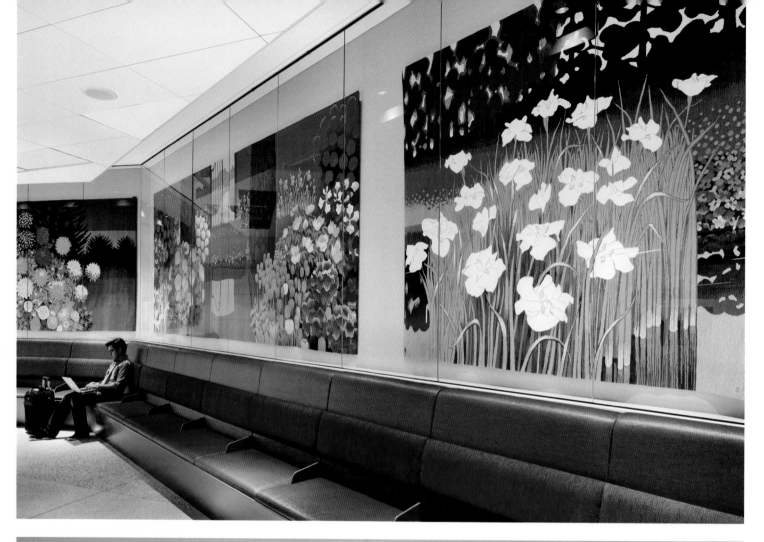

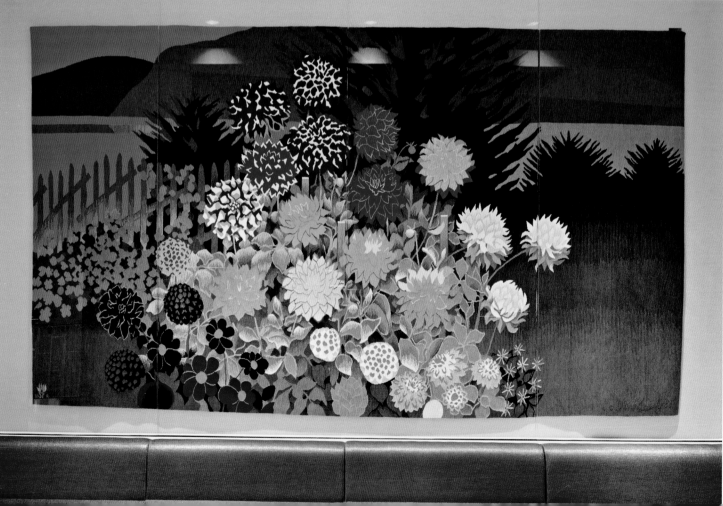

Mazzolini said. *Chronicle* jazz critic Jon Hendricks praised the show as "the greatest artistic and cultural event to hit this area since the first Monterey Jazz Festival."

The NAP's second Blues Festival, held the following year, drew nearly ten thousand fans to Golden Gate Park for two days of Southern, Chicago-style, country, eclectic, and funky blues. Mazzolini's annual gathering of blues legends and devoted fans went on to become the longest-running blues festival in U.S. history, increasing the appreciation and audience for a vital, varied, and enduring American art form.

The commission's Arts Festival, too, was attracting a record number of visitors in the mid-1970s. Director Elio Benvenuto—a European who appreciated vibrant street life—cultivated the tradition of large, outdoor public gatherings that had been part of San Francisco's identity since the 1960s. He brought a spirit of lively expression and spontaneous performance to what, by the event's twenty-fifth anniversary, was a booming art marketplace. The festival was ringing up yearly sales of more than $100,000, and purchase prize amounts were larger than ever. In 1977, several festival works that the Art Commission acquired formed the nucleus of a major new public art collection at San Francisco International Airport.

Since 1969, San Francisco's Art Enrichment Ordinance—a national model and one of the first of its kind—had mandated that 2 percent of the building cost of all municipal government structures be allocated for public art. The measure—proposed and championed by Ernest Born, an architect and artist and head of the Art Commission's Civic Design Committee—had funded collections in San Francisco General Hospital and other civic facilities. As required by the ordinance, the Art Commission provided curatorial and project management for those programs. By the late 1970s, with a new airport terminal under construction, the commission had a budget greater than $2.7 million—more than any other city in the country—to launch a permanent airport collection of paintings, sculptures, mosaics, and large-scale works, bringing art to the traveling public. Among the initial acquisitions—made in the early 1980s under the supervision of Henry Hopkins, director of the San Francisco Museum of Modern Art—were works by many leading local artists, including Wayne Thiebaud, Robert Bechtle, Jay DeFeo, Joan Brown, Manuel Neri, and William T. Wiley. Those works became the initial core of San Francisco's most valuable collection outside the city's art museums.

In the view of San Francisco's new mayor, George Moscone, who succeeded Alioto in 1976, art played an essential role in the city's vitality, increasing its attractiveness to visitors and its desirability as a place to live and work. An advocate for underserved groups in San Francisco, Moscone championed community arts and believed that the Neighborhoods Arts Program, in particular, was central to the welfare of the city. To make sure that the Art Commission reflected San Francisco's diverse communities, he appointed ten new members when he took office. Harold Zellerbach stepped down as president after twenty-eight years, and Ray Taliaferro succeeded him as head of the commission.

TOP: Construction of the first terminal at San Francisco International Airport (SFO) began in 1951.

ABOVE: Crowds gathered to celebrate the airport's opening in 1954. In the late 1970s, the Art Commission began providing curatorial and program management for a new permanent airport art collection.

OPPOSITE, TOP AND BOTTOM: *Garden Outside Gate* tapestries, 1983, by Mark Adams, in Terminal 2 at SFO

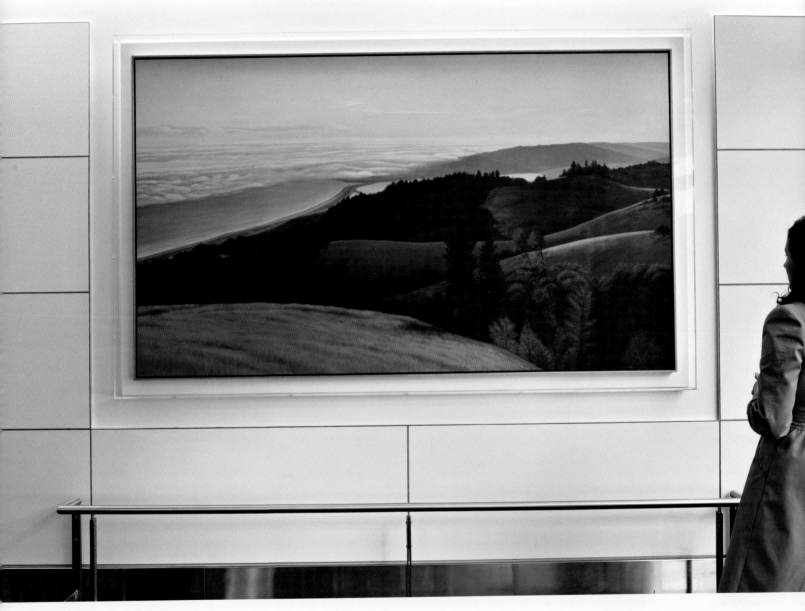

Acquisitions for the Airport Collection in the 1970s included (OPPOSITE, CLOCKWISE FROM TOP LEFT) *Homage to Zane Gray*, 1978, by Roy DeForest; *Figure*, 1943, recast 1973, by Isamu Noguchi; *18th Street Downgrade*, 1978, by Wayne Thiebaud; *The Great Transparents*, 1973, by Lee Mullican; *Journey #2*, 1976, by Joan Brown; and *San Francisco Nova*, 1979, by Robert Bechtle

THIS PAGE: *Above Bolinas*, 1979, by Willard Dixon

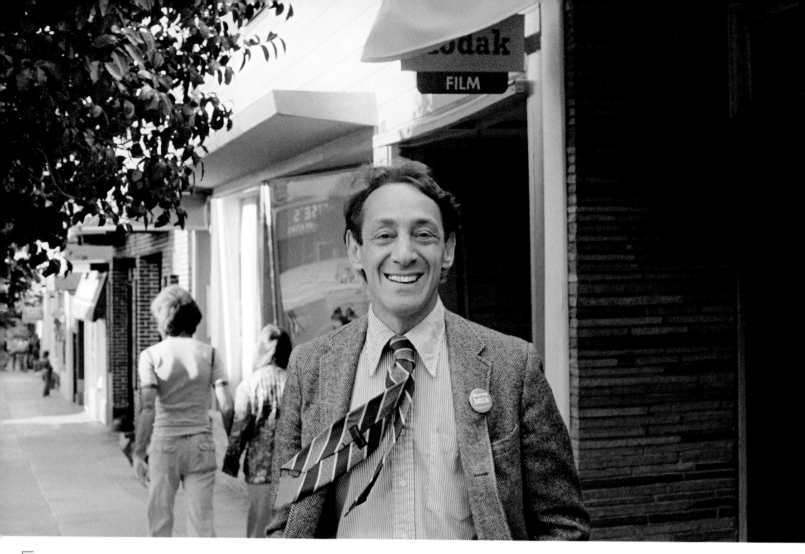

This photograph of Supervisor Harvey Milk, the city's first openly gay official, was the model for the 2008 bust by Daub, Firmin, and Hendrickson (see page 17) that stands in the Board of Supervisors Rotunda in City Hall. Milk and Mayor George Moscone were assassinated in November 1978.

A PAINFUL ERA

It was a tumultuous time. By 1977, CETA funds were shrinking, and economic strains were worsening in California. A combination of inflation, the 1973–1975 recession, and property reassessments caused the state's property taxes to rise so much that older, retired Californians could no longer afford to remain in homes they had bought years earlier. In June 1978, California voters launched a taxpayer revolt and approved Proposition 13, which slashed property taxes. The drastic cuts in local government revenues had a devastating impact on funding for the Art Commission. Taliaferro, according to Martin Snipper, spent his days "at the Commission, on the phone, and in the halls of City Hall—lobbying, buttonholing, cajoling, twisting arms, and promising the earth, moon, and sky, in order to achieve a sustaining budget." As a consequence of Prop 13 and diminished CETA funds, the NAP faced extensive layoffs and the termination of many programs, and community arts groups had to take more responsibility for their activities. San Francisco was still fertile ground for politically focused and multicultural art, but the trust that had developed between communities and the Art Commission frayed as city funding and support began disappearing. Feeling angry and abandoned, neighborhood protesters, led by Mission Cultural Center employees, picketed the Art Commission and occupied its offices. A few days later, a bomb threat forced the staff to evacuate the commission building.

Sharp budget cuts strained civic life, and more shocks were to come. On November 27, 1978, Mayor Moscone and Supervisor Harvey Milk, the city's first openly gay official, were assassinated in City Hall by Dan White, a former supervisor who had clashed with

both men during his board tenure. That day, while White was firing the gunshots that killed Moscone and Milk, the Art Commission was holding a meeting just steps away in City Hall. "We heard the screaming," Taliaferro said, and a staffer left the hearing room to find out what was going on. She came back in tears, with the news that someone had shot the mayor and a member of the Board of Supervisors. "She could barely say the words," Taliaferro recalled.

Dianne Feinstein, president of the Board of Supervisors, was sworn in as the city's new mayor. Pledging to continue Moscone's programs, she strove to restore a sense of stability and hope and reaffirmed the importance of art and culture to the city's future. Art, reflected Roger Boas, the city's chief administrative officer, could even be a healing agent in traumatic times. Budget cuts, however, were shrinking the city's arts programs—despite continuing support from Grants for the Arts—and Prop 13 eliminated all art teachers from public elementary and middle schools.

Although arts funding vanished from schools and communities, the city's major cultural institutions were aided by contributions from their patrons, and the controversial Performing Arts Center was under construction. The three-thousand-seat Davies Symphony Hall and the expansion of the War Memorial Opera House were funded by donors, in large part, but the city contributed $10 million to the projects, anticipating an economic boost from the new complex. The center was expected to bring more performances to San Francisco and restore the city's luster as the West Coast's cultural capital. Still, some neighborhood groups criticized the use of public funds to benefit a limited number of concert-goers while support for community arts programs was shrinking.

In September 1980, when Davies Symphony Hall opened, tensions ignited. Angry neighborhood activists planned to hold a demonstration on opening night. Alfonso Maciel, the NAP's new director, managed to defuse the crisis by brokering talks between the community arts groups, the Art Commission, and the Performing Arts Center administration. In late fall, however, the commission was still under fire for defunding neighborhood groups, and its own ability to function was soon disrupted. On November 25, just before midnight, a fire swept through the commission's headquarters at 165 Grove Street, collapsing portions of the second floor and destroying many offices and records. Prints, drawings, and paintings suffered damage, but a firewall kept the blaze from spreading to the art gallery next door. The staff was displaced to several temporary locations, and the building was ultimately demolished.

"It was a very difficult and emotional time for the commission and the arts community in San Francisco," recalled Joan Ellison, who had succeeded Snipper as commission director in 1980. For community art activists, the cuts in public support highlighted disparities in cultural funding. Art, Ray Taliaferro believed, was one of the strongest tools for resolving problems and bringing about "the kind of urban community this country has long hoped for." It was clear, however, that new models would have to be found to fund robust public, community arts in a time of cutbacks.

TOP AND ABOVE: As the city grieved the murders of Milk and Moscone, Dianne Feinstein, former president of the Board of Supervisors, became San Francisco's new mayor and worked to restore stability.

INAUGURAL WEEK
SEPTEMBER 16 - 21 1980
LOUISE M. DAVIES SYMPHONY HALL

Civic Center Plaza, San Francisco, California, 1985, by Henry Wessel

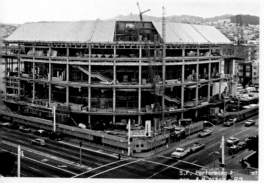

CLOCKWISE FROM TOP RIGHT:
Philanthropist Louise M. Davies and San Francisco Symphony conductor Edo de Waart during the construction of Davies Symphony Hall; *Large Four Piece Reclining Figure*, 1973, by Henry Moore, in front of Davies Symphony Hall on Van Ness Avenue at Grove Street; the symphony hall nearing completion in 1980; and an announcement of the symphony hall's opening celebration

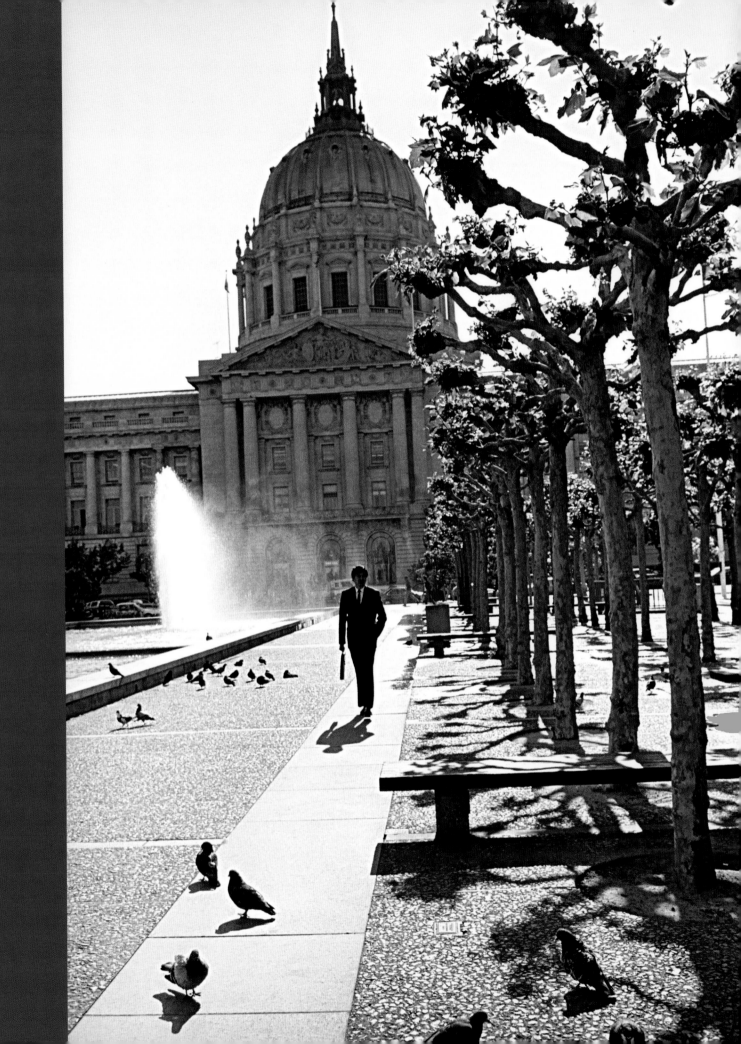

CHAPTER FOUR

1981

1992

AFTERSHOCKS. *Hard times hit San Francisco's arts community in the 1980s. Jolting cutbacks forced city art programs to reevaluate and restructure in a time of conflicts, political controversy, and competition. The Neighborhood Arts Program quickly felt the effects. In 1981, the federal government stopped funding the CETA arts program, and the NAP lost 75 percent of its staff.*

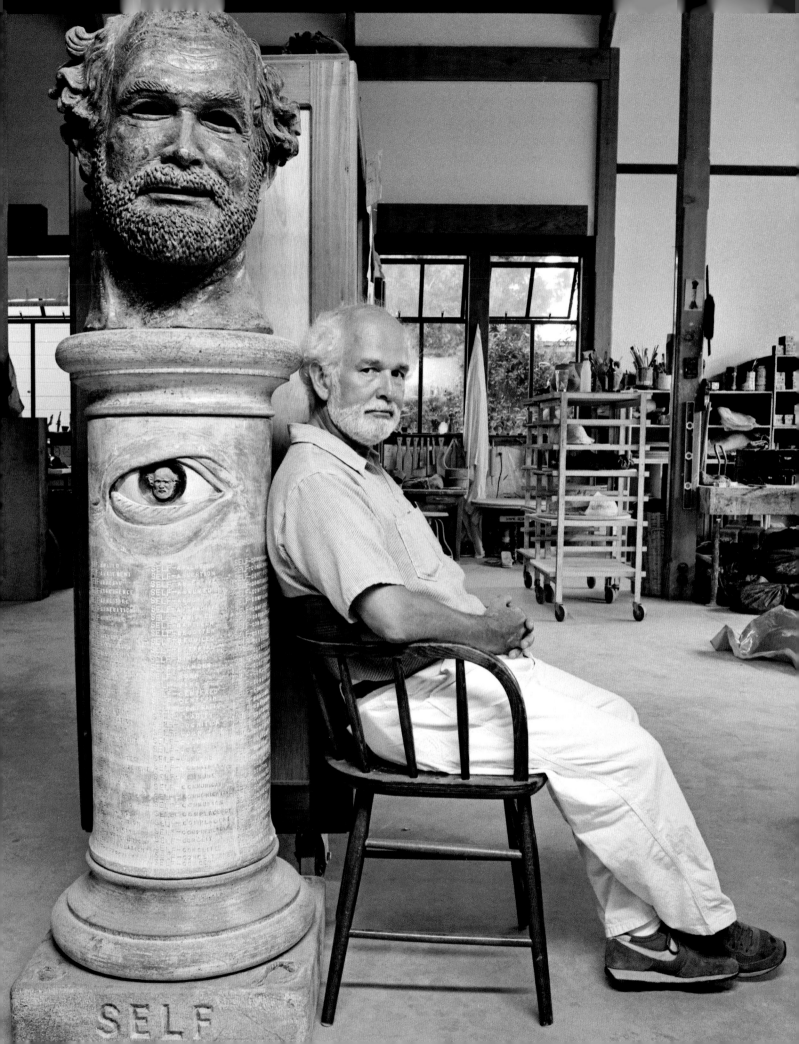

SELF

'04

Starved of financial resources, the Art Commission soon made the city-owned neighborhood cultural centers responsible for their own programming, funding, and staffing as independent nonprofit

organizations, governed by community boards. Suddenly on their own, with staff that had no training, the centers competed for resources and increasingly clashed with the commission. Because the facilities were owned by the City of San Francisco, they also had to be brought up to code through extensive renovations supervised by the Neighborhood Arts Program. By the late 1980s, NAP employees were spending much of their time and energy on repairs instead of cultural programming, and the centers were battling the commission over red tape and construction delays. The NAP, its director warned, was "under tremendous strain," with inadequate financial and staff resources to meet its responsibilities.

The lack of stability in programs and funding led the commission to reflect on its mission as an advocate for public art in municipal government. In 1984, the agency changed its name to the Arts Commission, reflecting its commitment to all forms of creative expression. As director Claire Isaacs noted that year, the agency was asking searching questions about its role, given its expanding involvement in communities and program sponsorship and the varied expectations of San Franciscans.

NEW PUBLIC ART

Those expectations occasionally collided head-on in high-profile debates over public art. Across the country, government-funded art was a hot topic. Contemporary sculpture, paintings, and other works—funded by federal, state, and local governments—adorned and transformed public spaces from coast to coast. The new public art bore little resemblance to traditional monuments and statuary in the public square. Contemporary pieces were often innovative, conceptual, and provocative, expressing artistic visions that inspired but also confounded, and even infuriated, members of the public.

In San Francisco, a furor erupted in 1981 over a sculpture commemorating late mayor George Moscone. After inviting twenty artists to compete, civic leaders had

selected sculptor Robert Arneson to create a memorial sculpture, which would be unveiled at the opening of the new Moscone Convention Center. Two weeks before the December event, an art commissioner had viewed and approved the work, declaring it "magnificent." When the ceramic sculpture was installed, however, viewers were stunned to see that Arneson had placed the bust atop a four-foot column covered with gory references to Moscone's murder, including bloodstains, bullet holes, the imprint of a gun, the name of his assassin, and the words "Bang. Bang. Bang."

The commission asked Arneson to remove the offensive text and imagery from the column or replace it with a plain, unadorned pedestal. When he refused, the agency voted seven to three to reject the work. Supporters of the sculpture charged censorship, arguing that it was a powerful piece of public commentary. It "struck a nerve," one commissioner noted, "and that's exactly what art is all about." The piece was soon removed from the convention center, and Arneson was asked to return his advance payment. Weeks later, the sculpture was exhibited at the San Francisco Museum of Modern Art. A Grant Avenue gallery owner later purchased the work, which is now in the collection of SFMOMA. The fiasco, the *San Francisco Chronicle* declared, put San Francisco "in the world-class league" of public art controversies. Arneson, for his part, gloomily predicted that in the future only sanitized municipal art—"large jewelry," as he called it—would be able to win public approval.

Three years later, in November 1984, another battle broke out over public art—this time focusing on a stark Holocaust memorial by sculptor George Segal. Commissioned and paid for by Mayor Dianne Feinstein's Committee for a Memorial to the Six Million Victims of the Holocaust, the artwork was a life-size tableau of white-patinated bronze figures standing and lying behind a barbed wire fence. Months before the sculpture was installed in Lincoln Park, near the Palace of the Legion of Honor, the Arts Commission received angry mailings of anti-Semitic literature. Four days after the installation,

OPPOSITE: *Portrait of George*, 1981, by Robert Arneson

ABOVE: After the sculpture was installed at Moscone Center, its controversial pedestal was covered with draping.

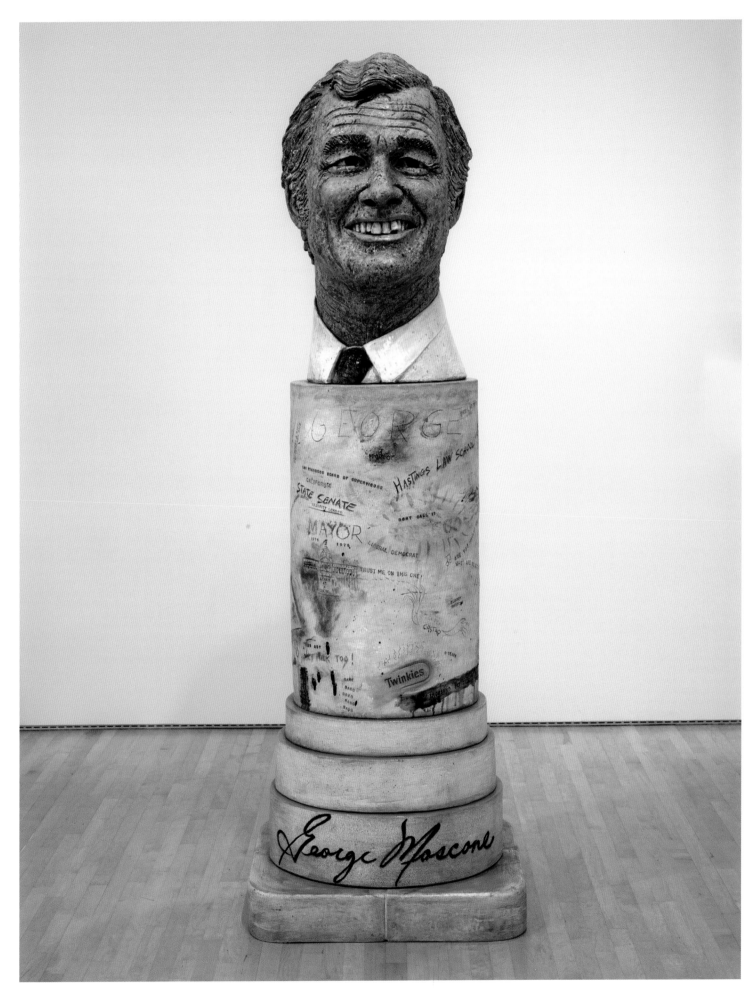

Northern Vista, George Moscone Site, San Francisco, CA, 1980, by Catherine Wagner

ABOVE: *Greenhouse Project*, 1990, by Ned Kahn, at the San Francisco County Jail in San Bruno

OPPOSITE, TOP AND BOTTOM: *The Holocaust*, 1982, by George Segal, near the Palace of the Legion of Honor in Lincoln Park; Holocaust survivors left flowers on the artwork after vandals had spray-painted the memorial four days after its installation.

vandals spray-painted the bronze memorial with yellow and black paint, graffitied the words "Is This Necessary" on a wall behind it, and left a note reading, in German, "Forgive and Forget." The city organized police patrols to protect the memorial, while crews struggled to clean and restore the damaged artwork. The desecration of the sculpture, condemned by all, did not mute intense critical debate over the piece. Originally, the memorial was supposed to have been placed directly across from the entrance to the Legion of Honor. That plan provoked an outcry, so it was moved to a grove of trees on a nearby slope adjacent to the road and parking lot. Still, there was controversy over the work's social realism, its appropriateness as a memorial, and its setting in the majestic beauty of Lincoln Park. For Segal, a sculptor who had worked on private commissions for more than twenty-five years, the challenge of creating art in a public setting raised questions about what kind of work was possible under those conditions.

Other public art projects sparked no resistance. In 1989, for example, Ned Kahn was commissioned to create a work, funded by the Art Enrichment Ordinance, for the new San Francisco County Jail in San Bruno. Frustrated with the idea of creating art as an ornament for the facility, Kahn found inspiration instead in the jail's garden program, which rewarded inmates for good behavior by allowing them to work outside weeding, planting, and picking organic produce. In order for the program to grow its own seedlings and enable more inmates to participate, the garden project needed a greenhouse, and Kahn proposed to create one as a work of art. The artist, known for his work with mist and fog, incorporated those elements to provide moisture for the seedlings and used color-shifting dichroic glass to make the structure distinctive. The greenhouse—essentially a conceptual work of art made of glass, steel, bricks, and mortar—was the commission's first completed project with a social justice purpose.

The Public Art Program, however, soon faced more controversy. In 1991, a debate erupted over a huge piece of conceptual art proposed for the Moscone Convention Center. The Arts Commission had chosen a team of three Los Angeles artists to create a dramatic sculptural piece that would beautify the area, welcome visitors, and visually connect the north and south parts of the center. The artists proposed a series of thirty-foot-high structures that would span Howard Street and use the vernacular design of freeway signs

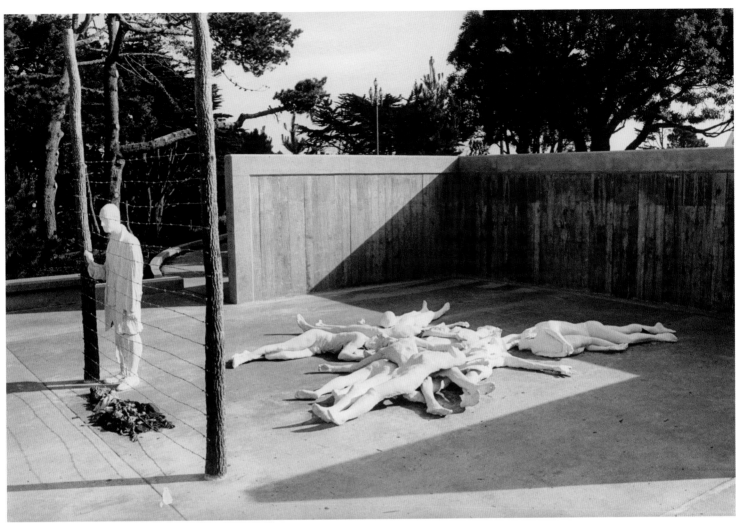

RIGHT: In the 1980s and '90s, the San Francisco Arts Commission Gallery (formerly Capricorn Asunder) showcased compelling, often provocative contemporary art, including *What's Wrong with This Picture?* The exhibition invited Bay Area artists to respond directly to the issue of arts censorship, which was being spearheaded by U.S. Senator Jesse Helms.

OPPOSITE, CLOCKWISE FROM TOP LEFT: In 1989, protesters gathered in front of the Arts Commission Gallery; a poster for the *What's Wrong with This Picture?* exhibition; *Staged Garden*, a 1986–1987 installation by Anna Murch in the gallery's outdoor exhibition space; an announcement for the gallery's *Liquid Eyeliner* show, organized to coincide with the sixth annual International AIDS Conference and the SF Pride Parade in 1990; *Madonna*, 1989, by Billie Grace Lynn, in the *Tableau Vivant* exhibition; attendees at the *Liquid Eyeliner* opening.

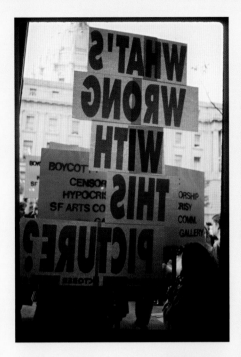

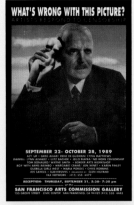

to proclaim "This is a Nice Neighborhood" in English, Spanish, and Chinese. The plan set off a dispute over the work's $500,000 cost and its appropriateness for the city. Supporters saw it as a dynamic enhancement of the streetscape. Critics, however, complained that it would make the area look like Las Vegas, that it was designed for drive-by viewing in automobiles, and that its message was banal, even arrogant. Some saw the message as a sarcastic reference to the former character of the neighborhood, where single-residence occupancy hotels—the only affordable housing in the low-income area—had been destroyed to make room for the convention center. In response, the Arts Commission asked the artists to make the project less expensive and more appealing to pedestrians. It ultimately canceled the project after protracted criticism. Balancing artistic choices with public sentiment was a difficult task, and new definitions of public art raised thorny questions. "Whose taste will prevail," the *Chronicle* asked, "that of the artists and art experts, or that of the politicians? Should an artist create differently for the public than for humanity? If public money pays for art, should the public call the tune?"

Art created with public funds pushed established limits, expressing artistic visions that reflected new aesthetic, ethnic, economic, gender, sexual, and political fault lines.

Those questions were being debated nationally in the 1980s and 1990s. Art created with public funds pushed established limits, expressing artistic visions that reflected new aesthetic, ethnic, economic, gender, sexual, and political fault lines. People of color, gays, and other marginalized groups, more and more, were finding empowerment in artistic expression, and San Francisco, for decades, had been fertile ground for their explorations. Feminist arts groups—including the long-standing Wallflower Order as well as the Dance Brigade and Women's Caucus for the Arts—probed issues including reproductive rights, lesbianism, and sexual abuse. Women artists of color established organizations, such as the Asian American Women's Art Association and the Medea Project, that examined race and feminism. Gay, lesbian, and transgender artists played a visionary role, and well-established San Francisco performance groups, such as the Cockettes and Angels of Light, emerged from the underground drag scene.

Many of these issues of identity and empowerment were publicly addressed in art exhibitions across the city. They were also explored in the forum of the newly renamed San Francisco Arts Commission Gallery, formerly Capricorn Asunder. In 1983, three years after it closed due to the fire in the commission offices, the agency's visual art space reopened as a center for compelling, often challenging contemporary art. Under the direction of John McCarron, who was succeeded by Anne Meissner, the gallery presented shows that dealt with issues of identity politics, censorship, the body, and the AIDS epidemic. Among its notable exhibitions was *Tableaux Vivant*, which addressed representations of the body, biotechnology, AIDS, and nuclear threats. Another show,



What's Wrong with This Picture?, invited Bay Area artists to respond directly to the subject of artistic censorship, while *Liquid Eyeliner* probed gender in the context of drag culture. McCarron formed a new advisory board that helped attract private funding to support the gallery's innovative vision. Audiences were enthusiastic, attendance rose to an all-time high, and the gallery became a popular public hub for new forms of artistic expression in a contentious time.

ABOVE: **Nina Fichter and Krissy Keefer of the Wallflower Order feminist dance company**

What I really want is a real home with with
nice furniture, also a van to drive. I also would
like to give my son what I didn't get in life.
Which includes love.

Sharon D. Butts

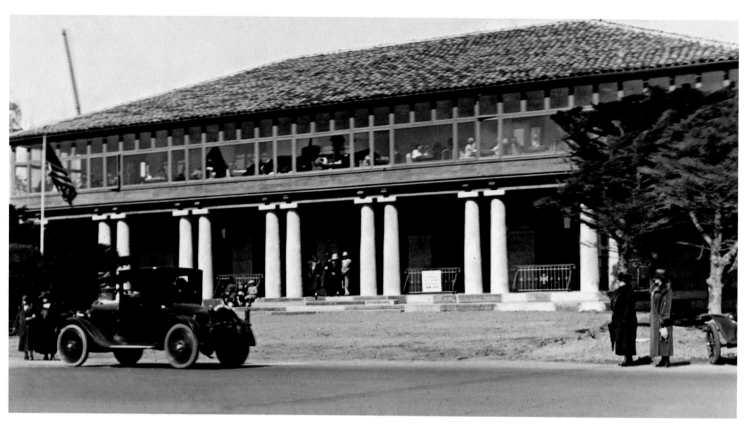

PRESERVING THE PAST

The Arts Commission was also devoting serious attention to the city's public art collection. The holdings, accumulated over many decades, included monuments, WPA and PWAP art, art enrichment projects, and works purchased from the annual arts festivals. In 1984, despite serious financial constraints, the Arts Commission included in its budget, for the first time, funding for a new city-collection registrar who would bring the neglected records and inventory up to date. Under the registrar's guidance, the commission turned its attention to conservation. The city's outdoor monuments were a top priority, especially deteriorating bronzes. By 1989, some two-thirds of the monuments had been cleaned and repatinated with funds from the National Endowment for the Arts and contributions from community and business groups.

The commission also began restoring many of the murals created by WPA and PWAP artists during the Depression. In the mid-1980s, the city funded the restoration of 1,500 square feet of frescoes in the Beach Chalet, a national monument at the ocean end of Golden Gate Park. Built in 1925, the building, designed by Willis Polk, originally featured a bar and restaurant and seaside changing facilities. In 1936, the WPA had commissioned Coit Tower muralist Lucien Labaudt to cover the first-floor walls with vividly colored scenes of leisure activities on the Embarcadero, Fisherman's Wharf, Baker Beach, Golden Gate Park, Lands End, the Marina, and Chinatown. By the 1980s, the Beach Chalet

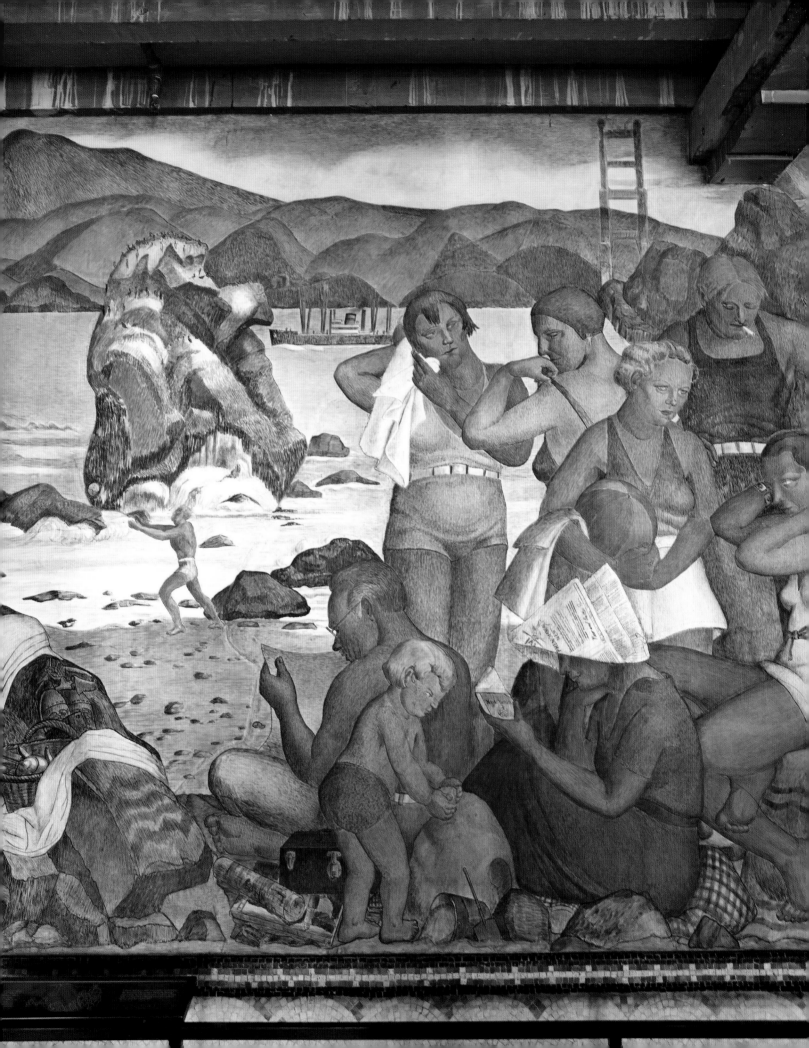

In 1971, Ant Farm, an avant-garde performance collective, created inflatable structures in a live/work space occupied by Project Artaud, a pioneering arts complex in the Mission District.

had been locked for years, and Labaudt's frescoes were badly damaged. In 1985, the city appropriated funds to restore the murals. Encouraged by Commissioner Jo Hanson, Labaudt's widow also donated hundreds of the artist's paintings and drawings to the Civic Art Collection. Two years later, San Francisco began restoring the lobby murals in Coit Tower, which had been defaced by vandalism, accidental damage, and fog seeping through the walls of the leaky tower. The work, performed by a team of nationally renowned conservators and funded by a National Endowment for the Arts grant, was completed in 1990.

SUPPORTING MUNICIPAL ART PROGRAMS

While preserving the past, the Arts Commission turned to active fundraising and corporate sponsorships to sustain current programs in a time of harsh budget cuts. In 1981, the American Express Company donated $2 to the agency for every new credit card it issued in the Bay Area, as well as five cents each time a Bay Area purchase was charged to an American Express card. The three-month promotion netted $100,000 for the Arts Commission, and the agency subsequently established funding partnerships with companies such as Chevron USA, Security Pacific Bank, and Transamerica.

In 1982, the commission's president, art patron Roselyne C. Swig, recognized that the agency needed to reach out to the community to raise funds. That year, the commission established a nonprofit group, Friends of the Arts, to solicit outside gifts. It was also applying for funds from the Grants for the Arts program to support the cultural centers and other neighborhood arts activities. By the end of the decade, many staff members had essentially become fundraisers, procuring corporate and in-kind donations, volunteer services, and grants from state and national organizations.

Meanwhile, a growing concern was the migration of artists from San Francisco. Artists had long settled in the city's less pricey areas, including North Beach and South of Market, attracted by low rents and large studio spaces. The presence of artists, in turn, increased the desirability of those neighborhoods, resulting in rent hikes and studio shortages. By the 1980s, development was raising rental and real estate prices in neighborhoods that had once been affordable, and many artists began leaving the city for cheaper enclaves such as Emeryville, Oakland, and Benicia.

Worried that artists might become an endangered species in San Francisco—crowded out by trendy office buildings and design showrooms—the Arts Commission persuaded the city to undertake a study of their housing needs. Based on the report's findings, the commission teamed with California Lawyers for the Arts to create ArtHouse, a clearinghouse for information about artists' studio and live/work space. The commission also worked with other city agencies to craft model legislation and administrative guidelines for urban live/work housing, increasing the economic sustainability of the arts community in San Francisco.

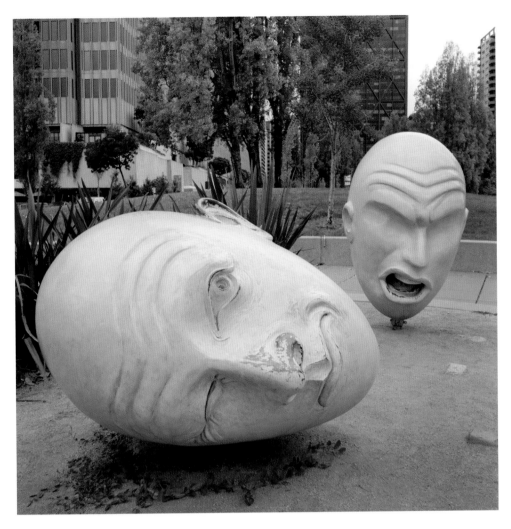

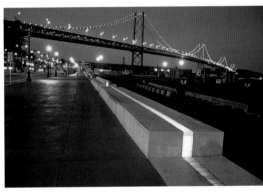

ARTQUAKE

Stability, however, was out of reach at the end of the decade. On October 17, 1989, Bay Area residents were shaken by a 7.1-magnitude earthquake that destroyed hundreds of buildings, buckled the Central Freeway, and collapsed part of the Bay Bridge. Sixty-three people lost their lives in the temblor, and damage in San Francisco alone amounted to $2 billion.

Most of the city's public art inventory survived intact, but the San Francisco International Airport and its art collection suffered serious damage. Two sculptures by Robert Irwin, a pioneer in the use of light and space, were a total loss. Paintings by Sam Francis and William T. Wiley were slashed and stained. Other works—including a suspended fiber piece by Nance O'Banion, a painting by Robert Ramirez, and a mural by Edith Hamlin—were torn or disfigured.

In the months after the earthquake, many cultural groups in the city struggled to survive because of lost performance spaces and diminished box office revenues. A year after the disaster, moreover, as some groups were starting to recover, they found themselves on shaky ground again after the collapse of a major multicultural event that the *Chronicle* dubbed "The Artquake of 1990."

The event, Festival 2000, was planned as a two-week celebration of cultural diversity in the arts. Conceived by the Arts Commission and the Grants for the Arts program, it was a response to pressure for greater public funding of multicultural, women's, lesbian/gay, and other underserved arts communities. Racial minorities were now a collective

CLOCKWISE FROM LEFT: *Ying Yang*, 1992, by Robert Arneson, in Justin Herman Plaza; demolition of the Embarcadero Freeway in 1991; and *Promenade Ribbon*, 1995, by Vito Acconci, Stanley Saitowitz, and Barbara Satuffacher Solomon, a two-mile-long linear sculpture on the Embarcadero that synthesizes art and infrastructure

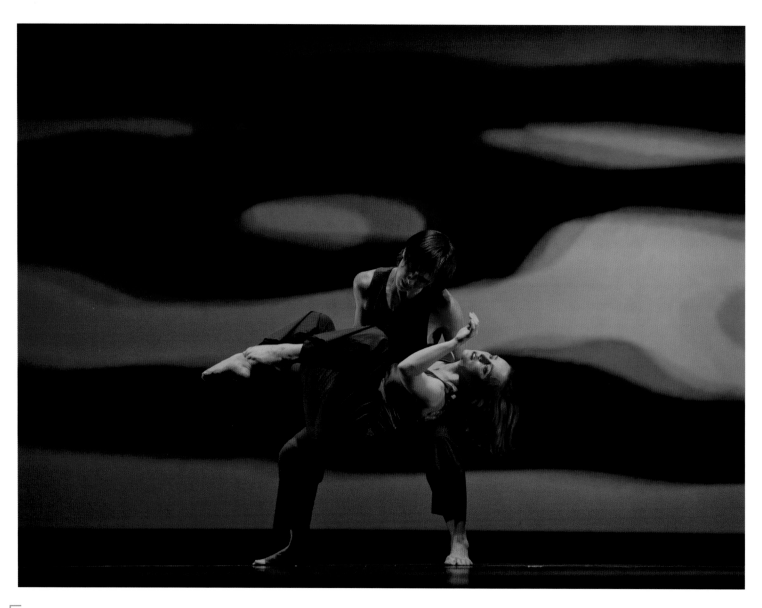

In 2011, Margaret Jenkins Dance Company performed *Light Moves* at the Novellus Theater at Yerba Buena Center for the Arts.

demographic majority in San Francisco, but multicultural arts groups received only 5.1 percent of municipal arts funds. More than 80 percent of those funds went to major arts institutions, including the symphony, ballet, and opera.

By the time it opened in early October 1990, Festival 2000 had been expanded into a three-week extravaganza featuring a thousand artists at thirty venues around the city. Two weeks later, on October 17, 1990—a year to the day after the earthquake—Festival 2000 announced a huge deficit, and the bankrupt event shut down that week. Although most participants received at least 75 percent of their promised funding, its collapse threatened fragile multicultural arts groups. The failure also exposed major rifts in the city's arts community and its public funding process, forcing the Board of Supervisors to address the political and cultural emergency head-on.

The failure also exposed major rifts in the city's arts community and its public funding process, forcing the Board of Supervisors to address the political and cultural emergency head-on.

Within eight months, the board had appointed a Cultural Affairs Task Force to prevent future funding debacles. It was the biggest advisory group in the city's history. As supervisors worked to foster an inclusive process, the task force swelled from twenty-seven to fifty-nine members representing all the competing, antagonistic sectors of the city's art scene. Arts Commission Director Joanne Chow Winship served on a small subcommittee charged with hammering out an agreement for the larger group. After more than a year of difficult negotiations, the task force voted unanimously to recommend the creation of a new Cultural Equity Endowment Fund—the first of its kind in the country—to support historically underserved arts communities in San Francisco. The fund, administered by the Arts Commission, would provide grants from the Hotel Tax Fund to individual artists and small and midsize arts groups. By 1995, the Cultural Equity Endowment Fund was expected to total around $1.5 million—more than double the funding previously allocated to multicultural, disabled, gay and lesbian, and other long-underserved arts organizations in San Francisco.

Signed into law by Mayor Frank Jordan in January 1993, the Cultural Equity Endowment Fund was a hard-fought political solution to the problem of public arts financing in a diverse urban arts ecosystem. The challenge going forward, Winship observed, was to start bridging the rifts that had fractured the city's arts community. "At some point," she remarked, "there's got to be some trust. How do we go about building that?" San Francisco, she reflected, had "all the ingredients" to make that happen. "If not here," she said, "it's not going to happen anywhere."

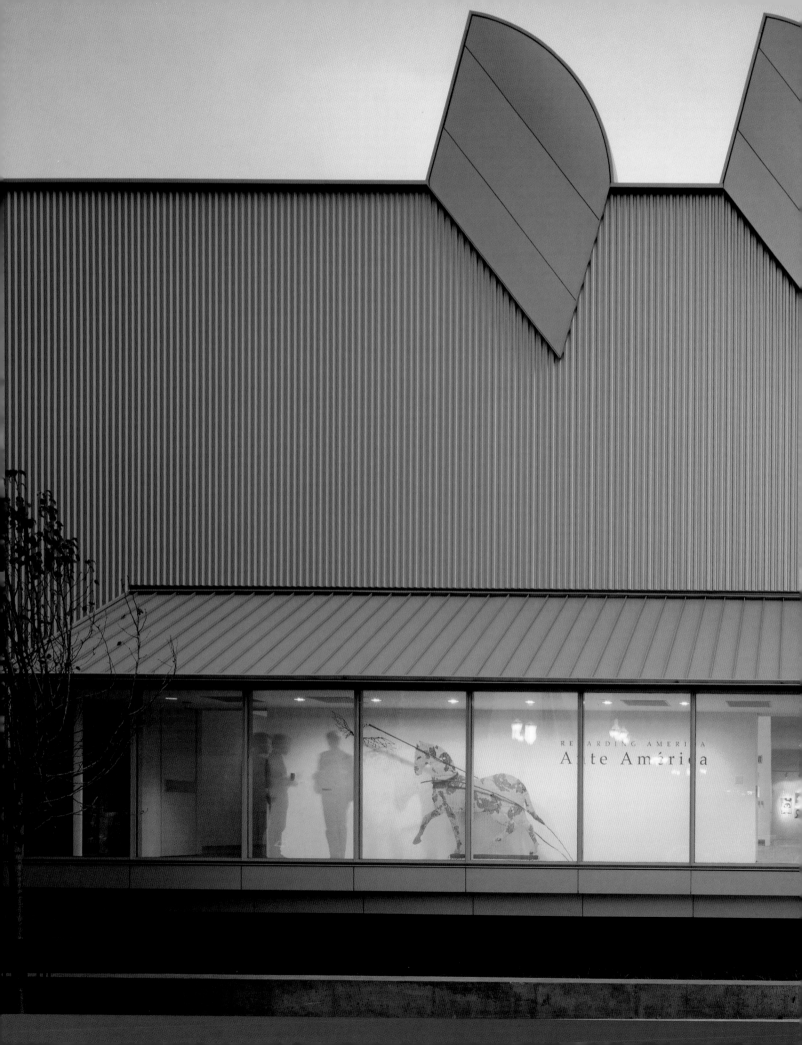

Yerba Buena Center for the Arts, San Francisco,
1993, by Richard Barnes

CHAPTER FIVE

1993

2005

THE POWER OF THE PUBLIC.

By the mid-1990s, the arts were flourishing again in San Francisco, thanks to the rich diversity of its arts community and dramatic new cultural spaces. In 1993, after decades of community negotiations, Yerba Buena Center for the Arts opened south of Market.

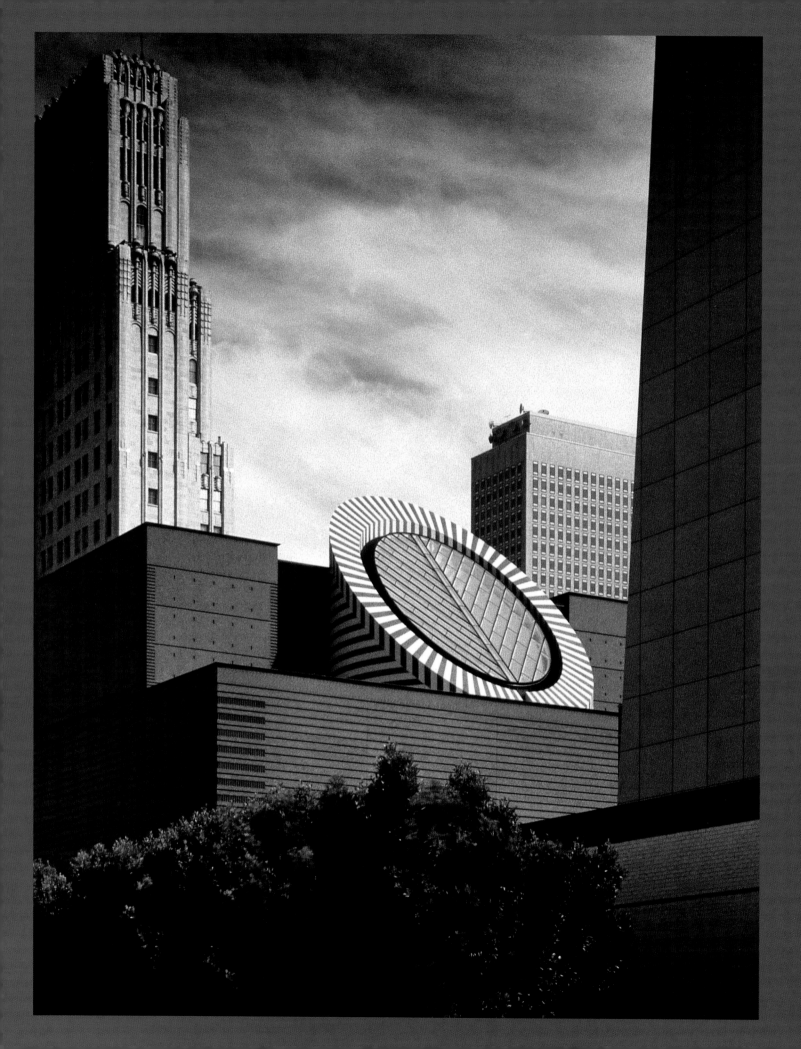

'05

Dedicated to showcasing experimental and multi-cultural art, the center contained a theater and gallery. Overlooking five acres of green, open space, it was a creative oasis in a dense urban setting.

The center was soon flanked, in 1995, by a bold cultural landmark, the new San Francisco Museum of Modern Art. The museum had outgrown its space in the War Memorial Veterans Building in the Civic Center, and its new building—designed by Swiss architect Mario Botta—instantly became an emblem of the vitality of the arts in San Francisco. Other major cultural projects were planned or under way—including a new Jewish Museum, Mexican Museum, and Main Library; renovations of the Palace of the Legion of Honor and M. H. de Young Memorial Museum; and a relocated and expanded Asian Art Museum. The changes signaled a cultural resurgence and renewed civic commitment to the arts.

In 1994, the San Francisco Arts Commission Gallery moved to the first floor of the War Memorial Veterans Building, after the city determined that its building on Grove Street was seismically unsafe. At Mayor Willie Brown's request, the new gallery director, Rupert Jenkins, also began organizing exhibitions for the ground floor of the newly restored City Hall. Shows in the gallery's multiple venues—including installations in the window of the Grove Street building and adjacent empty lot—broadly represented San Francisco's arts communities. In 1997, *Switchstance*, for example, showcased art from the city's surf and skate subcultures, and in 1998, *When Borders Migrate*—guest curated by Rebecca Solnit—invited artists to respond to anti-immigration legislation and notions of California as a frontier.

ABOVE: **A poster for the 2001 Butoh Festival**

HIGH-PERFORMING ARTS

Nurtured by the Cultural Equity Endowment Fund and a booming economy, long-established and new city arts groups were thriving in the late 1990s. In ensemble theaters, visual art, spoken word, dance groups, and world and new music, city artists were blending innovative and traditional forms and exploring boundaries between

CLOCKWISE FROM TOP LEFT: *Easy Speak* by Margaret Kilgallen, part of a 1996 exhibition at the San Francisco Arts Commission Gallery; Kilgallen's cover design for *What It Took for Me to Get Here*, a 1999 anthology of poetry and prose by WritersCorps participants in San Francisco; Jason Jägel's *Listening by the C-Side* and Clare Rojas's *Red Dress Lady in Living Room* in the 2009 SFAC Gallery exhibition *Trace Elements*

OPPOSITE: In 2009, Barry McGee created an original rubber stamp design for *Passport*, the SFAC Gallery's annual DIY art collecting event.

cultures and disciplines. The Japanese Butoh Festival, for example, presented the edgy, avant-garde Japanese dance form that originated after World War II. The city's Black Choreography Festival explored the African and African American dance experience in traditional and emerging forms. "Mission School" artists—inspired by graffiti, murals, and the street culture of the Mission District—created whimsical urban artworks using found materials, spray painting, and other nontraditional media. Transgender artists of color, prison and disability arts groups, and other art subcultures were coalescing into new communities. "It was a period of incredible hybridity, diversity, and socially committed art," said San San Wong, former director of the Cultural Equity Grants program.

Neighborhood art, too, was benefiting from increased city support. In 1996, the Board of Supervisors passed a legislative line-item measure allocating a portion of the annual Hotel Tax Fund for programming, operations, and maintenance of the city's four neighborhood cultural centers. The Arts Commission's Community Arts and Education program—formerly Neighborhood Arts—assisted the cultural centers, helped artists obtain live/work space, and supported arts programs for seniors, people with HIV, and the city's homeless, disabled, and low-income residents.

It was also sponsoring WritersCorps, an innovative program that funded professional writers to work with at-risk youth, ages six to twenty-one, on creative writing projects in the community. In 1994, San Francisco was chosen as one of three launch sites in the country for the program, originally a pilot project of AmeriCorps in partnership with the National Endowment for the Arts. In 1997, WritersCorps, no longer funded by the federal government, became a project of the Arts Commission, with support from other municipal departments. By 1998, more than four hundred city youths had taken part in poetry, playwriting, and other literary workshops in youth centers and schools, competed in poetry slams, and contributed to published literary anthologies.

"Mission School" artists—inspired by graffiti, murals, and the street culture of the Mission District, created whimsical urban artworks using found materials, spray painting, and other nontraditional media.

CLOCKWISE FROM TOP LEFT: A poster for photography classes at the Kearny Street Workshop in Chinatown; the Beijing Trio—with Jon Jang on piano, Jiebing Chen on erhu, and Max Roach on drums—played at Herbst Theater in 2000; Rhodessa Jones, co-artistic director of Cultural Odyssey and founder of its Medea Project, a performance workshop for incarcerated women; and a 2006 Medea Project production, *My Life in the Concrete Jungle*, at the Lorraine Hansberry Theatre, which was funded by a Cultural Equity Grant

⌐ ABOVE: In 1996, WritersCorps student Joel Hernandez read at a White House event marking the release of the Youth at Risk Report by the President's Committee on the Arts and Humanities, chaired by First Lady Hillary Rodham Clinton.

LEFT: Artist Willie Harris works on a painting in the visual arts studio of San Francisco's National Institute for Art and Disabilities.

RESTORING PUBLIC HISTORY

Community involvement also increased during the 1990s in efforts to restore city monuments damaged by the elements and time. One project—the repair of San Francisco's oldest monument, historic Lotta's Fountain—drew broad civic support. The cast-iron landmark had been given to the city in 1875 by Charlotte Mignon (Lotta) Crabtree, a popular, cigar-smoking Gold Rush entertainer who was famous for dancing on empty barrels in local saloons. Lotta's Fountain, at the intersection of Geary, Kearny, and Market streets, was a downtown hub, a meeting place for survivors of the 1906 earthquake, and the site where the disaster has been commemorated every April 18. In 1998, when the municipal monument was badly corroded and clogged with sludge, the city began a high-profile restoration of the fountain with support from the San Francisco Lesbian, Gay, Bisexual, Transgender Pride Celebration Committee; California Federal Bank; and the Office of the Mayor.

> *The cast-iron landmark had been given to the city in 1875 by Charlotte Mignon (Lotta) Crabtree, a popular, cigar-smoking Gold Rush actress and entertainer who was famous in San Francisco for dancing on empty barrels in local saloons.*

Not all projects, however, inspired public consensus and cooperation. In 1991, a furor erupted over the city's plan to relocate an 1894 landmark, the Pioneer Monument, which commemorated the founding of California. The artwork featured life-size statues of a friar and a Spanish vaquero looming triumphantly over a Native American seated submissively on the ground. Preservationists objected to the relocation, and others wanted the monument destroyed because it celebrated, as Martina O'Dea of the American Indian Movement explained, "the humiliation, degradation, genocide, and sorrow inflicted upon this country's indigenous people by a foreign invader, through religious persecution and ethnic prejudice." Before the artwork was moved to its new Civic Center location in 1993, enraged protesters pelted it with rocks and splattered it with red paint. Five years later, after intensive consultations with members of local Native American tribes, the Spanish consul general, the San Francisco archbishop, and city officials, the Arts Commission installed an explanatory plaque on the base of the sculpture that provided historical context for the monument.

Another flashpoint, in 1997, was the fate of fourteen city-owned murals in the old Main Library, which was being converted into the new home of the Asian Art Museum. The oil-on-canvas paintings of seascapes and hills had been created in 1931 and 1932 by Swiss-born artist Gottardo Piazzoni, a noted Bay Area painter of the period. San Francisco preservationists, backed by prominent conservation organizations, wanted the murals to remain in the building, where they complemented the beaux arts architecture. Asian Art Museum Director Emily Sano agreed that the frescoes had to be preserved, but argued

ABOVE: **The Pioneer Monument, created by Frank H. Happersberger, was dedicated to the city in 1894.**

OPPOSITE: **The restored Lotta's Fountain at the intersection of Market, Kearny, and Geary streets**

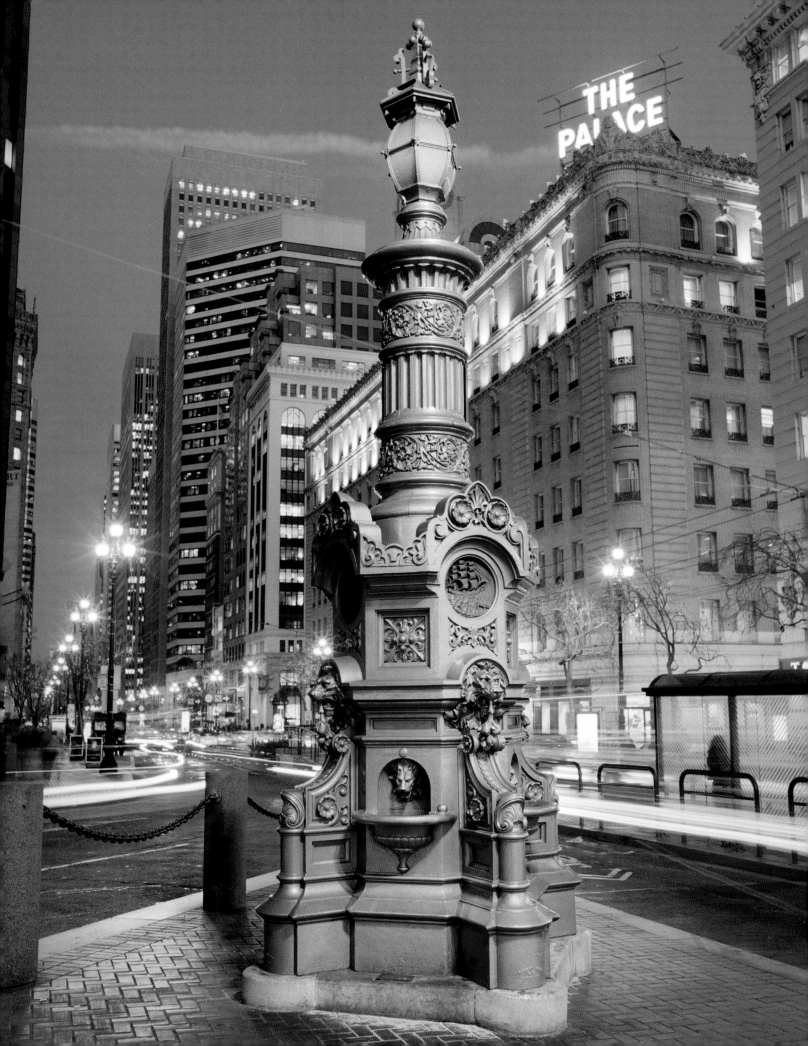

*The San Francisco Public Library as It Is
Transformed into the Asian Art Museum*, 2000,
by Susan Schwartzenberg

Functional and Fantasy Stair and Cyclone Fragment, 1996, by Alice Aycock, in the San Francisco Main Library

Gottardo Piazzoni created sets of mural panels, *The Sea* and *The Land*, in 1931 and 1932 for the loggia surrounding the old Main Library's marble staircase (ABOVE). In 1999, when the library was being converted into the Asian Art Museum, 10 restored panels were transferred to the M. H. de Young Memorial Museum in Golden Gate Park (TOP OF PAGE).

that they were inappropriate for the Asian Art Museum, which had jurisdiction over the paintings. "Cultural sensitivity," Sano insisted, "requires that Asian art be shown from an Asian point of view, not displayed in the context of American and European art." The fight over the murals divided the San Francisco arts community over issues of art, architecture, politics, and multiculturalism. It was finally resolved when the paintings were carefully removed and ten restored panels were transferred to and permanently installed in the new de Young Memorial Museum in Golden Gate Park.

POWER AND PUBLIC ART

As cultural groups battled over art legacies from the past, San Francisco's new art in the public sphere, at the end of the twentieth century, was forward-looking and experimental. In 1998, the Arts Commission Galleries drew thousands of artists, performers, and residents to a neo-primitive experience—the ritual lighting of a fifty-foot-high Burning Man totem in the Civic Center and *The Art of Burning Man: An Incendiary Exhibition*. In 1986, the original wooden Burning Man—the symbol of the annual festival, now held in Nevada's Black Rock Desert—had been erected on San Francisco's Baker Beach by the event's founders, including Larry Harvey and Jerry James. They had set the structure ablaze on the summer solstice as an impulsive act of "radical self-expression," according to Harvey. At the commission's outdoor gallery exhibition space, the effigy's neon red and purple outlines were symbolically lit, accompanied by drums, dancing, a street fair, and a display of photographs and art installations from the Black Rock festival.

Temporary site-specific public art was also on display, from the Embarcadero to the Castro, as part of the commission's Market Street Art in Transit Program. Established by Jill Manton, then director of the commission's Public Art Program, it was a laboratory for artists who were new to working in the public realm. The projects—including poster exhibitions, sculptures in public plazas, and dance performances on the facades of civic buildings—explored the relationship of art to street life, transit, and local businesses on the three-mile-long Market Street corridor. The commission's goal, according to President

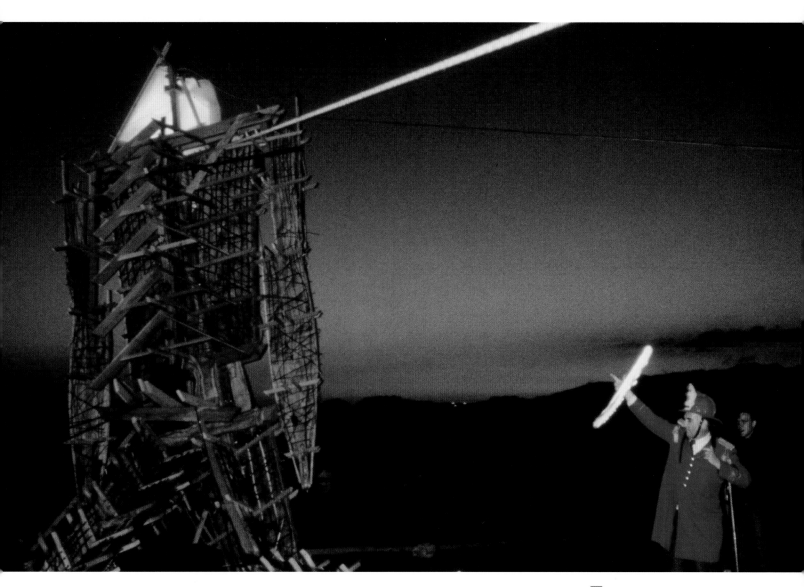

In 1989, the Burning Man structure was ritually ignited on San Francisco's Baker Beach. The next year, the annual event was moved to Nevada's Black Rock Desert.

Stanlee Gatti, was to bring more public art to the city landscape and for San Francisco "to be a little more brave" and to "get out there on the edge." As Director of Cultural Affairs Richard Newirth admitted, however, nothing was ever easy in San Francisco, where engaged activist communities were ready to confront and challenge the authority of city government.

In 1997, those power struggles came to a head over a monumental permanent sculpture proposed for the Embarcadero. The artwork, which had won a national competition two years earlier, was an eighteen-foot-high stainless steel sculpture of a foot that seemed to be emerging from San Francisco Bay. Titled *Embark*, the work by Seattle artist Buster Simpson, when installed, would rhythmically emit pulsating lights from its hollow interior. Gatti described it as a "cutting-edge" piece, and Newirth predicted it would be "a new marker for the city, a new landmark," but critics condemned it as inappropriate, overly literal, or bizarre. Thousands of residents contacted city officials to complain about the proposed sculpture, which the Board of Supervisors—as commissioners of the county Transportation Authority—had to approve. In 1999, they decided to reject the work. *Chronicle* columnist Ken Garcia bluntly expressed the public's frustration with municipal "plop art," which was installed without adequate consultation and consideration. As a result of the controversy, the Arts Commission redoubled its efforts to engage residents and win early community support for civic art projects at the proposal stage, through greater access to information and opportunities for comment.

The Market Street Art in Transit Program
(OPPOSITE, FAR RIGHT) showcased temporary
site-specific public art, from kiosk poster
exhibitions to dance performances and
sculpture. Works included (RIGHT) *On Time*,
1993, by Maria Porges; a poster in the
Underdog Agency series, 1996, by Joanna
Poethig (TOP); and a performance of *The Blue
Family* (ABOVE), by Keith Hennessy and K.
Ruby Blume, in Justin Herman Plaza in 1995.

SAN FRANCISCO: ARTS FOR THE CITY

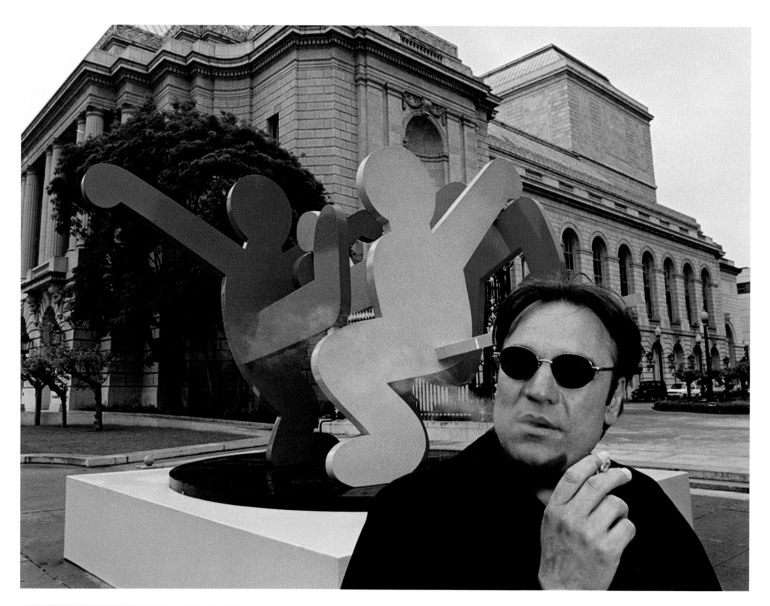

The commission also took a more systematic approach to public art planning. One of its oldest programs, Civic Design Review, changed its submission requirements to ensure that public art was considered part of the architectural design, not an add-on or a competing element, and integrated into capital projects from the beginning. As a result, in the late 1990s, conceptual artist Lewis deSoto thoughtfully integrated commissioned artwork into the design of a new jury assembly room in the Civic Center Courthouse. DeSoto's goal was to give the waiting room the same level of importance as the building's courtrooms to convey respect for citizens who were performing their civic duty. After consulting with the architects and municipal court judges, deSoto created eight panels of sandblasted glass, some of them depicting sections of the U.S. Constitution and Bill of Rights. Others showed the empty room in which the constitution was signed and that same room filled with people. The identities of individuals had been removed so that potential jurors could see their own reflections in the glass and imagine themselves participating in a great legal tradition. "Public art has a job to do," explained Susan Pontious, director of the commission's Public Art Program and the Civic Art Collection. "At its best, it engages the community and evokes meaning as part of a greater project."

Between 1993 and 2004, San Francisco had added fifty-seven permanent public artworks to its collection. Seventeen contemporary, permanent installations were commissioned for the new International Terminal at the San Francisco International Airport,

which opened in 2000. The works, funded by the city's Art Enrichment Ordinance, included mosaics, sculptures, and large-scale lighting installations that created distinctive environments throughout the $840 million facility.

City residents were increasingly favoring artworks that remained in public spaces for short periods of time. As curator Gary Garrels of the San Francisco Museum of Modern Art observed, "When you're doing things on a temporary basis, people tend to be more open. When you say something is going to be there 'forever,' suddenly the stakes go way up."

In 1998, the Arts Commission sponsored a popular five-month exhibit of ten monumental outdoor sculptures by the late Keith Haring. The playful, brightly colored works were displayed at public sites throughout the city. The response was so positive that the city purchased one of the works, *Untitled (Three Dancing Figures)*, and installed it permanently on the corner of Third and Howard streets at the Moscone Center. Another popular temporary installation was a wooden "civic temple" conceived by Burning Man artist David Best, well known for his giant installations at the desert festival. In 2005, Best erected a structure made of recycled plywood in a Hayes Valley park, where it served for three months as an altar and place of reflection for the community. "We absolutely love it," commented the head of the neighborhood association, and some residents hoped it would remain there permanently.

> *"When you're doing things on a temporary basis, people tend to be more open. When you say something is going to be there 'forever,' suddenly the stakes go way up."*

BOOM AND BUST

In the 1990s, San Francisco had been the hub of a surging technology industry. For artists, the flush economy was a mixed blessing. Private and corporate arts funding was high, but as dot-com companies snapped up affordable space, rents and real estate prices skyrocketed south of Market. Arts groups were priced out of living, studio, rehearsal, and performance spaces, and the soaring costs threatened the city's ability to keep a vibrant creative community. In October 2000, to provide relief, the Board of Supervisors approved $1.5 million in rent subsidies for nonprofit arts groups, to be administered by the Arts Commission and California Lawyers for the Arts. Still, Mayor Willie Brown acknowledged that the fund did "not begin to scratch the surface" of what he called a crisis for the arts in San Francisco.

Like many other communities in the city, artists responded by organizing politically. Arts activists canvassed, campaigned, and staged dozens of rallies and protests against high-tech development and in support of Proposition L, a slow-growth measure. Although the proposition lost narrowly on the November ballot, the arts community helped defeat several supervisors who backed development and elect new members to the board who favored pro-art, slow-growth policies. As arts activist Kevin Arnold asserted, "Politicians

New commissioned works for the San Francisco Airport Collection included (CLOCKWISE FROM ABOVE) *Salty Peanuts*, 2002, by Mildred Howard; *Gateway*, 2000, by Ik-Joong Kang; *Thinking of Balmy Alley*, 1999, by Rigo 23; *Take Off*, 2008, by Hung Liu; *Bird Technology*, 1999, by Rupert Garcia; *Wind Portal*, 2002, by Ned Kahn; and *Four Sculptural Light Reflectors*, 2000, by James Carpenter.

ABOVE: *Sea Change*, 1995, by Mark di Suvero, on the Embarcadero at Pier 40, in South Beach Park

OPPOSITE: *Temple*, 2005, by David Best, a temporary installation on Patricia's Green in Hayes Valley

now realize they can't write off the arts community as being apathetic or apolitical. We're not on the sidelines anymore... we need to be reckoned with."

Within months, however, San Francisco's economy nose-dived. High-tech firms began shutting their doors and declaring bankruptcy. The terrorist attacks of September 11, 2001, accelerated the downturn. Arts audiences dwindled, along with tourist revenues, government funding, and donations from corporations and foundations. For nonprofit arts groups that were fragile in normal times, the new economic environment was "very scary," according to Carolina Ponce de León of Galería de la Raza. The combination of the dot-com collapse and the climate of fear following 9/11, she said, forced the Galería, like many community organizations, to reduce programming substantially.

San Francisco, by 2004, was facing what its new mayor, Gavin Newsom, described as "the most severe budget crisis in our history." As an austerity measure, the mayor proposed merging the city's two primary arts funding agencies, the Arts Commission and Grants for the Arts. The move would supposedly save the city money, but the arts community protested the plan, fearing that it would destabilize and politicize arts funding. For more than forty years, Grants for the Arts had provided reliable operating support for hundreds of small, midsize, and large cultural organizations. The Arts Commission, especially through its Cultural Equity Grants, provided critical funds to nurture emerging artists and small-to-midsize groups in communities that were historically underserved. Through their different, complementary missions, the agencies provided a web of support, and arts groups strongly opposed the change.

Newsom, in response, tabled the plan and agreed that a task force should review the city's organizational structure, revenue sources, programming, and priorities for the arts. The twenty arts professionals named as members of the new municipal arts task force—actors, dancers, writers, musicians, painters, curators, foundation officers, and arts agency officials—concluded, after a year's work, that the city was underfunding and underutilizing its arts resources. New initiatives, however, were unlikely in a city grappling with huge budget deficits. Complicating matters were seductive technologies that presented new challenges for the arts community. In the emerging digital age, wrote the *Chronicle*'s Steve Winn, when audiences "have compelling reasons to stay home—to get lost in the virtual space of their Xbox instead of an art museum, to sort out the politics of *The West Wing* instead of a G. B. Shaw play," the city's artists faced scarce resources and a fast-changing, unpredictable future.

CHAPTER FIVE: THE POWER OF THE PUBLIC

Henry Chong Rice Company, Chinatown, San
Francisco, 1979, by Reagan Louie

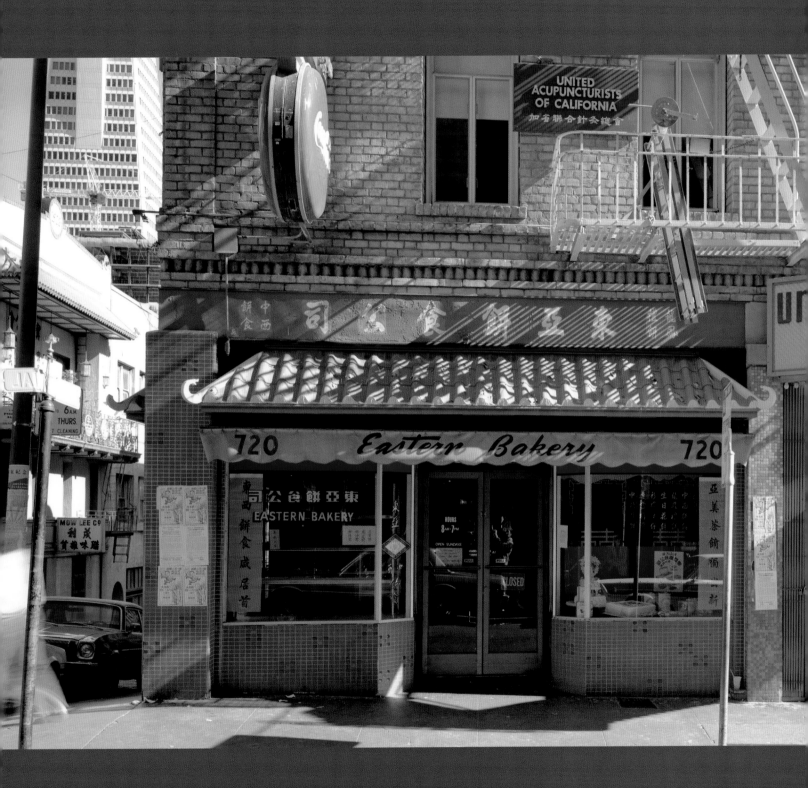

Eastern Bakery, Chinatown, San Francisco, 1979,
by Reagan Louie

Grizzly Peak at Claremont, 2011, by John Chiara

2006

CHAPTER SIX

2012

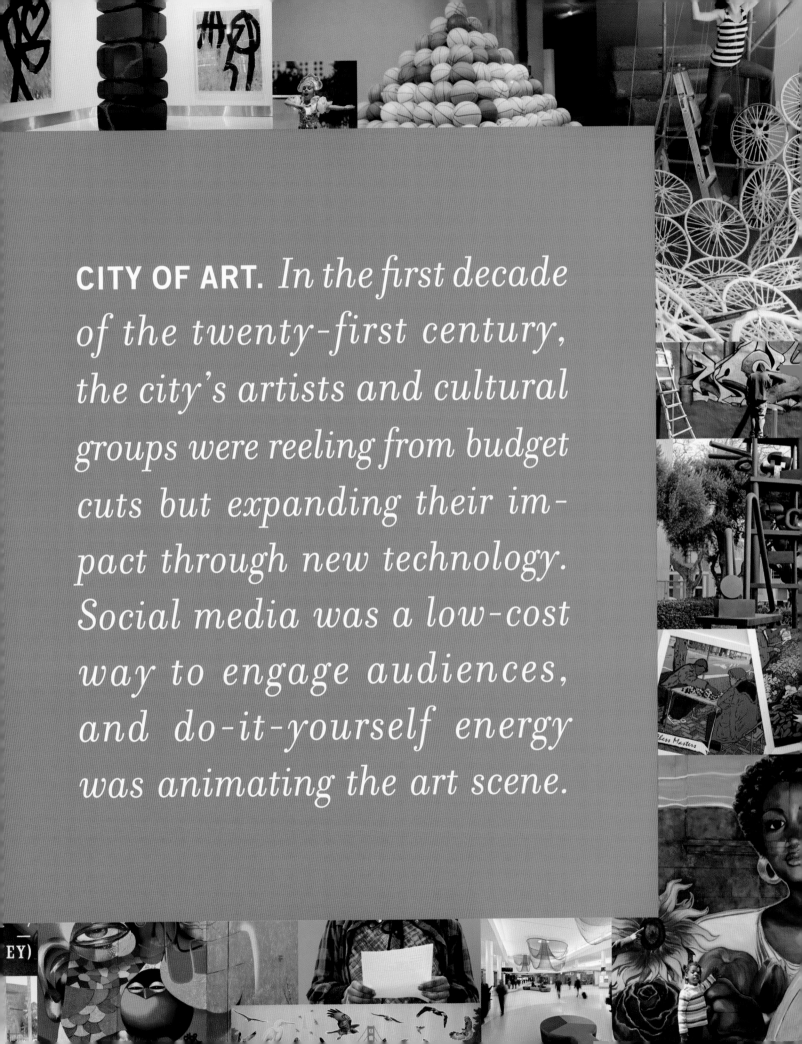

CITY OF ART. *In the first decade of the twenty-first century, the city's artists and cultural groups were reeling from budget cuts but expanding their impact through new technology. Social media was a low-cost way to engage audiences, and do-it-yourself energy was animating the art scene.*

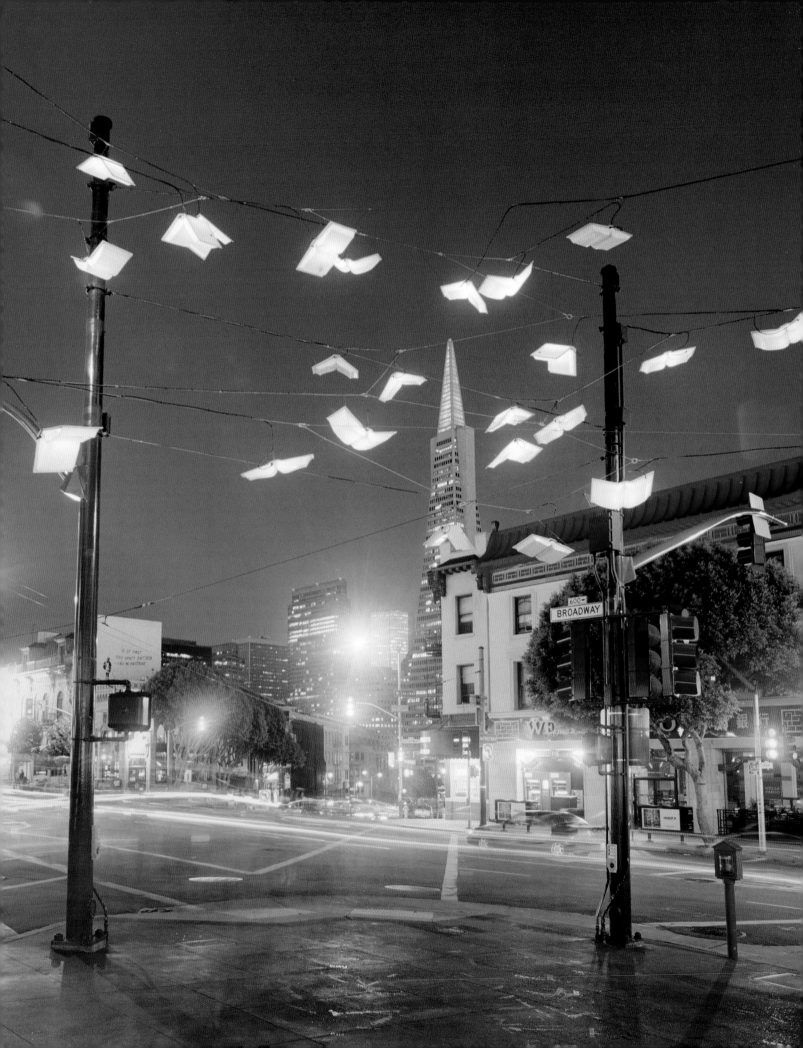

'06

In an era of digital culture and global consciousness, artists were pushing the boundaries between art, audience, activism, cultural traditions, and creative disciplines.

Pop-up galleries and site-specific art were spontaneously engaging viewers. Groups such as the Center for Asian American Media were exploring new forms of digital storytelling that delved into social issues. Others, like the Bay Area Video Coalition, were bringing together futurists, technologists, and international groups to design global art projects targeting social change. Musical artists were blending ancient cultural genres with jazz, folk, hip-hop, and blues elements. After the 2008 economic collapse, artists and arts groups such as Southern Exposure and the Bayview Hunters Point Center for Arts and Technology helped city residents prepare for the digital workforce through technology and skill-building workshops.

In 2010, the San Francisco Arts Commission teamed with artists, the city's Office of Economic and Workforce Development (OEWD), and community-based groups to use art as a catalyst for urban revitalization. Their joint project, Art in Storefronts, commissioned local artists to create temporary installations in empty store windows in communities hard-hit by the recession. On Market Street and in the Mission District, Tenderloin, Bayview–Hunters Point, and Chinatown neighborhoods, artists transformed empty spaces that had once evoked decline and despair into showcases for their talent, centers of attraction, and sources of community pride.

A second, larger renewal initiative, the ARTery Project, sought to redefine the blighted stretch of Market between Fifth and Ninth streets as an urban arts destination. The program built on the neighborhood's landmark architecture, transit, and existing cultural activities. Its goal was to create a vibrant commercial corridor for the Tenderloin and South of Market neighborhoods. In 2010, the National Endowment for the Arts awarded the project a $250,000 grant. That funding was more than matched by $1 million in community contributions and support from the OEWD. New cultural groups, including People in Plazas, joined longtime arts organizations—such as the luggage store gallery

BELOW: Guillermo Gómez-Peña founded Pocha Nostra, an organization that has received numerous Cultural Equity Grants for its performances, experimental art, lectures, writing, and teaching programs.

and the Central City Hospitality House's community arts program—to activate blocks with boarded-up storefronts and tap the neighborhood's creativity. With art as the foundation of change, the area was soon energized by live performance art, temporary installations, outdoor dance classes, food trucks, and a weekly art market in UN Plaza. Artists and arts groups also invested in local communities through informal partnerships with non-arts neighborhood organizations. In 2006, the Arts Commission's Cultural Equity Grants program launched Arts & Communities: Innovative Partnerships to support collaborations that engaged neighborhoods and residents in artistic expression.

Art making was also an economic lifeline for artists and craftspeople who would otherwise have been unemployed during the downturn. Between 2008 and 2011, the Arts Commission's Street Artists Licensing Program, launched in 1972, saw a 25 percent surge in enrollment. "If you can create something with your hands," explained longtime director Howard Lazar, "the doors of this program are wide open." The cost of a street artist's license, he noted, was "essentially the daily price of a cup of coffee."

EDUCATION AND CONSERVATION

The city's public schools had long benefited from arts education programs sponsored by the symphony, ballet, opera, and nonprofit arts providers. In 2004, voters expanded the city's commitment to arts education when they passed Proposition H. The measure authorized a ten-year revenue stream to support art and music in the public schools, as well as sports, libraries, and preschool programming. Two years later, the city completed its Arts Education Master Plan. Spearheaded by the San Francisco Arts Commission's

Around the city, street-level art projects promoted community pride and economic development. CLOCKWISE FROM TOP LEFT: *Valiant Flowers*, 2010, and *Dandelion*, 2010, by Karen Cusolito at UN Plaza on Market Street; *Greetings from Central Market*, 2011, by Vicky Knoop and Beatrice Thomas, at 989 Market Street; *The Crystal Bike Blanket*, 2011, by Alexis Arnold, at 1106 Market Street; and *Fight for the Neighborhood*, 2009, by Chris Treggiari and Billy Mitchell, at 104 Taylor Street

OPPOSITE, AND FOLLOWING PAGE:
Central Market Dreamscape, 2011, by Paz de la Calzada, at 1127 Market Street

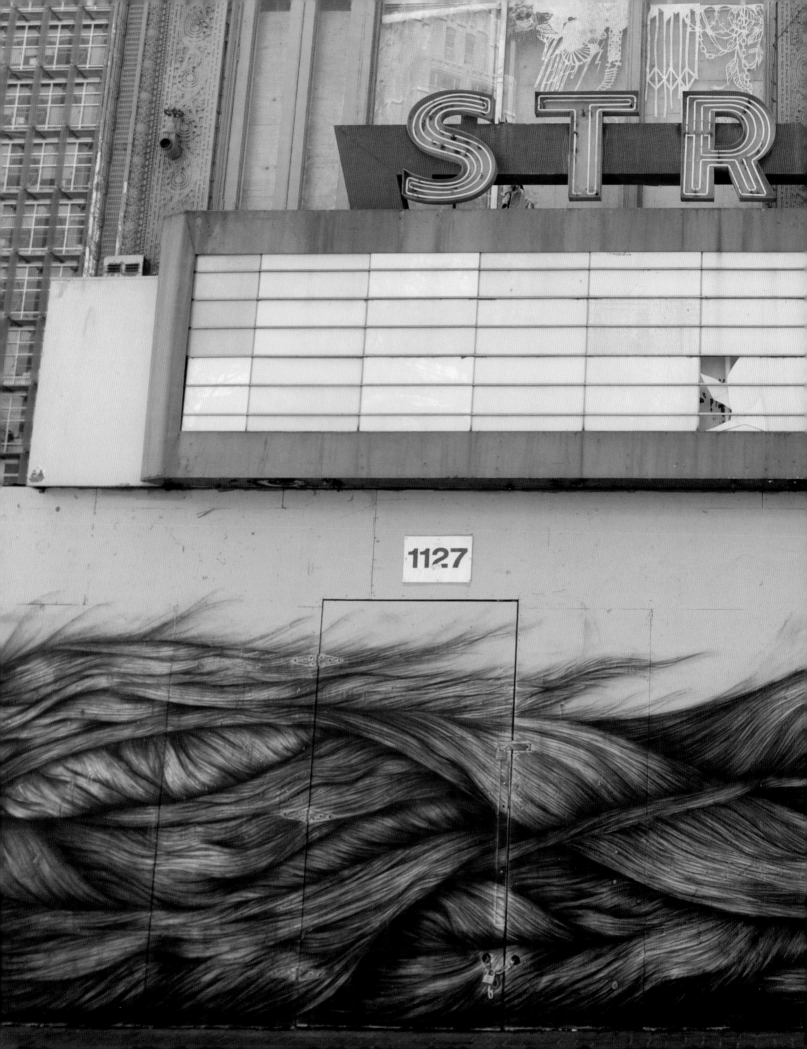

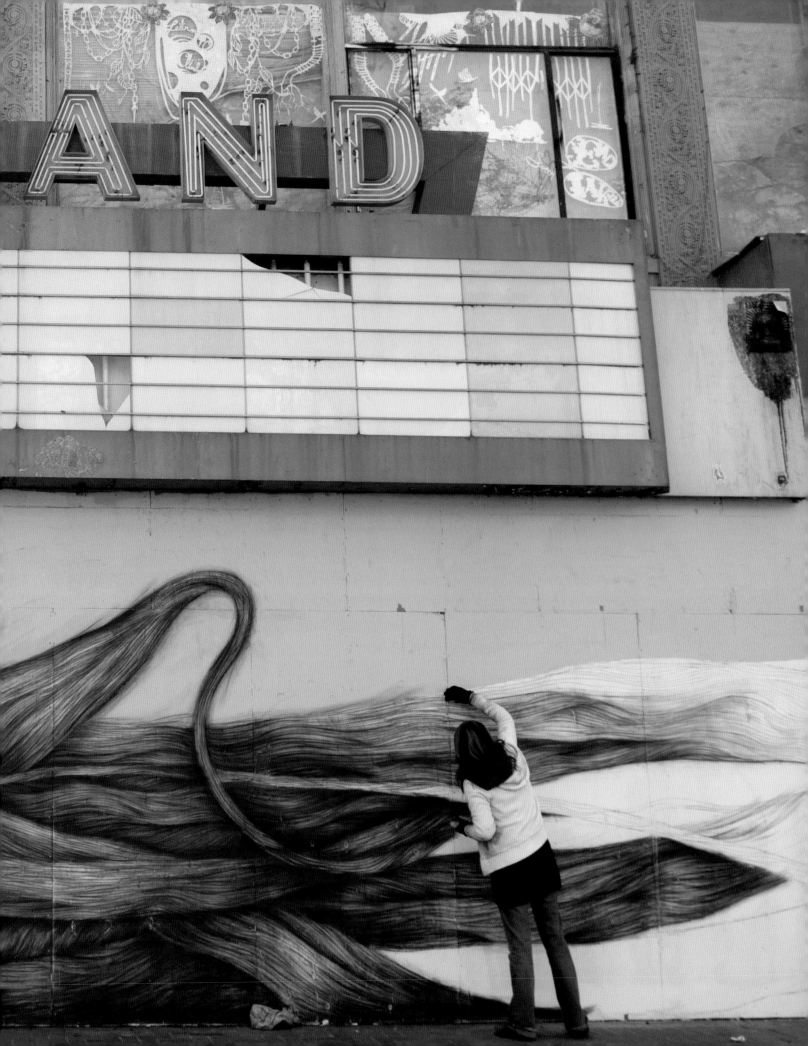

CLOCKWISE FROM TOP LEFT: **The San Francisco Street Artists Program (with Director Howard Lazar, left, and former commission president and program founder Ray Taliaferro) celebrated its 40th anniversary in 2012; street artist Vivena Cuyugan; the artisan marketplace on Market Street, in front of the Ferry Building; and street artists Tad Sky and Sam Culkin**

Community Arts and Education Program—in partnership with the San Francisco Unified School District (SFUSD) and community stakeholders—it was a blueprint for integrating the arts into every student's daily curriculum. The school district now had a clear outline for a full program of arts education, including weekly instruction in music, drama, dance, and visual arts and regular classroom visits by teaching artists.

Through the Arts Commission's WritersCorps program, local literary artists were teaching creative writing to marginalized young people in schools, public housing, juvenile hall, and community programs. WritersCorp, funded by the city, the NEA, and private philanthropy, trained and supported the teaching literary artists, who served three-year residencies and developed long-term mentoring relationships with students. Since the program began, more than a hundred literary artists had worked with some eighteen thousand young people in San Francisco, building their skills and creating forums—including publishing projects, readings, and videos—where they could share their stories. In 2010, WritersCorps was one of fifteen programs in the country to win a prestigious National Arts

In 2010, WritersCorps was one of fifteen programs in the country to win a prestigious National Arts and Humanities Youth Program Award from the President's Committee on the Arts and the Humanities, presented at the White House by First Lady Michelle Obama.

RIGHT: Downtown High School student David McKeely read at WordStorm 2012 at the Main Library.

OPPOSITE, CLOCKWISE FROM TOP: Student Venyse Jeannine Sims reads her writing to classmates at Oasis for Girls; Ixchel Cuellar with Presidio Dance Theatre performed at the SF Youth Arts Festival in 2004; youths from the Presidio Dance Theatre performed a traditional Ukrainian dance at the 2009 Ethnic Dance Festival; Writers-Corps Program Manager Melissa Hung (left) and student Nicole Zatarain Rivera at the White House with First Lady Michelle Obama, who presented the National Arts and Humanities Youth Program Award in October 2010; Sarah Pfeiffe, of the Performing Arts Workshop's Artists-in-Schools program, leads a creative movement class in the Mission District.

and Humanities Youth Program Award from the President's Committee on the Arts and the Humanities, presented at the White House by First Lady Michelle Obama.

The Arts Commission also partnered with the Department of Public Works (DPW) on a public school program, Where Art Lives, to help curb increasing vandalism of public art. Through classwork and community mural projects with urban artists including Chor Boogie, Cameron Moberg, and Senay Dennis, the program taught fourth-, fifth-, and sixth-graders about public and personal artwork, the damage caused by vandalism in public spaces, and the value of creating and caring for public art. In 2010, the commission teamed with DPW on a second initiative to help reduce vandalism. Called StreetSmARTS, the program hired urban artists—among them Cameron Moberg, Chor Boogie, and Jet Martinez—to create large murals on private properties that were often targets of graffiti. The murals, with their edgy designs, were respected and protected by local taggers; when art went up, graffiti stopped.

Restoring vandalized public art could be an extraordinarily expensive task, beyond the limited budget of the Arts Commission. To help protect and preserve the city's

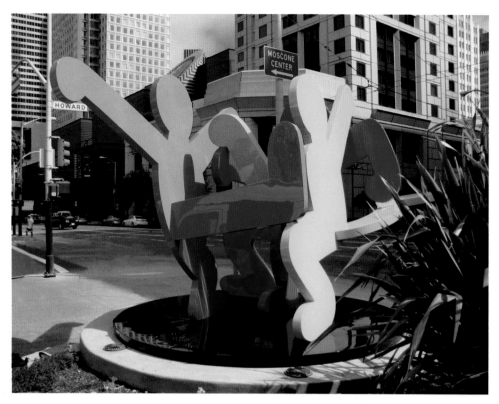

ABOVE: In 2012, the restored 1989 Keith Haring sculpture *Untitled (Three Dancing Figures)* was reinstalled on the corner of Third and Howard streets. The artwork was restored with funds from the Keith Haring Foundation and ArtCare, a public-private fundraising partnership between the Arts Commission and the San Francisco Art Dealers Association.

RIGHT: *Hall of Justice*, 1971, by Peter Voulkos, was restored in 2011 with funds from ArtCare. The sculpture is located in front of the Hall of Justice, at Bryant and Seventh streets.

$90 million Civic Art Collection, Ruth Braunstein—a longtime gallery owner and a founder of the San Francisco Art Dealers Association (SFADA)—came up with the idea of a public-private fund-raising partnership called ArtCare. With SFADA leadership, ArtCare raised tens of thousands of dollars. The foundation and private contributions augmented the commission's small annual budget for repairs and upkeep, which the Board of Supervisors voted to raise in 2010. In 2011, ArtCare helped fund the cleaning and repatination of the twenty-six-foot-tall bronze sculpture *Hall of Justice* by Peter Voulkos. In 2012, it partnered with the Keith Haring Foundation to fund the restoration of Haring's colorful sculpture, *(Untitled) Three Dancing Figures*. That

ABOVE: Gallery owner Ruth Braunstein, a founder of the San Francisco Art Dealers Association, spearheaded the creation of ArtCare in 2010 to help protect and preserve the Civic Art Collection.

year, the Board of Supervisors passed and Mayor Ed Lee signed an ordinance allowing downtown developers to contribute some or all of the 1 percent of private construction costs they had to spend on public art to a Public Art Trust that could support "the creation, instal-lation, exhibition, conservation, preservation, and restoration of temporary and permanent public art and capital improvements to nonprofit art facilities."

URBAN ARTSCAPES

The Civic Art Collection, which expands as the city grows, was increasingly integrated into new public buildings. In 2010, more than a hundred artworks were installed in the newly renovated Laguna Honda Hospital and Rehabilitation Center. All were intended to be part of patients' healing experience, and many were conceived as aids for wayfinding, orientation to place and time, sensory stimulation, and memory activation.

On the building's ground floor, artist Owen Smith created a series of WPA-style mosaic murals depicting construction of the Golden Gate Bridge. Smith also created cast-stone relief sculptures that paid homage to the WPA murals Glen Wessels had originally painted in Laguna Honda's 1926 building. Americans for the Arts named Smith's two installations among the best public artworks in the country in 2011.

For the hospital's entry gate, artist Diana Pumpelly Bates drew inspiration from the building's natural setting. For the esplanade, artist Lewis deSoto used archival imag-es and artifacts to design sixteen intricately woven tapestries. The artworks intimately explore significant eras and events that shaped the hospital and surrounding community.

The San Francisco Arts Commission (SFAC) partnered with the Department of Public Works (DPW) on StreetSmARTS, an initiative to curb vandalism of public art. The program hired urban artists to create large murals on private properties that were often targets of graffiti. OPPOSITE: In 2011, Vernon Davis (right), tight end for the San Francisco Forty-Niners, helped artist Cameron Moberg (left) complete his mural outside the Tenderloin Boys and Girls Club. Moberg was also an instructor in another SFAC-DPW partnership, called Where Art Lives, which taught fourth-, fifth-, and sixth-graders in public schools about public and personal artwork. CLOCKWISE FROM TOP: StreetSmARTS murals by Chor Boogie and Apex at 1001 Market Street; by Bryana Fleming at 4901–4911 Third Street in the Bayview District; and by Wes Wong at 835 Pacific Avenue

SAN FRANCISCO: ARTS FOR THE CITY

┌ LEFT: *Laguna Line (The possibility of the everyday)*, 2010, by Cliff Garten, at the Laguna Honda Hospital and Rehabilitation Center

TOP: *Water*, 1934, by Glen Wessels, one of a series of five WPA murals that the artist painted for the lobby of the original Laguna Honda building

ABOVE: *Building the Iron Horse*, 2010, by Owen Smith, a mosaic mural on the hospital's ground floor, paid homage to Wessels's paintings. It was named one of the best public artworks in the country in 2011.

ABOVE: Artworks in the lobby of SFO's new
Terminal 2 included (FROM LEFT) *Torso*, 1985,
by Mark Katano; *Slacking Stones*, 1983, by
Seji Kunishima; and *Greeting a Totem*, 1983,
by Mark Katano.

OPPOSITE: *Every Beating Second*, 2011,
by Janet Echelman, in Terminal 2

In the corridors, artist Cliff Garten created a sensuously sculptural handrail that meets all codes and functional requirements and actively engages residents on visual, tactile, and psychological levels.

New commissions were added to the Airport Collection during the 2011 renovation of SFO's Terminal 2. Norie Sato's *Air Over Under*, a site-specific installation for the terminal's facade, featured images of clouds, a bird, and a plane on 150-foot-wide laminated glass panels. Kendall Buster and Janet Echelman created sculptural works, and Walter Kitundu and Charles Sowers transformed children's play areas with unique interactive installations. Kitundu's artwork included two benches, shaped like bird wings, that doubled as musical instruments. Sowers's *Butterfly Wall* was a kinetic sculpture of mechanical butterflies that viewers activated with a series of hand cranks. To complement the new commissions, the terminal reinstalled twenty previously displayed works by artists including Joan Brown, Willard Dixon, Roy De Forest, Hassel Smith, Sam Tchakalian, Mark Katano, and Wade Hoefer.

Many exhibitions have been installed in and around City Hall. Former mayor Newsom, in particular, favored art that was bold and challenging. In 2010, a mammoth sculpture by renowned Shanghai artist Zhang Huan was placed in Civic Center Plaza. The twenty-six-foot-tall, sixty-foot-long, fifteen-ton artwork, called *Three Heads, Six Arms*, was exhibited as part of celebrations for the thirtieth anniversary of San Francisco's Sister City partnership with Shanghai.

Artists also animated the beaux arts interior of City Hall with programming by Grants for the Arts and the SFAC Galleries. For the Grand Rotunda, in 2009 the galleries commissioned a site-specific sound installation by renowned sound artist Bill Fontana. Called *Spiraling Echoes*, the installation, funded by an NEA grant, bounced sounds that Fontana had recorded—of the city's birds, F-line trolley bells, sea lions, and burbling bay water—from point to point around the rotunda, filling the interior architecture with sound.

Other gallery exhibitions in City Hall confronted timely international and controversial issues, such as gay marriage and the war in Afghanistan. In the North Light Court, for example, the SFAC Galleries presented large-scale photographic banners by

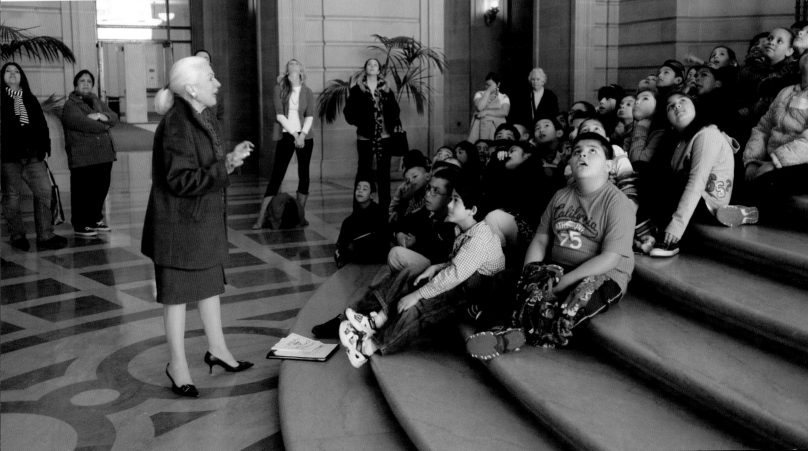

URBANITION

2011 SISTER CITY BIENNIAL / (SAN FRANCISCO — SYDNEY)

THE SAN FRANCISCO ARTS COMMISSION GALLERY'S
ART AT CITY HALL PROGRAM PRESENTS

AFGHANISTAN IN 4 FRAMES

4 EMBEDDED PHOTOJOURNALISTS
TAKE AIM AT THE WAR

9 FEBRUARY–13 MAY
2011

James Lee with Lynsey Addario, Eros
Hoagland and Teru Kuwayama

CLOCKWISE FROM TOP FAR LEFT: A postcard
for *Urbanition*, an SFAC Gallery sister-city
exhibition with Sydney, Australia; the an-
nouncement for the *Afghanistan in 4 Frames*
exhibition at City Hall; an image by Iranian
photographer Mahboube Karamli in the 2008
SFAC Gallery exhibition *After the Revolution*
at City Hall; in his *Winning the Water* perfor-
mance piece, artist Pawel Kruk swam from
Alcatraz to Aquatic Park, accompanied by
the band Coconut, as part of the 2010 multi-
sited SFAC Gallery exhibition *Transplanted*; a
commissioned multimedia work at the SFAC
Gallery's window installation site on Grove
Street by Chris Bell, Elaine Buckholtz, and
Floor Vahn, was part of the 40th anniversary
exhibition *Chain Reaction XI* in 2010; a kiosk
poster on Market Street, part of Lonnie
Graham's global project *A Conversation with
the World*, commissioned by the SFAC Gallery;
and *Out of Bounds*, 2011, by David Huffman,
in the *SHIFT* exhibition at the SFAC's main
gallery space

ABOVE: *Bay Area Bird Encounters*, 2011, by Walter Kitundu, at SFO's Terminal 2

OPPOSITE: *Tiled Steps*, 2005, by Colette Crutcher and Aileen Barr, at Sixteenth Avenue and Moraga Street

FOLLOWING PAGES: *Three Heads, Six Arms*, 2008, by Zhang Huan, in Civic Center Plaza (pages 192–93); and *Crouching Spider*, 2003, by Louise Bourgeois, on the Embarcadero (pages 194–95)

contemporary artists working on global projects. One banner exhibit, *A Conversation with the World,* was part of a two-decade-long project in which prominent Philadelphia photographer Lonnie Graham posed the same eight questions about human experience to people around the world. San Francisco residents were depicted on banners alongside their answers to the photographer's questions. In *LUX*, Bay Area–based artist Christina Seely expanded on her ongoing project documenting the artificial glow produced by major cities in the world's three brightest regions, as captured on NASA's night map of the Earth.

In addition to their curated programs for City Hall, the main gallery in the Veterans Building, and the window installation site on Grove Street, the SFAC Galleries staff presented off-site projects to increase the accessibility of contemporary art. Programs included an exhibition of book art at San Francisco's Main Library; a video about the biracial experience that was screened at the city's cultural centers; a poster series about the Afghanistan war, displayed in kiosks at transit stops; and a digital video novella that was posted on the Internet and featured weekly episodes. Inspired by San Francisco's history of activism and open dialogue, the gallery programs pushed viewers to pause and think about contemporary art and sociopolitical issues.

A city, *Chronicle* arts and culture critic Steve Winn observed, is always streaming forward, carrying sediments of the past. Civic art in San Francisco reflects the city's changing environment as well as its continuing diversity, creative energy, and political activism. Since 1932, when the Art Commission was established to help mediate aesthetic issues, San Francisco has been a cultural innovator. Art has frequently been a flashpoint in the city's politics and conflicts over power and identity. It has also, like roads and bridges, been a connector, the creative infrastructure of expression, cultural understanding, and inspiration. San Francisco has evolved into a city of art—not just in its grand public buildings and plazas, but in neighborhoods and communities where it sparks creativity and builds pride of place.

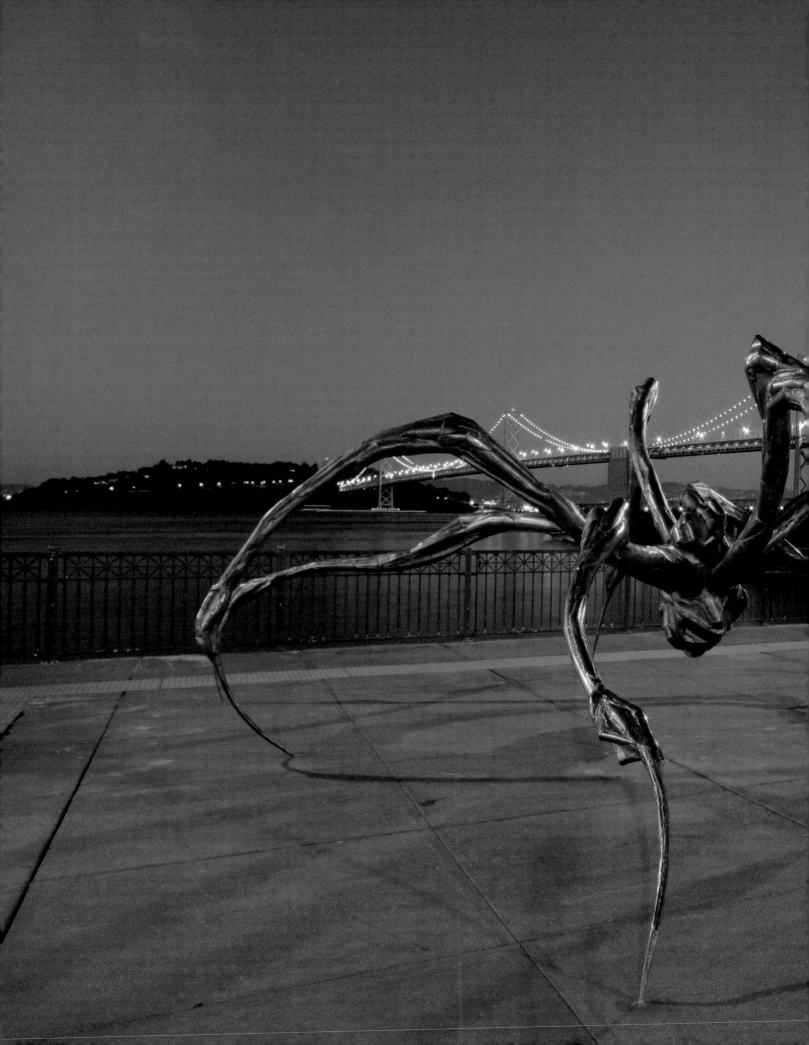

San Francisco Arts Commissioners*

* THE INFORMATION CONTAINED IN THIS TIMELINE WAS COMPILED FROM EXISTING CITY RECORDS. WE APOLOGIZE FOR ANY ERRORS OR OMISSIONS AND WELCOME CORRECTIONS.

JANUARY 7, 1931–JANUARY 8, 1944

Angelo J. Rossi, Mayor

Lewis P. Hobart President
Edgar Walter President
Gertrude Atherton
John Bakewell Jr.
Albert Bender
W. W. Chapin
Cornelius Collonan
Eustace Cullinan
Leland S. Cutler
Mark Daniels
Frank P. Deering
Charles Stafford Duncan
Herbert Fleishhacker
Edward L. Frick
William Gaskin
Cameron George
Albert Greenbaum
Maurice Harrison
J. Emmett Hayden
Elmer Hubbard
George W. Kelham
Clarence King
Emerson Knight
Spencer Macky
Mrs. Alfred McLaughlin
Milton Meyer
Daniel Murphy
Mrs. A. S. Musante
Edward T. O'Day
Edward B. Page
Thomas Rolph

Ottorino Ronchi
Paul A. Ryan
John J. Ryan
Florentine Schage
Alma de Bretteville Spreckels
A.W. Stokes
Douglas Dacre Stone
Ruth Cravath Wakefield
Edgar Walter
Walter Weber
Marie de Laveaga Welch West
W. P. Wobber
Frank P. Deering ex officio

JANUARY 8, 1944–JANUARY 7, 1948

Roger D. Lapham, Mayor

Edward D. Keil President
Ernest A. Born
Beniamino Bufano
Thomas D. Church
John Cuddy
Gardner Dailey
George W. Kemper
Oscar Lewis
Edward S. Moore
Nat Schmulowitz
Elridge T. Spencer
Paul Verdier
Carton Wall
Michel D. Weill
Lloyd E. Wilson

Elmer E. Robinson, *Mayor*

Harold L. Zellerbach President

William Stephen Allen

Douglas Baylis

Dr. Bernard C. Begley

Ellen Campondonico

Jean Coblentz

William M. Coffman

John Garth

John Hagopian

George D. Hart

Robert Howard

Betty Jackson

Charles H. Kennedy

Roger D. Lapham Jr.

Sam M. Markowitz

Francis Joseph McCarthy

J. Henry Mohr

James Moore

Clarence O. Peterson

William B. Poyner (Alice)

George Rockrise

John Barney Rodgers

Albert Roller

Oliver Rousseau

Antonio Sotomayor

Ralph Stackpole

Louis Sutter

Harvey E. Teller

Ernest Torregano

Ernest E. Williams

Gurdon Woods

George Christopher, *Mayor*

John M. Bransten

Walter Buck

George Cameron

Louis M. Cole

Joseph Esherick

Walter Haas

Mark Harris

Dr. William Knuth

Gardner Mein

Fred D. Parr

Richard Rheem

Burton L. Rockwell

Albert E. Shwabacher Jr.

Bert Simon

Nell Sinton

William R. Wallace

Dr. Thomas S. Wu

John F. Shelley, *Mayor*

Albert F. Arnold

Ernest Born

William M. Brinton

Edward F. Callanan Jr.

Jean Colbentz

Ransom M. Cook

T. H. Delap Jr.

Jeremy M. Ets-Hokin

David Hayes

Sally Hellyer

James S. Kearney

Raymond H. Lapin

Daniel H. Lewis

Anita G. Martinez

David Mayes

Tito Patri

Ronald Pelosi

Julia Porter

Richard S. Rheem

Burton L. Rockwell

Dr. Albert Shumate

Elvin C. Stendell

William R. Wallace

Joseph L. Alioto, *Mayor*

Ray Taliaferro President

Agnes Albert

Ruth Asawa

Philip Boone

Edward P. Callanan

Larry L. Cannon

Jean Coblentz

Ransom M. Cook

Francis Ford Coppola

Loris Di Grazia

Eric Hoffer

Thomas Hsieh

Elsie Lisle

Anita G. Martinez

David Mayes

William McCormick

Walter Newman

Emmy-Lou Packard
Julia Porter
Walter H. Shorenstein
Daniel G. Volkmann
Alec Yuill-Thornton

FEBRUARY 2, 1976–NOVEMBER 27, 1978

George Moscone, Mayor

Jacqueline Nemerovski President
Roselyne C. Swig President
Ray Taliaferro President
Scott Beach
Blanche Brown
Patricia Ann Carlisle
Maurice Englander
Richard Felciano
Alfred Frankenstein
Eugene L. Friend
Gordon Lau
Evangeline Montgomery
Domingo Rivera
Toby Rosenblatt
Marjorie Stern
Dimitri Vedensky Jr.

MARCH 5, 1979–JANUARY 7, 1988

Dianne Feinstein, Mayor

Robert LaRocca President
Vernon Alley
Sue Bierman
Edward Branston
Timothy Duncan

Stanley Eichelbaum
Keith Eickman
William Gaylord
Fred Goerner
Jo Hanson
Walter Jebe
Leonard Kingsley
Richard Mayer
Anna-Marie Metwally
William Paterson
Piero Patri
Alexandra Phillips
Lucio Raymundo
Raye Richardson
Peter Rodriguez
Mary Louise Stong
Felix Warburg
Florence Wong

SEPTEMBER 7, 1988–JANUARY 7, 1992

Art Agnos, Mayor

Anne Healy President
Barbara Sklar President
Nancy Boas
Steven Coulter
Douglas Engmann
Kim Fowler
Daniel Genera
Richard W. Goss II
Wayne Hu
John Kriken
Genny Lim
Amalia Mesa-Bains, PhD

James Morales
Connie O'Connor
Rai Okamoto
Dodie Rosekrans

JANUARY 6, 1992–JANUARY 7, 1996

Frank Jordan, Mayor

Terri Simon President
Nancy Bechtle
Theodore Brown
Aristides Demetrios
Tom Flynn
Rod Freebairn-Smith
James Herlihy
Jack Immendorf
Emily Keeler
Alonzo King
Willis Kirk
William Meyer
Stephen Nakajo
Trent Orr
Armando Rascon
Emery Rogers
Sidney Unobskey
Lisa Zenni

FEBRUARY 5, 1996–JANUARY 7, 2004

Willie L. Brown Jr., Mayor

Stanlee Gatti President
P.J. Johnston President
Kirk Anderson
Anne Brauer

Andrew Brother-Elk

Andrea Cochran

Rod Freebairn-Smith

Nery Gotico

Ralph Guggenheim

Steve Ishii

Andrew Lisac

Susan E. Lowenberg

Eddie Marshall

Maria X. Martinez

William Meyer

Janice Mirikitani

Denise Roth

Barbara Stauffacher Solomon

Dugald Stermer

David Stroud

Anthony Turney

William Villa

Ethel Pitts Walker

Dede Wilsey

José Cuellar

Topher Delaney

Maya Draisin

Lorraine Garcia-Nakata

Ralph Guggenheim

Astrid Haryati

Leonard Hunter

John Kriken

Alexander Lloyd

Sherene Melania

Beverly Prior

Jeannene Przyblyski

Lawrence Rinder

Denise Roth

Jessica Silverman

Barbara Sklar

Cass Calder Smith

Dugald Stermer

Kimberlee Stryker

Sherri Young

Pop Zhao

Dwight Alexander ex officio

M. Sue Lee ex officio

Shelley Bradford Bell ex officio

Ron Miguel ex officio

Christina Olague ex officio

JANUARY 8, 2004–JANUARY 10, 2011

Gavin Newsom, Mayor

P.J. Johnston President

JD Beltran President

René Bihan

Mark Breitenberg

Blanche Brown

Nínive Calegari

John Calloway

Greg Chew

Leo Chow

Amu Chuang

JANUARY 11, 2011–PRESENT

Edwin M. Lee, Mayor

JD Beltran President

Charles (Chuck) Collins

Dorka Keehn

Roberto Ordeñana

ABOVE AND OPPOSITE: Photographs from
House Hunting, 1996–2011, by Todd Hido

SAN FRANCISCO: ARTS FOR THE CITY

POSTSCRIPT

The arts flourish in an environment that cherishes their importance and value, and a city's population flourishes in an environment enriched with art. The stories recounted in the preceding chapters recall the many episodes where the San Francisco Arts Commission has been a genuine innovator in building the municipal infrastructure to support the incubation of new forms of art. In doing so, the Arts Commission has been instrumental in framing the cultural landscape and in demonstrating the essentiality of the arts in day-to-day civic life.

"It is impossible to have a society that is civil and educated without public art. It lifts up humanity and challenges the individual who encounters it to think differently about the world."

—DARREN WALKER

So while San Francisco isn't usually on the list of major art centers in the world, perhaps it's because of the city's nurturing environment that artists living here have felt the freedom to experiment in innovative directions, untethered by expectations or commerce. As art critic Kenneth Baker notes, "The big art world—which got big in America only in the 1960s—has long judged Northern California a better place to be from than to be living in. But the Bay Area has always attracted artists who care at least as much about how they lived as about career success."

Many watershed art movements have been incubated here: Eadweard Muybridge's invention of motion graphics—the precursor to film—in 1878; Ansel Adams's reframing of photography as art and the genesis of the abstract film movement in the 1940s; the Beat movement and the Bay Area Figurative art Movement in the 1950s; and the performance and video art of the 1960s and 1970s. The 1990s spawned the Mission School aesthetic and new media art, which married fine art with technology. Now, in the twenty-first century, San Francisco's rich artistic history, along with the area's proximity to the inventions of Silicon Valley, place the Bay Area at the forefront of continuing to nurture new forms of art.

For the past several decades, on the first Monday of the month, an assemblage of eight to fifteen practicing artists, arts professionals, architects, musicians, writers,

performing artists, educators, and arts patrons have convened in leather-bound chairs behind an elevated semicircular dais in various meeting rooms of San Francisco's glorious City Hall to undertake the work of the San Francisco Arts Commission. Although the tasks can be as glamorous as approving a four-story million-dollar figurative sculpture by Tim Hawkinson, commissioners might also ponder a new arrangement of stalls in one of the public park bathrooms. As evidenced by the vocal participation of San Francisco citizens in either case, all aesthetic decisions affecting the city landscape are equally important.

Visionary past commission leaders have been characters as colorful as businessman and philanthropist Herbert Fleishhacker and paper magnate Harold L. Zellerbach. More recently, the commission was headed by the irrepressible Stanlee Gatti, whose background was as an event designer, but who, during his nine-year tenure, accomplished the completion of fifty-seven permanent pieces of public art, including artworks by such noted artists as Vito Acconci, Ned Kahn, Robert Arneson, Bill Viola, and Keith Haring. That number grew even more impressively with the tenure of P.J. Johnston, who, during his eight years as commission president, oversaw the addition of 495 major new artworks. With the assistance of senior agency staff members Jill Manton, Judy Nemzoff, and Susan Pontious, he also spearheaded citywide agency participation in the arts, advancing new art-based collaborations and fruitful partnerships with the city's Planning Department, Department of Public Works, Department of Economic Development, and Public Utilities Commission.

Most municipal art commissions began out of the need for a governing body to approve a city's built environment by providing design review for city projects. Their mandate frequently was limited to the architecture of government buildings and public monuments. Boston's is the oldest art commission in the country, formed in 1890, but it only reviews public art. Other commissions, such as those in New York (formed in 1898), Los Angeles (1903), Philadelphia (1907), and Milwaukee (1911), oversee the built environment as well as public art. Although the San Francisco Arts Commission

began with a similarly limited mandate in 1932, it quickly rewrote the concept of a city's role in the arts: San Francisco became the first city in the country to underwrite musical arts through the support of a municipal symphony.

As chronicled in the prior pages, this innovation and the Arts Commission's progressively expansive vision of a municipality's role in the arts in the subsequent eight decades are illuminated in its many groundbreaking feats: first municipally sponsored symphony concerts

in the country (1935); first municipal outdoor arts festival (1946); first international film festival in North America (1957); first community cultural program of its kind in the United States (Neighborhood Arts Program, now Community Arts and Education, 1967); first blues festival (1973); and first program for street artists (1975). The San Francisco Arts Commission also was among the first in the country to initiate a percent for the arts program (Art Enrichment Ordinance, 1969) and was the first to create a fund to support historically underserved art communities (Cultural Equity Endowment Fund, 1993). In 2006, the commission's Arts Education Master Plan, spearheaded in partnership with the San Francisco Unified School District, became a national model for arts education. And in 2012, the commission finalized legislation creating one of the first percent for the arts programs that will tap private development to endow an art trust for the conservation of public art.

The agency has truly been a pioneer in striking new ground for what is possible. Now, more than a hundred international film festivals and more than a thousand art festivals are held in cities across the nation. Percent for art legislation has been adopted by municipalities all over the world, and the Art Commission's creation of the Cultural Equity Endowment Fund brought the necessity for cultural equity in the arts to the forefront.

The innovation continues with the agency's latest pursuit: hatching both tested and novel strategies in the efforts to revitalize the long-blighted mid-Market area of downtown San Francisco. Working with multiple arts organizations and other city agencies, and supported by more than $1.2 million from the local community and the National Endowment for the Arts, the Arts Commission launched the ARTery Project. This series of highly successful temporary art installations and performances uplifted the local community, enhanced the neighborhood, and attracted new audiences to the area. Such joint efforts helped plant the seeds for the area's rejuvenation, and every week brings more good news of that neighborhood's transformation. Not only are the arts necessary for culture—they're a proven economic engine. A 2005 study by Americans for the Arts indicated that the direct economic impact of San Francisco's nonprofit arts and culture organizations and their audiences exceeded $1 billion.

Supporting public art and fostering community arts have been essential components of San Francisco's urban fabric for more than four generations. With its mantra of innovation, stable foundation, and energetic new leadership, the San Francisco Arts Commission can continue to grow its support of contemporary forms of artistic expression and further enhance the city's prominence, sustain its economic stability, and affirm its identity as one of the most captivating, beautiful, and desirable places in the world.

—**JD Beltran,** President of the San Francisco Arts Commission

ABOVE: *What Is Missing?*, 2009, by Maya Lin, outside the California Academy of Sciences in Golden Gate Park

OPPOSITE: *The Conquest of Space*, 1983, by Rufino Tamayo, outside SFO's International Terminal

Making a book is a team effort.
We have a long list of people who
need to be thanked.

Susan Wels brought with her the thoroughness of a historian and the tenacity of a journalist when she tackled the giant task of putting the Arts Commission's history to paper. For her professionalism and grace under pressure, we thank her. We also acknowledge the keen insights and consummate intellect of Jeannene Przyblyski.

Arts Commissioners, whose dedicated efforts guided this process and continually help the Arts Commission thrive in our communities, across all disciplines: JD Beltran, Mark Breitenberg, John Calloway, Greg Chew, Leo Chow, Amy Chuang, Charles Collins, Lorraine Garcia-Nakata, P.J. Johnston, Dorka Keehn, Sherene Melania, Roberto Ordeñana, Jessica Silverman, Barbara Sklar, Cass Calder Smith, Kimberlee Stryker, and Sherri Young. We would especially like to thank Commissioner and former Interim Director JD Beltran who nurtured the book and generously contributed her photographic and production expertise as well as many photographs.

At the City and County of San Francisco, Mayor Edwin M. Lee, former mayor Gavin Newsom, Deputy Attorney Adine Varah from the City Attorney's office, and Nicole Wheaton from the Mayor's Office.

Staff at the San Francisco Arts Commission, whose countless efforts and contributions made this book not only possible, but a work of art: Luis R. Cancel for his original conception of this project, Tom DeCaigny (Director of Cultural Affairs), Rachelle Axel (Development Director), Michelle Chang (Accountant), Mary Chou (Public Art Project Manager), Jaime Cortez (former Cultural Equity Grants Program Associate), Allison Cummings (Collections Senior Registrar), Carol Marie Daniels (Public Art and Collections Project Manager), Marcus Davies (Public Art Project Manager), Tyra Fennell (Community Arts & Education Program Manager), Cristal Fiel (Community Art and Education Program Associate), Kan Htun (Former Director of Finance), Melissa Hung (WritersCorps Program Manager), Esther Ip (Accounting Clerk), Vicky Knoop (Civic Design Review Program Manager), Rebekah Krell (Deputy Director), Amanda Kwong (former Public Program Accountant) Howard Lazar (Street Artists Licensing Program Director), Aimee Le Duc (SFAC Galleries Manager), Alyssa Licouris (Street Artists Licensing Program Director), Lucy Seena K. Lin (Cultural Equity Grants Interim Program Director), Jennifer Lovvorn (Public Art Project Manager), Jill Manton (Director of Public Art Trust and Special Manager), Corinne Matesich (Former Cultural Equity Grants Assistant), Judy Moran (Public Art Project Manager), Marissa Mossberg (Arts Education Program Associate), Nirmala Nataraj (former WritersCorps Program Associate), Judy Nemzoff (Community Arts & Education Program Director), Sharon Page Ritchie (Commission Secretary), Kate Patterson (Director of Communications), Ellen Schumer (City Hall Historian and Docent Tour Program Manager), Meg Shiffler (Director of SFAC Galleries), Susan Pontious (Public Art Program Director), Sylvia Sherman (Former Cultural Equity Grants Program Associate), Robynn Takayama (Community Arts & Education Program Manager), Zoë Taleporos (Public Art Program Associate), Weston Teruya (Cultural Equity Grants Program Associate), Beatrice Thomas (Cultural Equity Grants Program Manager), Victoria Tran (Accounting Clerk), Amy Ward (Former Accounting Clerk), and Daryl Wells (former Arts Education Assistant) and E. San San Wong (Former Cultural Equity Grants Program Director).

Many thanks to the **book production team:** Leslie Jonath (book producer), Brianna Smith (project manager), Brian Singer (design director), Kirstin Kowalsky (designer), Michael Rauner (photographer), Judith Dunham (copy editor), Jan Hughes (proofreader), Carolyn Miller (proofreader), Ken DellaPenta (indexer), Jenna Mukuno (lead photo and editorial researcher), Mallory Barclay (researcher and photo editor), Amanda Halbakken (researcher), Nick Janikian (researcher), Jacqueline Langelier (researcher), Mitra Parireh (researcher), and Christina Yoseph (researcher).

For contributing to the book in the form of artwork, photographs, permissions, access to their collections and archives, thoughtful editorial input, and ongoing support of the project, we would like to thank:

John Almond, Michael Amici, Dr. Amalia Mesa Baines, Richard Barnes, Calvert Barron at the Rena Bransten Gallery, Jeffrey Blankfort, Neal Benezra at SFMOMA, Chor Boogie, Callie Bowdish at the UCSB Special Collections, London Breed at the African American Art and Culture Complex, Michael JN Bowles, J. Astra Brinkmann, Paz de la Calzada, Lin Cariffe, Eric Carroll at the Jim Goldberg Studio, Robert Cherny, John Chiara,

Paul Chinn, Kevin Clarke, Bruce Damonte, Anne Bast Davis at SFMOMA, Willard Dixon, Mark Eastman, Joseph Evans at the San Francisco Symphony, Oscar Espaillat at Corbis, Kurt Fishback, Bryana Fleming, Peter Fries, Chris Fox, Lydia Gonzales, Rupert Garcia, Nicole Grady at the Brubeck Institute, Richard Grant at the Richard Diebenkorn Foundation, Cliff Garten, Stanlee Gatti, Ingeborg Gerdes, David Lance Goines, Jim Goldberg, Stephen Goldstine, Traude Gomez, Marion Gray, Jeff Gunderson at the San Francisco Art Institute, Doug Hall, Hilary Hart at the San Francisco Film Society, Ilka Hartmann, Stewart Harvey, Tim Hawkinson, Luis Herrera at the San Francisco Public Library, Todd Hido, Katie Higgins at Pace/MacGill Gallery in New York, Eros Hoagland, Janet Hoelzel, Jerri Holan, Jay Hsiu at the Asian Art Museum, Ginny Huo at the George Adams Gallery, William Issel, Jason Jägel, Carin Johnson at the Fraenkel Gallery, Rupert Jenkins, David S. Johnson, Rhodessa Jones, Ned Kahn, Krissy Keefer, Nan Keeton at the San Francisco Symphony, Shubhangi Kelekar at the California Department of Transportation, Mary Kerr, Nathan Kerr at the

Gay marriage supporters surround Zhang Huan's sculpture *Three Heads, Six Arms* in a rally in the Civic Center in 2010.

Oakland Museum of California, John Kreidler, Katie Langjahr at Artists Rights Society (ARS), Lisa Law, Lex Leifheit at SOMArts, Hung Liu, Terry Lorant, Reagan Louie, Vince Maggiora, Veena Manchanda at the United Nations Photo Library, Adriana Marcial at Joe Goode Performance Group, Julie Mau and Patrick Makuakane at Na Lei Hulu IKa Wekiu, Mike Mandel, Genevieve Massé, Will Maynez at the Diego Rivera Mural Project, at City College of San Francisco, Dania Maxwell, Pat Mazzera, Tom Mazzolini at the San Francisco Blues Festival, Matthew Millman, Richard Misrach, Christina Moretta at the San Francisco Public Library, Margo Moritz, Jean Moulin, Beth Murray at the San Francisco War Memorial, Mia Nakano, Jane Nakasako at the Japanese American National Museum, Dan Nicoletta, Ira Nowinski, Tim O'Brien at the SFO Museum, Barbara Ockel at the Bayview Opera House, Nic Paget-Clarke, Meg Partridge at the Imogen Cunningham Trust, Miguel Pendas at the San Francisco Film Society, Carolina Ponce de Léon at Galería de la Raza, Bill Proctor at the San Francisco Film Society, Steve Rhodes, Karen Richter at the Princeton University Art Museum, Rigo 23, Iraya Robles and the Elio Benvenuto Archives, Jennie Rodriguez at the Mission Cultural Center for Latino Arts, Patricia Rodriguez, Barbara Rominski at the SFMOMA Research Library and Archives, Larry Rothe at the San Francisco Symphony, Monica Roy, Stanley Saitowitz, Don Santina, Anne Schnoebelen, Kary Schulman at Grants for the Arts, Joshua Singer, Benjamin Sisson at the Museum of Performance & Design, Peter Somerville at the Treasure Island Development Authority, C.R. Snyder, Susan Snyder at the Bancroft Library, Susan Schwartzenberg, the estate of Larry Sultan, Roselyne C. Swig, Ray Taliaferro, Kirsten Tanaka at the Museum of Performance & Design, Mattie Taormina at Stanford University Special Collections, Jerry Telfer, Emma Tramposch at La Pocha Nostra, Anne Trickey at Performing Arts Workshop, Vivian Truong, Roberto Vargas, Xavier Viramontes, Jack von Euw at the Bancroft Library, Catherine Wagner, Claire Isaacs Wahrhaftig, Ian Wang, Po Shu Wang, Henry Wessel, Ansel Wettersten, Audrey Whitmeyer-Weathers, Adriana Williams, Cody Williams at RayKo Photo Center, Griff Williams at Gallery 16, Amanda Williford at the National Park Service/Golden Gate National Recreation Area, Diane B. Wilsey and the Fine Arts Museums of San Francisco, Bill Wilson, Linda Wilson and El Tecolote Photo Archive, Joanne Chow Winship, Joan Ellison Wong, Leland Wong, Sergio Waksman and the Bud Lee Archives, ruth weiss, Wes Wong, René Yañez, Gallery Paule Anglim, Presidio Dance Theater, San Francisco Symphony, RayKo Photo Center, Robert Arneson Estate, Virtual Museum of the City of San Francisco, Krystal Harfert, Amanda Moran, and Amelia Rudolph at Project Bandaloop, Susan Grinols, Clara Hatcher, and Kara Whittington at the Fine Arts Museums of San Francisco, Debra Kaufman, Eileen Keremitsis, and Mary Morganti at the California Historical Society.

We would like to thank Heyday for taking on this project with enthusiasm. At Heyday, we would like to especially thank publisher Malcolm Margolin and production director Diane Lee for keeping everyone on schedule and on task. Thanks also to publicists Natalie Mulford and Lillian Fleer.

Finally, we would like to thank all of our commissioners past and present who have served in the support of the good work of the Arts Commission (see pages 196–99).

The San Francisco Arts Commission staff—
with Mayor Edwin M. Lee (front row, center)
at City Hall in 2012—included (front row, left
to right) Susan Pontious, Jill Manton, Judy
Nemzoff, Ellen Schumer, Director Tom DeCaigny,
President JD Beltran, former president P.J.
Johnston, Rebekah Krell, Howard Lazar, and
Kate Patterson; (second row, from left) Zoë
Taleporos, Judy Moran, Allison Cummings,
Esther Ip, Rachelle Axel, and Alyssa Licouris;
(third row, from left) Jennifer Lovvorn, Vicky
Knoop, Sharon Page Ritchie, Michelle Chang,
and Melissa Hung; (fourth row, from left)
Mary Chou, Tyra Fennell, Cristal Fiel, Marissa
Mossberg, Brianna Smith, and Beatrice Thomas;
(back row, from left) Meg Shiffler, Carol Marie
Daniels, Victoria Tran, and Lucy Seena K Lin.

SFAC staff members (from left) Robynn
Takayama, Aimee LeDuc, and Marcus Davies

CHAPTER ONE: THE POLITICAL ARTS

27 Since the end of the nineteenth century: Issel and Cherny, *San Francisco 1865–1932*, 109.

27 In 1904, its new Association: Benton, *The Presidio*, 37.

27 Local artists and architects: Panama-Pacific International Exposition brochure, accessed March 1, 2011, at http://bit.ly/bkLI7X.

27 Intended to celebrate: Issel and Cherny, *San Francisco 1865–1932*, 204.

27 Still, as one newspaper: Lee, *Painting on the Left*, 38–39.

28 The city was beginning to raise: Issel and Cherny, *San Francisco 1865–1932*, 111–12.

28 After voters approved bonds: Ibid., 113–14.

29 Boston had established an art panel: Bogart, *The Politics of Urban Beauty*, 281, note 4.

29 The city's first symphony concert series: "San Francisco Symphony: Our Mission and History," accessed December 3, 2011, http://bit.ly/NIRWLo.

29 The commission supervised: Sauners, *Music and Dance in California and the West*, 155.

29 The Art Commission also sponsored: SFAC minutes, 1932.

31 A member of the Board of Supervisors: Jewett, *Coit Tower*, 24; *New York Times*, January 1, 1929.

31 A gregarious, backslapping businessman: *Time*, September 6 1934; Rosenbaum, *Cosmopolitans*, 134.

31 The mayor had rewarded: *San Francisco Chronicle*, July 11, 1944.

31 Coit, the handsome, dashing daughter: Atherton, *My San Francisco*, 28.

31 In 1863, they gave her: *San Francisco Chronicle*, May 30, 1939.

33 The group proposed erecting: Jewett and Beatty, *Coit Tower*, 24; Lee, *Painting on the Left*, 244.

33 Fleishhacker pushed to finish: Jewett and Beatty, *Coit Tower*, 24.

33 By mid-August, nearly five hundred San Franciscans: SFAC Minutes, 1932.

33 She was "a brilliant, very unusual woman": *New York Times*, April 10, 1932.

33 Atherton and the only other woman on the Art Commission: Atherton mistakenly recalled that the other woman was Mrs. Musante.

33 "So there it stands, insulting the landscape.": Atherton, *My San Francisco*, 30.

33 The *San Francisco Chronicle* called the tower: Jewett and Beatty, *Coit Tower*, 32.

36 Many of San Francisco's best painters: Jewett and Beatty, *Coit Tower*, 33.

37 Despite his reputation as a master painter: Lee, *Painting on the Left*, 55.

37 "Like the lion and the lamb": *San Francisco Chronicle*, January 1, 1934.

37 Without warning, in mid-February: *San Francisco Chronicle*, February 14, 1934.

37 Union members held a protest meeting: *San Francisco News*, February 14, 1934; Jewett and Beatty, *Coit Tower*, 46.

37 Fleishhacker advocated destruction of the murals: Lee, *Painting on the Left*, 135.

39 By the end of that night: *San Francisco Chronicle*, July 6, 1934.

39 Downtown streets were deserted: *Literary Digest*, August 22, 1934.

39 That day, art commissioners visited: ibid.

39 The mural project—which had employed: SFAC Minutes, 1934.

39 Art critic Junius Cravens: *San Francisco News*, October 20, 1934.

39 Construction of the span: SFAC Minutes, 1933.

39 The commission's main concern: SFAC Minutes, 1935.

42 Some stated that painting the bridge: SFAC Minutes, 1936.

42 Orchestras were costly: *San Francisco Chronicle*, February 11, 1934.

42 Once more, a mural ignited: *New York Times*, December 12, 1940.

48 On December 16, 1941: SFAC Minutes, 1942.

48 That December, James C. Petrillo: SFAC Minutes, 1942.

48 It gave free concert admission: SFAC Minutes, 1947.

48 A million and a half servicemen: Solnit, *Infinite City*, 57–60.

49 San Francisco was changing rapidly: SFAC Minutes, 1946.

49 According to Mayor Roger Lapham: Wilkening and Brown, *Bufano*, 163.

49 In 1944, determined to shake things up: *New York Times*, November 5, 1944.

51 In 1944, the commission approved: SFAC Minutes, 1944, 1946.

51 Public art, Bufano stated: Brooks, Carlsson, and Peters, *Reclaiming San Francisco*, 193.

CHAPTER TWO: CULTURAL CLASHES

55 New eclectic, avant-garde impulses: *Time*, July 14, 1958.

55 The city, once a western outpost: *Time*, November 9, 1959.

57 The city's African American population: Solnit, *Infinite City*, 61.

57 In the Fillmore District: Pepin and Watts, *Harlem of the West*, pp. 13, 84.

57 Asian nightclubs: Robbins, *Forbidden City*, pp. 33, 91.

58 Poets, hipsters, and bohemians: *Time*, December 2, 1957; *Time*, August 9, 1959; Arthur Monroe, "The Decade of Bebop, Beatnicks and Painting," SOMArts, accessed December 4. 2011, at http://bit.ly/T4j4et.

58 According to the *Chronicle*, Horn's decision: Ferlinghetti, "Horn on Howl" in Hyde, *On the Poetry of Allen Ginsberg*, 53.

59 At an exhibition sponsored by: Albright, *Art in the SF Bay Area, 1945–1980*, 42; *San Francisco Chronicle*, December 5, 1950.

64 Local artists protested: *San Francisco Chronicle*, September 17, 1955; *New York Times*, September 21, 1955.

66 Staged at the huge, semicircular Palace of Fine Arts: Alfred Frankenstein, "Art Show Appraisal," *San Francisco Chronicle*, December 3, 1950.

66 Folk dancers, madrigal singers: *New York Times*, December 31, 1950.

66 Second only to New York: ibid.

66 Attendance doubled: San Francisco Art Festival brochure, 1951, SFPL.

66 Given its "migratory history": ibid.

68 Fiedler, an energetic, peripatetic showman: Dickson, *Arthur Fiedler and the Boston Pops*, 83–139.

68 By 1956, when television was increasingly competing: SFAC Minutes, 1956.

68 Arthur Fiedler never turned down: Dickson, *Arthur Fiedler and the Boston Pops*, 83–139.

69 On the evening of December 4, 1957: *San Francisco Chronicle*, December 5, 1957.

69 San Francisco "is no Cannes": *New York Times*, November 3, 1963.

69 In 1958, Twentieth Century Fox: *New York Times*, September 7, 1959.

69 Herb Caen scathingly dubbed it: *San Francisco Chronicle*, March 2, 2007.

69 As a matter of sportsmanship: *New York Times*, September 7, 1959.

69 "Audiences at the Metro Theater": *New York Times*, November 11, 1962.

69 In 1963, Columbia Pictures director Carl Foreman: *New York Times*, October 30, 1963; *San Francisco Chronicle*, October 31, 1963.

70 Former Congressman John F. Shelley was sworn in: "San Francisco Arts Policy: A Background Paper" (San Francisco State University: 1980).

70 Shelley and his opponent, Harold Dobbs: *San Francisco Chronicle*, October 30, 1963.

70 "This new generation of California culture-bearers": Kenneth Rexroth, "Thar's Culture in Them Thar Hills," *New York Times*, February 7, 1965.

70 Ets-Hokin ignited a furor: *San Francisco Chronicle*, November 24, 1964; *New York Times*, November 29, 1964.

72 Mayor Shelley protested: Editorial, *San Francisco Chronicle*, November 27, 1964; *New York Times*, November 29, 1964.

72 The project was transforming L.A.: *Time*, December 18, 1964.

72 Mayor Shelley saw Prop B: *San Francisco Chronicle*, November 25, 1964.

72 From the beginning, he had been interested: Harold Zellerbach interview transcript, UCB.

73 As the *New York Times* noted: *New York Times*, May 23, 1966.

73 The study proposed: "San Francisco Arts Policy: A Background Paper" (San Francisco State University: 1980), SFPL.

73 For the first time, according to cultural critic Amalia Mesa-Bains: Interview with Amalia Mesa-Bains, March 12, 2012.

CHAPTER THREE: CREATIVE UPHEAVAL

75 In May 1966, poet Kenneth Rexroth urged students: "The Artists Liberation Front and the Formation of the Sixties Counterculture," *The Digger Archives*, http://www.diggers.org/alf.htm.

79 The ALF wanted to bring recognition: *The San Francisco Mime Troupe Reader*, p. 21.

79 Called Free Fairs: *San Francisco Chronicle*, October 10, 1966.

79 In the fall, the Diggers: Cavallo, *A Fiction of the Past*, 100.

79 Artistic expression—unfettered, flamboyant, and experimental: *Time*, July 7, 1967.

79 In October, a free performance: *San Francisco Chronicle*, October 7, 1966.

79 Three months later, in January 1967: Richard M. Harnett, "All Kinds of 'Kooks' Gather for Happening," United Press International, printed by the *Plain Dealer* (Cleveland, Ohio) January 16, 1967, accessed in "News in History" at http://bit.ly/g5aYLL.

79 By July, a hundred thousand young people: *San Francisco Chronicle*, January 15, 1967.

81 According to Beat poet Michael McClure: Joel Selvin, "1967: The Stuff That Myths Are Made Of," *San Francisco Chronicle*, May 20, 2007.

81 Snipper, a longtime teacher and painter: Martin Snipper interview transcript, UCB.

Evolves the Luminous Flora, 2010, by Jovi Schnell, at Tutubi Plaza on Russ Street between Minna and Natoma streets

81 Together, they conceived of a three-way partnership: *Council on Museums and Education in the Visual Arts, The Art Museum as Educator*, 193.

81 "Harold was very responsive": Martin Snipper interview transcript, UCB.

81 Its first performing arts festival: ibid.

84 In fiscal year 1968–1969, the program sponsored: "Neighborhood Arts Program," SFAC, February 1970; *San Francisco Chronicle*, August 1, 1970.

84 The NAP, according to Snipper: Martin Snipper interview transcript, UCB.

85 "There were nearly a hundred fifty artists living in the Mission District": Interview with René Yañez, June 7, 2012.

85 The Neighborhood Arts Program, stated the Ford Foundation: "About Neighborhood Arts," SFAC.

86 They were "desperately poor": John Kriedler interview transcript, UCB

86 The program inspired CETA arts initiatives; *New York Times*, January 16, 1976.

87 The festival was a forum: *San Francisco Chronicle*, February 14, 1973; Neighborhood Arts Program Annual Report 1972–1974, SFAC.

95 The program had converted an old UC Extension gym: Marina T. Budhos, "Neighborhood Rhythms: 20 Years of the San Francisco Neighborhood Arts Program," SFAC.

96 "The cultural centers were an exciting civic investment": Interview with Roberto Vargas, May 18, 2011.

96 Soon after, in early 1972: "Statement by Mayor Joseph Alioto on Street Artists," December 31, 1971, SFAC Minutes, 1972.

100 Europeans knew about Bay Area blues: *San Francisco Chronicle*, February 14, 1973.

100 "It was a smash": *Living Blues*, Issues 90–94 (Center for the Study of Southern Culture, University of Mississippi, 1990), 7.

103 *Chronicle* jazz critic Jon Hendricks praised the show: Neighborhood Arts Program Annual Report, 1972–1974, SFAC.

103 The NAP's second Blues Festival: Neighborhood Arts Program Annual Report 1972–74, SFAC.

103 In the view of San Francisco's new mayor: "San Francisco Arts Policy: A Background Paper" (San Francisco State University: 1980), SFPL.

106 By 1977, CETA funds were shrinking: Marina T. Budhos, "Neighborhood Rhythms: 20 Years of the San Francisco Neighborhood Arts Program," SFAC.

106 Taliaferro, according to Martin Snipper, spent his days: SFAC Minutes, 1978.

106 San Francisco was still fertile ground: Marina T. Budhos, "Neighborhood Rhythms: 20 Years of the San Francisco Neighborhood Arts Program," SFAC.

106 A few days later, a bomb threat: SFAC Minutes, 1978.

107 "We heard the screaming": Interview with Ray Taliaferro, September 9, 2011.

107 Art, reflected Roger Boas, the city's chief administrative officer: "San Francisco Arts Policy: A Background Paper" (San Francisco State University: 1980), SFPL.

107 The center was expected to bring more performances: *Time*, July 29, 1980.

107 Still, some neighborhood groups criticized: *New York Times*, September 8, 1977.

107 Angry neighborhood activists planned: Marina T. Budhos, "Neighborhood Rhythms: 20 Years of the San Francisco Neighborhood Arts Program," SFAC.

107 On November 25, just before midnight: SFAC Minutes, 1980.

107 "It was a very difficult and emotional time": Interview with Joan Ellison, September 9, 2011.

107 Art, Ray Taliaferro believed: "San Francisco Arts Policy: A Background Paper" (San Francisco State University: 1980), SFPL.

CHAPTER FOUR: AFTERSHOCKS

111 In 1981, the federal government stopped funding: "Neighborhood Arts Program Milestones, 1967–1985," SFAC.

113 Suddenly on their own: Marina T. Budhos, "Neighborhood Rhythms: 20 Years of the San Francisco Neighborhood Arts Program," SFAC.

113 The NAP, its director warned: "Neighborhood Arts Program Director's Report, June 1989," SFAC.

113 As director Claire Isaacs noted that year: "Memorandum re State of the City Report, 1983–1984," SFAC.

113 After inviting twenty artists to compete: *Controversial Public Art from Rodin to di Suvero*, Milwaukee Art Museum, October 21, 1983–January 18, 1984, SFAC.

114 Two weeks before the December event: *San Francisco Chronicle*, December 8, 1981.

114 When he refused, the agency voted: *San Francisco Chronicle*, December 8, 1981.

114 It "struck a nerve": Chris Goodrich, July–August 1984, article clipping in SFAC Gallery binder.

114 The piece was soon removed: *San Francisco Chronicle*, March 2, 1982.

114 The fiasco, the *San Francisco Chronicle* declared: *California Living* magazine, *San Francisco Sunday Examiner* and *Chronicle*, August 8, 1982.

114 Arneson, for his part: *California Living* magazine, *San Francisco Sunday Examiner* and *Chronicle*, August 1, 1982.

114 Four days after the installation: *San Francisco Chronicle*, November 12, 1984.

118 Still, there was controversy over the work's social realism: Ann Seymour, *Arts Journal* clipping in SFAC Gallery binder.

118 For Segal, a sculptor who had worked: *California Living* magazine, *San Francisco Sunday Examiner* and *Chronicle*, August 12, 1982.

122 Critics, however, complained: *San Francisco Examiner*, December 15, 1991.

122 In response, the Arts Commission asked the artists: *San Francisco Examiner*, March 13, 1992.

122 "Whose taste will prevail?": *California Living* magazine, *San Francisco Sunday Examiner* and *Chronicle*, August 1, 1982.

126 In 1984, despite serious financial constraints: SFAC Minutes, 1984.

128 In 1981, the American Express Company: Editorial, *San Francisco Chronicle*, October 5, 1981.

128 The commission also worked with other city agencies: Draft Arts Policy Plan for the City of San Francisco, March 1989, SFPL.

129 Other works—including a suspended fiber piece: SFAC Minutes, 1989.

129 A year after the disaster: *San Francisco Chronicle*, October 26, 1990.

129 Conceived by the Arts Commission: *San Francisco Chronicle*, November 9, 1990.

129 Racial minorities were now: Jeff Jones and Russell T. Cramer, "Institutionalized Discrimination in San Francisco's Arts Funding Patterns," April 20, 1989, SFAC.

130 By the time it opened: *San Francisco Chronicle*, October 8, 1990.

130 Two weeks later, on October 17, 1990: *San Francisco Chronicle*, October 18, 1990.

130 Within eight months, the board had appointed: *San Francisco Examiner*, December 15, 1991.

130 It was the biggest advisory group: *San Francisco Chronicle*, June 11, 1991.

130 As supervisors worked to foster: *San Francisco Chronicle*, June 29, 1991.

130 After more than a year: *San Francisco Chronicle*, September 27, 1992.

130 "At some point," she remarked: *San Francisco Examiner*, August 30, 1992.

CHAPTER FIVE: THE POWER OF THE PUBLIC

142 The cast-iron landmark had been given: *San Francisco Chronicle*, December 2, 1998.

142 In 1998, when the municipal monument was badly corroded: *San Francisco Chronicle*, April 14, 1998.

142 Preservationists objected to the relocation: *New York Times*, May 6, 1996.

148 "Cultural sensitivity," Sano insisted: Tepper, *Not Here, Not Now, Not That!*, 207.

148 The fight over the murals: *San Francisco Chronicle*, May 12, 1997, and March 8, 2005.

148 The commission's goal, according to President Stanlee Gatti: *San Francisco Chronicle*, August 20, 1997.

149 As Director of Cultural Affairs Richard Newirth admitted: *San Francisco Examiner*, March 19, 1999.

149 Although Gatti described it: *San Francisco Examiner*, March 19, 1999.

153 Still, Mayor Willie Brown acknowledged: *San Francisco Chronicle*, October 19, 2000.

153 "Politicians now realize": *San Francisco Chronicle*, January 24, 2001.

158 For nonprofit arts groups: *San Francisco Chronicle*, November 27, 2001; interview with Carolina Ponce de Leon, April 12, 2012.

158 San Francisco, by 2004: *San Francisco Chronicle*, June 9, 2004.

158 In the emerging digital age: *San Francisco Chronicle*, June 2, 2005.

CHAPTER SIX: CITY OF ART

190 A city, *Chronicle* arts and culture critic Steve Winn observed: *San Francisco Chronicle*, March 8, 2005.

PRIMARY SOURCES

BERKELEY, CALIFORNIA, BANCROFT LIBRARY, UNIVERSITY OF CALIFORNIA (UCB)

Beniamino Bufano autobiographical notebooks: ms. [ca. 1958–1965]; San Francisco Neighborhood Arts Program, the Arts and the Community Oral History Project, Regional Oral History Office: transcripts of interviews with Maruja Cid, Steven Goldstine, John Kriedler, Martin Snipper, and Harold Zellerbach, 1978–1979

GOVERNMENT DOCUMENTS AND REPORTS, PAMPHLETS, AND CATALOGUES

SAN FRANCISCO ARTS COMMISSION (SFAC)

Minutes of the Art Commission of the City and County of San Francisco, 1932–1982; Minutes of the Arts Commission of the City and County of San Francisco, 1983–1989; "Neighborhood Arts Program," February 1970; Neighborhood Arts Program annual reports, 1970–1971, 1971–1972, and 1972–1974; "Neighborhood Arts Program Milestones, 1967–1985"; "San Francisco Art Commission Neighborhood Arts Program and Alvarado Art Workshop Documentation, March–May 1975"; *Controversial Public Art from Rodin to di Suvero*, Milwaukee Art Museum, October 21, 1983–January 18, 1984; Marina T. Budhos, "Neighborhood Rhythms: 20 Years of the San Francisco Neighborhood Arts Program," 1987; "Neighborhood Arts Program Director's Report, June 1989"; Jeff Jones and Russell T. Cramer, "Institutionalized Discrimination in San Francisco's Arts Funding Patterns," April 20, 1989

SAN FRANCISCO PUBLIC LIBRARY (SFPL)

San Francisco Art Festival brochure, 1951; "San Francisco Arts Festival Program," 1958; Martin Snipper, "A Survey of Art Work in the City and County of San Francisco," 1953; "The San Francisco Arts Resources Development Committee Report," November 16, 1966; "San Francisco Arts Policy: A Background Paper" (the Urban Center, San Francisco State University: 1980); "The City and County of San Francisco Art Commission and the Non-Profit 'Friends' Boards of Its Cultural Facilities Agreement," 1983; "Memorandum re State of the City Report, 1983–1984"; "Planning for the Arts in San Francisco, Phase III Report to the California Arts Council," 1984; "Draft Arts Policy Plan for the City of San Francisco," March 1989; "Proposed Arts Policy for the City and County of San Francisco: Draft for Citizen Review," August 1990; San Francisco Arts Commission Annual Reports, FY 1990–1991, 1994–1995, 1995–1996, 1996–1997, 1997–1998, 1998–1999, 1999–2000, 2000—2001; "San Francisco Art Commission Arts Education Summary," 1993; "Art in Transit Master Plan," June 1995

PUBLISHED SECONDARY SOURCES

Albright, Thomas. *Art in the San Francisco Bay Area, 1945–1980: An Illustrated History*. Berkeley: University of California Press, 1985.

Atherton, Gertrude. *My San Francisco*. Indianapolis: The Bobbs-Merrill Company, 1946.

Baverlein, Mark, with Ellen Grantham, ed. *National Endowment for the Arts: A History, 1965–2008*. Washington, D.C.: National Endowment for the Arts, 2009.

Benton, Lisa M. *The Presidio: From Army Post to National Park*. Lebanon, New Hampshire: Northeastern University Press, 1998.

Bogart, Michele H. *The Politics of Urban Beauty: New York and Its Art Commission*. Chicago: University of Chicago Press, 2006.

Brooks, James, Chris Carlsson, and Nancy J. Peters, eds. *Reclaiming San Francisco: History, Politics, Culture*. San Francisco: City Lights Books, 1998.

Caen, Herb. *Herb Caen's Guide to San Francisco*. New York: Doubleday, 1957.

Cavallo, Dominick. *A Fiction of the Past: The Sixties in American History*. New York: Palgrave Macmillan, 2001.

Council on Museums and Education in the Visual Arts. *The Art Museum as Educator: A Collection of Studies as Guides to Practice and Policy*, Newsom, Barbara Y., and Adele Z. Silver, eds. New York: University of California Press, 1978.

DeLeon, Richard. *Left Coast City: Progressive Politics in San Francisco, 1975–1991*. Lawrence: University Press of Kansas, 1992.

Dickson, Harry Ellis. *Arthur Fiedler and the Boston Pops*. Boston: Houghton Mifflin, 1981.

Doss, Erika. *Spirit Poles and Flying Pigs: Public Art and Cultural Democracy in American Communities*. Washington: Smithsonian Institution Press, 1995.

Falk, Randolph. *Bufano*. Millbrae, Calif.: Celestial Arts, 1975.

Federal Writers Project of the Works Progress Administration. *San Francisco in the 1930s: The WPA Guide to the City by the Bay*. Berkeley: University of California Press, 2011.

Ferlinghetti, Lawrence. "Horn on Howl," in Lewis Hyde, *On the Poetry of Allen Ginsberg*. Ann Arbor: University of Michigan Press, 1985.

Flamm, Jerry. *Good Life in Hard Times: San Francisco in the '20s & '30s*. San Francisco: Chronicle Books, 1999.

Florida, Richard. *The Rise of the Creative Class*. New York: Basic Books, 2002.

Forbes, B. C. *Men Who Are Making the West*. New York: B. C. Forbes Publishing Co., 1923.

Issel, William, and Robert W. Cherny. *San Francisco 1865–1932*. Berkeley: University of California Press, 1986.

Jewett, Masha Zackheim, and Don Beatty. *Coit Tower: Its History and Art*. San Francisco: Volcano Press, 1983.

Knight, Cher Krause. *Public Art: Theory, Practice and Populism*. Malden, MA: Blackwell Publishing, 2008.

Landauer, Susan. *The San Francisco School of Abstract Expressionism*. Berkeley: University of California Press, 1996.

Lee, Anthony W. *Painting on the Left: Diego Rivera, Radical Politics, and San Francisco's Public Murals*. Berkeley, University of California Press, 1999.

Mason, Susan Vaneta, ed. *The San Francisco Mime Troupe Reader*. Mason, Susan Vaneta ed. Ann Arbor: University of Michigan Press, 2005.

Miles, Malcolm. *Art, Space and the City*. London: Routledge, 1997.

Morgan, Bill, and Nancy J. Peters, eds. *Howl on Trial: The Battle for Free Expression*. San Francisco: City Lights Books, 2006.

Pepin, Elizabeth, and Lewis Watts. *Harlem of the West: The San Francisco Fillmore Jazz Era*. San Francisco: Chronicle Books, 2006.

Reinhardt, Richard. *Treasure Island: San Francisco's Exposition Years*. San Francisco: Scrimshaw Press, 1973.

Robbins, Trina. *Forbidden City: The Golden Age of Chinese Nightclubs*. Creskill, NJ: Hampton Press, 2010.

Rosenbaum, Fred. *Cosmopolitans: A Social & Cultural History of the Jews of the San Francisco Bay Area*. Berkeley: University of California Press, 2009.

Sauners, Richard Drake. *Music and Dance in California and the West*. Hollywood: Bureau of Musical Research, Inc., 1948.

Schrank, Sarah. *Art and the City: Civic Imagination and Cultural Authority in Los Angeles*. Philadelphia: University of Pennsylvania Press, 2009.

Solnit, Rebecca. *Infinite City: A San Francisco Atlas*. Berkeley, University of California Press, 2010.

Starr, Kevin. *Golden Dreams: California in the Age of Abundance, 1950–1963*. New York: Oxford University Press, 2009.

———. *Endangered Dreams: The Great Depression in California*. New York: Oxford University Press, 1996.

Tepper, Stephen J. *Not Here, Not Now, Not That!: Protest over Art and Culture in America*. Chicago: University of Chicago Press, 2011.

The Performing Arts: Rockefeller Panel report on the future of theatre, dance, music in America. New York: McGraw Hill, 1965.

Wilkening, H., and Sonia Brown. *Bufano: An Intimate Biography*. Berkeley: Howell-North Books, 1972.

Yang, Mina. *California Polyphony: Ethnic Voices, Musical Crossroads*. Urbana: University of Illinois Press, 2008.

Poster by John Almond. Courtesy of SFMOMA Research Library and Archives
94

Photograph by Ralph Alswaing. Official White House photograph
141

Photo by Michael Amici
180, 181

© Estate of Robert Arneson/Licensed by VAGA, New York, NY. Courtesy of the San Francisco Museum of Modern Art.
115

© Estate of Robert Arneson/Licensed by VAGA, New York, NY. Photo © Michael Rauner
129

© Robert Bechtle, courtesy of Gallery Paule Anglim, San Francisco
105

© David Best. Photographer unknown.
14

© Estate of Joan Brown, courtesy of Gallery Paule Anglim, San Francisco
104

AP Photo / Robert W. Klein
80

ARTonFILE.com
129

Courtesy of the Bancroft Library, University of California, Berkeley
86, 100

Photo © Richard Barnes
12–13, 132–133, 136

Photo © JD Beltran
34, 35, 99, 139, 175, 182, 187, 209

Courtesy of the Estate of Lydia and Elio Benvenuto
67, 70, 92–93, 94

© Bettmann / CORBIS
73

© David Best. Photographer unknown.
14

© Estate of Elmer Bischoff. Courtesy of George Adams Gallery, New York
62

Photo by Gregory H. Blaine. Courtesy of the Presidio Dance Theatre
177

Photo by Michael JN Bowles
177

Photo by J. Astra Brinkmann
176

Brubeck Collection, Holt-Atherton Special Collections, University of the Pacific Library © Dave Brubeck
57

Courtesy of the California Department of Transportation
26, 40

Courtesy of the California Historical Society
28

Photograph by Lin Cariffe. Courtesy of Na Lei Hulu
160

Photo by John Chiara. Courtesy of the Pilara Foundation, Pier 24 Photography
164–165

© Paul Chinn / San Francisco Chronicle / Corbis
141

© 2013 Banco de México Diego Rivera Frida Kahlo Museums Trust, México D.F./Artists Rights Society (ARS), New York. Photo © City College of San Francisco. www.riveramural.com. All Rights Reserved.
44–45, 46–47

Design by Kevin Clarke. Courtesy of the artist
137

Photo by Jon Cosner, 2011
172

Photo by Allison Cummings
178

© 2012 The Imogen Cunningham Trust. www.imogencunningham.com
74–75, 94

Photo © Bruce Damonte
8, 103, 104, 183, 184, 190

© Estate of Roy DeForest / Licensed by VAGA, New York, NY
104

Photo by Lewis deSoto
152

© The Richard Diebenkorn Foundation
63

Photo by Mark Eastman. Courtesy of Gallery Paule Anglim
19

Courtesy of El Tecolote Photo Archive
88, 89, 98

Courtesy of the Fine Arts Museums of San Francisco
148

© Estate of Robert Arneson/Licensed by VAGA, New York, NY. Photo by Kurt Edward Fishback.
112

Artwork by Rupert Garcia. Courtesy of Rena Bransten Gallery. Photo by Kurt Edward Fishback.
88

Photo by Bill Goidell. Courtesy of Cultural Odyssey
140

Courtesy of David Lance Goines
85

© Jim Goldberg. Courtesy of the artist
125

Courtesy of Lydia S. Gonzales
172, 173–174

© Estate of Robert Arneson/Licensed by VAGA, New York, NY. Photo © Marion Gray.
114

Photo by Zach Gross. Courtesy of Pocha Nostra
169

Photograph by Doug Hall, 2004
22–23

Photo by Krystal Harfert. Courtesy of Bandaloop
171

© Ilka Hartmann, 2013, www.ilkahartmann.com
86, 89

Courtesy of Stewart Harvey
149

Courtesy of Tim Hawkinson
19

© Todd Hido. Courtesy STEPHEN WIRTZ GALLERY, 1996–2011
200 [#f-2027 #2690], 201 [#1941]

© Todd Hido
208

Photo by Janet Hoelzel
101

Courtesy of Jerri Holan, FAIA
98

© Zhang Huan Studio, Courtesy of Pace Gallery. Photo by Scott Hess.
192-3

David Hodges, "The Invisible Circus: A 72-Hour Environmental Community Happening," 1979. Collection of the Oakland Museum of California, All of Us or None Archive. Fractional and promised gift of the Rossman Family.
84

© 2013 The Isamu Noguchi Foundation and Garden Museum, New York/Artists Rights Society (ARS), New York
104

© Jason Jägel
138

Japanese American National Museum (2005.97.5). Gift of San Francisco Taiko Dojo
91

© David S. Johnson
58

Photo courtesy of Ned Kahn
118

© Mahboube Karamli. Courtesy of the SFAC Gallery Archives
189

Photo by Teresa Kennett. Courtesy of Performing Arts Workshop
177

Kersten Brothers, Ed Beatty, "Today is the First Day of the Rest of Your Life," 1968. Collection of the Oakland Museum of California, All of Us or None Archive. Fractional and promised gift of the Rossman Family.
79

© Estate of Margaret Kilgallen. Courtesy of the SFAC Gallery
138

© Pawel Kruk. Courtesy of the SFAC Gallery Archives
189

© Lisa Law
78, 79, 80

Photos by Alyssa Licouris
175

© Hung Liu. Courtesy of Rena Bransten Gallery
157

Photo by Terry Lorant
85

Photo by Reagan Louie
162, 163

© Michael Macor / San Francisco Chronicle / Corbis
152

© Vince Maggiora / San Francisco Chronicle / Corbis
129

© 1999 Mike Mandel and Larry Sultan
154

Photo by Geneviève Massé. Courtesy of the San Francisco Arts Commission
156, 157, 183

Photo © Dania Maxwell
187

Photo by Pat Mazzera. Courtesy of Cultural Odyssey
140

Courtesy of Thomas Mazzolini
101

© Barry McGee, courtesy of Gallery Paule Anglim, San Francisco
1139

Photo by Matthew Millman. Courtesy of the San Francisco Arts Commission
172

© Richard Misrach, courtesy Fraenkel Gallery, San Francisco, Marc Selwyn Fine Art, Los Angeles and Pace / Macgill Gallery, New York
2–3, 220–221

Photo © Margo Moritz. Courtesy of Margaret Jenkins Dance Company.
130

Photo © marinocolmano.com
128

Courtesy of Moulin Studio Archives
30, 49, 108

© The Estate of Lee Mullican. Courtesy of Marc Selwyn Fine Art, Los Angeles
104

Photo by RJ Muna. Courtesy of Joe Goode Performance Group
160

Courtesy of the Museum of the City of San Francisco
142

Courtesy of the Museum of Performance and Design
60–61

Photo by Mia Nakano
177

David Ng Studio. Courtesy of Ansel Wettersten
94, 95

Photo by Daniel Nicoletta
106, 107, 121

Photo © Ira Nowinski
87, 124

Photo © Ira Nowinski. Courtesy of Stanford University Special Collections
119

Photo by Andy Nozaka. Courtesy of Jon Jang
140

Photo by Jim Orjala, Courtesy of Dance Mission Brigade
123

Photo by David Papas. Courtesy of Scott Wells and Dancers
171

Photo © Nan Park, Perretti & Park Pictures
194–195

Courtesy of Performing Arts Workshop
91

© Michael Rauner
15, 16, 17, 20, 37, 50 108, 126, 142, 143, 146–147, 156, 157–158, 161, 168, 178, 185, 191, 204, 205, 211

Diego Rivera, "Man at the Crossroads or Man, Controller of the Universe (detail)," 1934. Fresco on movable metal frame, 4.80 x 11.45 cm. Museo del Palacio de Bellas Artes, INBA, Mexico City. © 2013 Banco de México Diego Rivera Frida Kahlo Museums Trust, México, D.F./Artists Rights Society (ARS), New York
36

Photo by Steve Rhodes
188

Photo by Patricia Rodriguez
88, 89

© Clare Rojas, courtesy of Gallery Paule Anglim, San Francisco
138

Photograph by Monica Roy, www.monicaroy.com
181

Reproduced with permission of the Ruth Bernhard Archive, Princeton University Art Museum © Trustees of Princeton University
53

Photographer unknown. Courtesy of the San Francisco Arts Commission
14, 17, 88, 89, 90, 91, 94, 97, 101, 121, 150, 151, 159, 181, 202

Courtesy of the San Francisco Film Society, poster design by Saul Bass
69

Courtesy of the San Francisco History Center, San Francisco Public Library
10–11, 27, 28, 30, 32, 33 [Chas. M. Hiller, photographer], 37, 38, 39, 41, 42, 43 [Roberts & Roberts] 51, 52, 56, 59, 64, 66, 67, 68, 98, 126 [Illustrated Daily Herald Photo]

Courtesy of the San Francisco Symphony
29, 49, 108

© Susan Schwartzenberg
65, 144–146

Courtesy of the SFAC Gallery Archives 120, 121 [Liquid Eyeliner announcement by Rex Ray], 188 [Urbanition photograph by Chris Fox. Graphic Design by Joshua Singer.], 189

Courtesy of SFMOMA Research Library and Archives
51, 121

Collection of SFO Museum
102

Courtesy of SF Taiko Dojo
170

Courtesy of Joshua Singer. Design by Joshua Singer, Atomtan Design. Artwork by Chris Fox
186

Photo © C.R. Snyder. Courtesy of ruth weiss
71

Courtesy of SOMArts Cultural Center
98

© Jerry Telfer / San Francisco Chronicle / Corbis
107

Photo by Terry Lee Photography. Courtesy of the Presidio Dance Theatre
177

© Wayne Thiebaud / Licensed by VAGA, New York, NY
104

UN Photo / International News Photo
48

© Catherine Wagner
116–117

Photo by Wang Po Shu
17

© Henry Wessel. Courtesy Pace / MacGill Gallery, New York
82–83, 109

© Audrey Whitmeyer-Weathers / San Francisco Chronicle / Corbis
179

Photo by Bill Wilson, www.billwilsonphotos.com
18, 207

Photo © Frank Wing. Courtesy of Museum of Performance and Design
57

Artwork by Leland Wong. Courtesy of Kearny Street Workshop Archives, CEMA 33, Department of Special Collections, University Libraries, University of California, Santa Barbara
141

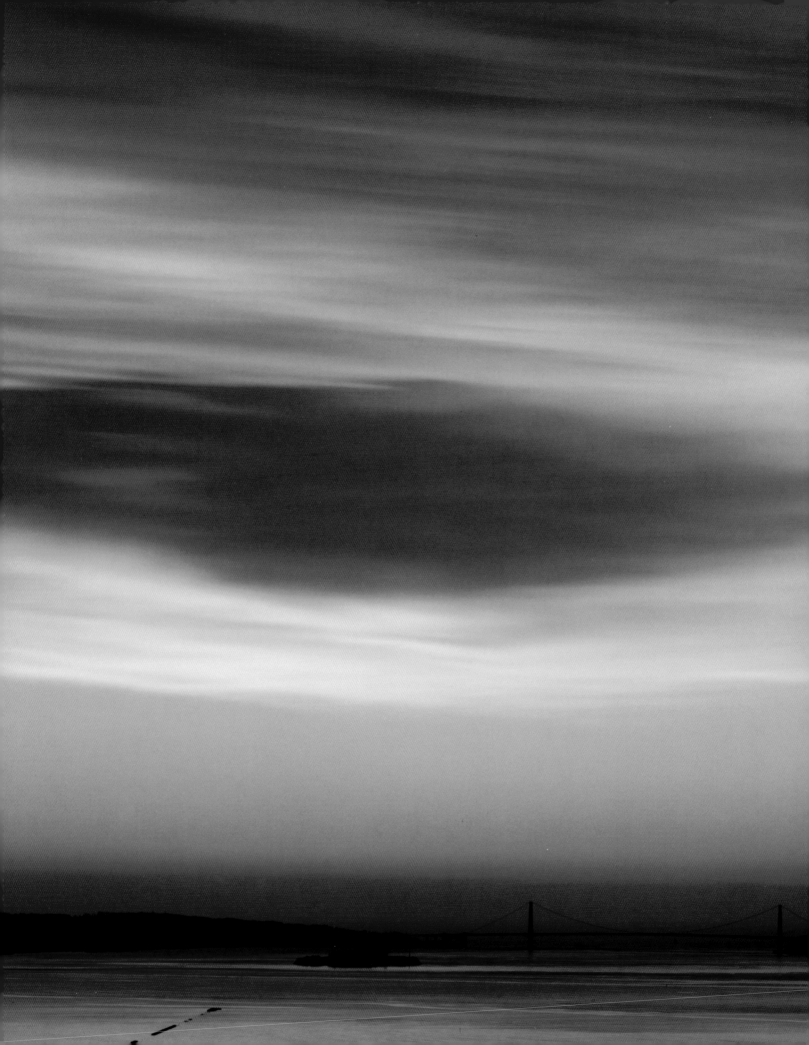

Golden Gate Bridge, 12.23.97, 5:09 pm, by
Richard Misrach